HONEST CREATIVITY

HONEST CREATIVITY

THE FOUNDATIONS OF BOUNDLESS, GOOD, AND INSPIRED INNOVATION

CRAIG DETWEILER

morehouse PUBLISHING

All Scripture quotations, unless otherwise indicated, are taken from the Holy Bible, New International Version®, NIV®. Copyright © 1973, 1978, 1984, 2011 by Biblica, Inc.™ Used by permission of Zondervan. All rights reserved worldwide. www.zondervan.com The "NIV" and "New International Version" are trademarks registered in the United States Patent and Trademark Office by Biblica, Inc.™

Scripture quotations marked (ESV) are from the ESV® Bible (The Holy Bible, English Standard Version®), © 2001 by Crossway, a publishing ministry of Good News Publishers. Used by permission. All rights reserved. The ESV text may not be quoted in any publication made available to the public by a Creative Commons license. The ESV may not be translated in whole or in part into any other language.

Scripture quotations marked (GNT) are from the Good News Translation in Today's English Version-Second Edition Copyright © 1992 by American Bible Society. Used by Permission.

Scripture marked (NCV) taken from the New Century Version®. Copyright © 2005 by Thomas Nelson. Used by permission. All rights reserved.

Morehouse Publishing, 19 East 34th Street, New York, NY 10016

Morehouse Publishing is an imprint of Church Publishing Incorporated.

Cover design by David Rothstein
Typeset by Nord Compo

Library of Congress Cataloging-in-Publication Data

Names: Detweiler, Craig, 1964– author.
Title: Honest creativity / by Craig Detweiler.
Description: New York : Morehouse Publishing, [2024] | Includes
 bibliographical references.
Identifiers: LCCN 2023040229 | ISBN 9781640656536 (hardcover) | ISBN
 9781640656543 (ebook)
Subjects: LCSH: Creative ability—Religious aspects—Christianity. |
 Integrity. | Christianity and the arts.
Classification: LCC BT709.5 .D48 2024 | DDC 204/.4—dc23/eng/20231122
LC record available at https://lccn.loc.gov/2023040229

To my faithful friend and mentor Ken Schultz

CONTENTS

INTRODUCTION: HONEST CREATIVITY

"There is no innovation and creativity without failure. Period."

—BRENÉ BROWN[1]

FRAUD. PHONY. FAILURE. THE LABELS STICK. AND STING.
Especially when we apply them to ourselves. It may not have started with us. Maybe it was the voice of a parent, a teacher, or a coach. Someone had the ability to instill just a bit more hope in us, a sense that we might be special. And yet, the words weren't forthcoming. Or maybe they arrived too late to sink in. And so, we sank from a tower of potential into a puddle of what-ifs.

Billie Eilish expresses such self-doubt so poignantly in her closing ballad for the *Barbie* movie, "What Was I Made For?" Her whispered, wistful vocals convey the gap between childhood innocence when we floated and now, when the weight of the world causes us to fall down. Our earlier confidence is replaced by the existential question "What was I made for?" Billie steps into Barbie's shoes, where the pressures of conforming to an ideal clash with her longing to be real. This tension can short-circuit our creative pursuits. The pressure to perform, to be perfect, can overwhelm us when we know our shortcomings. Having experienced joy, we wrestle with how to process complex feelings of sadness. Indecision can

stymie us. Eilish recalls writing the song with her brother, Finneas, "in a period of time where we couldn't have been less inspired and less creative."[2] Despite winning Grammys and an Oscar, Eilish felt like a failure, "We've lost it. Why are we even doing this?" Only after finishing the song, Eilish "realized it was about me. It's everything I feel. And it's not just me—everyone feels like that, eventually." For Barbie, for Billie, the song is a search for meaning, for something we can be. What are we made for? To live, to love, to create.[3]

The rise of Artificial Intelligence may also discourage our creativity. ChatGPT can generate well-written pages and detailed lists from a single prompt. Why should aspiring musicians practice their scales when a machine can complete Beethoven's Tenth Symphony?[4] Will the skills of a graphic designer still be needed when Midjourney can serve up complex images scraped from the best of what the Internet offers? We may feel we can't compete with the processing power and predictive pathways of machine learning. Generative A.I. raises core questions about our humanity. Why bother to paint or code if A.I. can do it faster and better? We seem so messy and inefficient in comparison to the data processors that are ready to render our requests.

We gladly rely upon algorithms to sort through the avalanche of pop cultural options on Netflix or Spotify. We're grateful if A.I. can scan all the data in our medical records to make recommendations for our healthcare treatments. Financial firms already make plenty of decisions based upon A.I.'s analysis of massive, complex data fields. Should doctors and financial analysts worry about their long-range job prospects? We will always need to add an ethical and humane dimension to the machines' recommendations. We will struggle to root out racism and sexism in large language models trained on our collective history. We remain glorious, fallible, frustrating creatures blessed with profound imaginative capacities and social responsibilities. *Honest Creativity* resists the temptation to

reduce life to bits and bytes, data and efficiencies. It counters with beauty and awe. My core thesis: as we embrace the possibilities embedded within A.I., we will depend upon the enduring wisdom and power of H.I.—Human Intelligence, Ingenuity, and Innovation. Yet, such creativity isn't summoned on demand, but nurtured in silence, humility, and practice. It is forged in failure, revealed via vulnerability, received with gratitude.

My conflicted feelings regarding A.I. swirl around the last Beatles song, "Now and Then." I'm grateful machine learning made this musical reunion possible by isolating John Lennon's vocal track from his piano part on an old cassette tape, making room for the surviving "threetles" to join in. George Harrison recorded guitar accompaniment back in 1995. Paul McCartney and Ringo Starr reunited, adding bass and drums and harmony vocals circa 2023. Producer Giles Martin added strings that resembled the orchestral scores penned by his deceased father, George Martin. The resulting song merges these three recording eras into a melancholic tribute to friendship and love. It communicates grief and loss with a simple chorus that echoed Lennon's final words to McCartney, "Think about me every now and then, old friend." Giles Martin reflects, "I do feel as though 'Now and Then' is a love letter to Paul, written by John," and "that's why Paul was so determined to finish it."[5] Artificial Intelligence provided a means to communicate love and care across the decades.

The accompanying "Now and Then" music video directed by Peter Jackson juxtaposes old band photos and warm memories with Paul and Ringo singing today. It conjures up so many emotions for Beatles' fans who've longed for a reunion that seems to have finally arrived onscreen. Yet, when vintage footage of the deceased John and George was dropped into the same frame as the contemporary Paul and Ringo, I popped out of the experience. The digital effects felt odd amid such an understated song. I started to think about the sources for this visual collage

rather than the people. For me, the Beatles' sound was undermined by special effects. Artificial Intelligence that made the music possible also proved too tempting for the video editors to resist. This nostalgic musical reunion should not have descended into the uncanny valley. Some fans cried. I cringed. This digital resurrection of the dead felt more like grave robbing. Just because we can, doesn't mean we should.

Maybe I should be more intimidated by A.I. because at best, I have been a middling artist. The first screenplay I sold was bought by the producers of *Air Bud*, a film about a dog who could dunk a basketball, which became an immensely profitable, fourteen-movie franchise. The Canadian company that made the movie sued Disney over the profits they rightfully deserved. Disney punished them by taking it out on my little movie *The Duke*. It was about a dog who inherited his master's British title and estate. You can see the poster, right? Dog wearing a crown, with a scepter in his mouth rather than a bone. The tagline was easy: "Royalty Goes to the Dogs." It had some sweet and silly moments in it. Unfortunately, the director didn't understand where the jokes were. I dare you to try to find this Disney release, buried by the company for almost all time as revenge against *Air Bud*. A.I. could have created a better poster than the half-hearted efforts of the Disney marketing team.

I also wrote some of the funniest lines in a faith-fueled film that arrived at a tumultuous time of collective grief. It was about four guys, a girl, and all the extreme sports montages our producers could pack into ninety minutes. We didn't have enough of a budget to film the actors doing any surfing, skating, or motocross. Consequently, we admitted from the opening frame, "This film is based on a true story. Only the facts have been changed to make it more exciting than it was." Our cast was quite talented, from Dante Basco, who played Rufio in Steven Spielberg's *Hook* to A.J. Buckley who eventually starred in TV series like *CSI: NY* and *SEAL Team*. We had an aggressive soundtrack featuring hot bands like

P.O.D. The title track launched TobyMac's solo career, topping the Contemporary Christian Music charts. Even as a low-budget film, *Extreme Days* lost money, opening two weeks *after* 9/11. That was not the moment people were rushing to theatres to see an absurdist comedy about a road trip from Baja to Alaska. A world in shock needed safety and reassurance in the wake of tragedy, not silliness on surfboards. Luck and timing are frustrating aspects of the creative life.

Why trust the artistic advice of someone who has written films that flopped? Because I know how many great ideas I failed to write out of fear and trembling. At USC film school, I let my intimidating professor talk me out of the scathing silent comedy I wanted to make about political correctness. She still ended up tossing a chair across the room that crashed above a classmate's head. This was before harassment was openly discussed. I learned in that class that you can't be scathing in your take on political correctness if you're scared of a bad grade or a professor's disapproval.

Earlier in film school, I did express my most absurd and original idea, a satire of the preponderance of superhero movies called "Pigman." The screenwriting professor called it the worst idea he could remember hearing. About two months later, it showed up as a recurring joke on an episode of *Seinfeld*, the top-rated comedy of the era.[6] Was it actually a great idea that the prof stole? Did he consider it so outlandish and awful that he told plenty of his fellow writers about it? I never found out. But it was a strange affirmation to watch Kramer and Jerry trade comedic barbs about the frightening appearance of a "Pigman."

I didn't trust my instincts. I didn't tell the truth. I got the half-baked creative career I deserved.

Why listen to me when we already have record producers like Rick Rubin, admen like David Oglivy, artists like Makoto Fujimura, choreographers like Twyla Tharp, and songwriters like Jeff Tweedy sharing their

creative secrets? Business titans regularly reveal their keys to innovation. How often I've returned to the wisdom of authors Anne Lamott, Stephen King, and Madeline L'Engle for ongoing inspiration. Novelist Elizabeth Gilbert reached back to the ancient world to find "Your Elusive Creative Genius."[7] Seventy-five million people listened to Sir Ken Robinson's TED Talk on how schools kill creativity.[8] So why trust a college professor like me? Because I'm that aspiring writer just like you. The one who has great ideas but can't quite get them on paper. The painter who dabbles just enough to not have enough results to buy a booth at the art fair. I'm the inventor who's tasted a fantastic, exotic flavor in Southeast Asia that would have been a huge soft drink in the West, if I bothered to produce it. Almosts, nearlys, what-might-have-beens. We've all been there—and *not* done that.

Goals

Why start with how and why I've failed? To save you some time and trouble. To warn you, chide you, guide you through the valleys ahead. For twenty-five years, I've tried to shave five or ten years of pain off my students' road to "overnight" success. It has still taken them five, ten, or usually fifteen years before they refine their voice, when they're actually paid to create. Some have entered the Creator economy, cranking out daily videos for TikTok and YouTube with exhausting results. They're now managing social media for Microsoft, developing scripts for LeBron James's production company, and composing soundtracks for Netflix. Kai is the head of story for Warner Brothers Animation. Chris heads up Universal's Theatrical Group—launching plays and musicals for Broadway. Some work for YouTube, Amazon, Meta, and Google. Others launched their own companies. What kind of teaching am I really offering? I'm aspiring

to counter all the self-doubt and defeat that is inescapable in artistic and business endeavors.

I'm your biggest cheerleader and fan, a representative for the One who made you so weird and disturbed and original. When Americana musician Jason Isbell was asked what makes his marriage to violinist extraordinaire Amanda Shires work, he quipped, "Never once has she looked at me like I'm strange. Never once. And everybody else has. At least once."[9] That's the affirming look I extend to you, your work, your wildest ideas. That's also how I hope you'll see yourself—with a gentleness and care that allows you to take chances, to risk rejection, to tell the truth. It results in the prophetic approach that Marvin Gaye, Sinead O'Connor, and Nick Cave brought to their songwriting. They are three of the most broken, spiritual, and enduring musicians of my lifetime. Each lost precious loved ones, from Marvin's muse, Tammi Terrell, to the tragic early death of Sinead and Nick's sons. Despite their intense proximity to grief, addiction, and abuse, their finest work summons a beauty that transcends the test of time. (Please seek out the *Honest Creativity* playlists I've created on YouTube and Spotify that accompany this book.[10])

My goal is to pour so much faith, hope, and love into your soul that your creative well will never run dry. Or at least, when the dry season arrives, you can embrace it as another realm of possibility, a chance to report from the wasteland to equally thirsty and parched companions. Because that's our superpower. Our frailty and vulnerability, our gaping need to know and be known is our strength. Honest failures set us apart from machines. Because it is a hole in our soul that causes us to write, paint, create. We want to know we're not alone; that the pain is shared. The pathos neither began nor will end with us. Because we're part of a long pageant, a parade of people who have lived and breathed and loved and lost as well.

Artificial Intelligence can't feel the heartbreak that has spawned the finest love songs. It doesn't know how scary it can be to feel alone, let alone how to turn it into the sublime beauty that is Al Green singing "Tired of Being Alone." So much elegance emerges from within his plaintive cry. It is silky, smooth, and seductive even amid pain. Nick Cave denounces the creative shortcuts offered by generative A.I. He writes, "ChatGPT is fast-tracking the commodification of the human spirit by mechanizing the imagination. It renders our participation in the act of creation as valueless and unnecessary."[11] Yet so much of our enduring art arises from struggle. Cave decries, "ChatGPT's intent is to eliminate the process of creation and its attendant challenges, viewing it as nothing more than a time-wasting inconvenience that stands in the way of the commodity itself. Why strive?, it contends. Why bother with the artistic process and its accompanying trials? Why shouldn't we make it 'faster and easier'?"[12] Is creativity about efficiency or something more sublime?

A.I. can ape and mimic emotions just like all kinds of bad art has across the centuries, but it will never create a more frightening and original mix of possessiveness/obsessiveness than Screamin' Jay Hawkins's "I Put a Spell on You."[13] He cackles and wails between the piano and saxophone riffs. His performance is unhinged and unforgettable. Only Nina Simone would dare to take on Screamin' Jay, concocting a different kind of brew in her own cover of "Spell."[14] She replaced Jay's grunts with more of a defiant resolve. The saxophone solo offers an occasion for Nina to stutter and scat over a string arrangement. If Screamin' Jay sounds like a drunken voodoo priest, the high priestess of soul spells out her plans with a matter-of-factness that should make any former lover shudder in fear. The madness that lost love puts on the human heart can be duplicated by a machine, but A.I. will not reveal hidden truths about heartbreak that cause us to pause, to ponder, to nod in recognition when we

have heard something we knew to be true, but never considered in quite as piercing a way before.

Classical compositions can also convey complex emotions that exist far beyond words. Samuel Barber's *Adagio for Strings*, Op. 11 arrived during the Great Depression of the 1930s. Conductor Leonard Slatkin noted how "this piece starts just with a single, very long melodic line in the violins, which then goes over to the violas and then goes over to the cellos. It reaches a very strong climax, followed by what seems like an interminable silence. And then the music reappears for one last time and we hear, at the very end, two chords that might as well be saying 'Amen.'"[15] The deliberate pace and mournful mood has made it a recurring choice for state funerals from President Franklin Delano Roosevelt's memorial service to Princess Grace of Monaco's last rites in 1982. As chief conductor of the BBC Symphony Orchestra, Slatkin chose to perform the *Adagio* four days after more than three thousand people died during the attacks of September 11, 2001. (You can find this poignant piece on the *Honest Creativity* playlist on YouTube.) Barber's composition consistently evokes tears in listeners who can't explain why. It seemed like an unlikely choice for an electronic remix by club DJs like William Orbit and Tiesto. Yet audiences of all ages respond to how the strings burrow into buried wounds, drawing out the hidden traumas we still can't name. Sad songs evoke grief, melancholy, and sorrow. Researchers have found that we listen to sad songs because they make us feel connected—less alone.[16]

I never wrote a masterpiece like that, but I coached some students who still might. Barber was only twenty-six when he penned the *Adagio*. I write this book because our need for healing beauty seems greater than ever before. Even though history and art tell us otherwise. The *Adagio for Strings* rings true for any era marked by grief. Do we need another song about love and loss? Music industry execs note that more than 100,000 new songs are being uploaded to streaming services *every day*.[17]

What a daunting and discouraging number for aspiring artists hoping to get noticed. Yet it also testifies to our collective, complex emotions being expressed via melody and lyrics. Embodied arts like dance and theatre allow us to literally shake off the burdens that surround us. We have so much to process that we can't stop creating. Joy and grief have always greeted us, but we need constant reminders in our contemporary language and metaphors to recall, "We are not alone. We are loved. Even in our sorrow."

This book is written by a mourner for those who grieve. In the past five years, I've buried my father and my mother. We've all lost plenty during the health, prejudicial, and political pandemics. *Honest Creativity* is offered as a prayer for those who lack words. It is a fountain of folly for those crazy enough to create regardless of reception. I wish we didn't have to pick up a pen or paintbrush, but our aching soul demands it. We have too much to work out, too many contradictions that seep out. Try as we might to hide our cringe, our creativity will eventually reveal our secrets. We are fragile freaks, broken vessels, daily disappointments that are capable of soaring sonatas, stirring sonnets, and scathing satire. What the world needs now is love and laughter and light which the Spirit planted within you, longing to be fruitful and multiply.[18]

If we'll be honest about our fear of failure, our imposter syndrome, our self-sabotage, we might be pleasantly surprised. We may discover that we're not alone. Others share our insecurities, need the same assurances, bear similar scars. I'll show you mine if you'll show me yours.

Joy and Pain

"Joy and pain, sunshine and rain." I first heard these conjoined human experiences intertwined by rapper Rob Base and his D.J. E-Z Rock in their

1988 rousing hip-hop classic. "Joy and Pain" is such a simple concept. It was easy to sing along with and internalize. We all experience highs and lows, days where the sun shines on us, seasons when it feels like the sky is falling. Even when we're enjoying a mountaintop moment, we'll start thinking about the pain of the hike down. The red-carpet premiere of our movie, *Extreme Days*, featured an all-female mariachi band wearing amazing pink outfits. We all smiled at such a wondrous sight. The sound of trumpets blaring snaps us all to attention. It is an announcement: "It is time to celebrate: life is good, beautiful, sweet." Yet a week later, the entire world fell silent at the sight of the World Trade Center collapsing. The horror on our television screens was almost impossible to comprehend. How could such mighty symbols of industry collapse so quickly? How could so many beloved lives be buried in the rubble? It was a sobering reminder: life is short, precious, fragile. We've seen enough news to know how quickly joy can turn to pain. Consequently, we gird ourselves for disappointment even amid peak experiences.

Like most old school rappers, Rob and E-Z nicked their chorus from a prior source. Those with a sense of history, a respect for what preceded them, are more likely to succeed in an era when machines can remix any precedents we can invoke. The original "Joy and Pain" was written by Frankie Beverly and recorded by his smooth R & B group, Maze, in 1980. In his warm baritone, Beverly asks the musical question, "How come the things that make us happy makes us sad?" "Joy and Pain" unspools over seven minutes full of enduring paradoxes. The song is meant to put our status in context. Whichever side of joy or pain you're experiencing, carry on. Because those seemingly conflicting emotions are the core of life itself.

Artists and entrepreneurs can often take themselves too seriously. Rabbinical wisdom punctures our pretense with the Yiddish adage, "Man plans, and God laughs." Our most popular comedians from Will

Farrell and Adam Sandler to Kevin Hart and Amy Schumer remind us that life is likely to fall apart. We will end up embarrassed, so start preparing now. The slacker persona of Pete Davidson suggests that tempering our ambitions is wisdom. He responds to hardship with bemusement rather than struggle. In the dour Coen Brothers' film *Barton Fink*, John Turturro plays the eponymous tortured writer trying to make it in Hollywood. He argues with an acclaimed novelist about the nature of art, declaring, "I've always found that writing comes from a great inner pain. . . . Maybe it's a pain that comes from a realization that one must do something for one's fellow man—to help somehow ease his suffering. Maybe it's a personal pain. At any rate, I don't believe good work is possible without it."[19] In response to Barton's high-minded aspirations, a drunken W. P. Mayhew shrugs. He counters with, "Me, well, I just enjoy making things up."[20] These are the two sides of life, the dark laughter wrought from legitimate pain.

In thirty years of researching how creative people live and work, psychologist Mihaly Csikszentmihalyi noted how they're able to hold contradictions in tension. He wrote, "If I had to express in one word what makes their personalities different from others, it's *complexity*. They show tendencies of thought and action that in most people are segregated. They contain contradictory extremes; instead of being an 'individual,' each of them is a 'multitude.'"[21] So instead of irreconcilable opposites, joy and pain can be held together as a single coin reflecting the complexity of human experience. Perhaps that's why the most talented chefs combine the bitter with the sweet. Life can be sour *and* salty. The Japanese enhanced our taste buds with the sublime and savory "umami." Poet William Blake knit our humanity together with a fashion metaphor: "Joy and woe are woven fine / A clothing for the soul divine."[22] To become our most creative selves, we will embrace our humanity with all its foibles

while also incorporating the latest technologies, especially A.I. This book will join "Joy and Pain, Humanity and Machine."

In her book *Braving the Wilderness*, socialist Brené Brown writes about the sacred aspects of joy and pain, especially when we experience it communally.[23] When we seek out shared moments of joy and sorrow with strangers, we're reminded of our common humanity. That sense of connection to more beyond ourselves can be a source of strength when we're in conflict and facing tests later in life. The birth of a child brings forth such awe and wonder. Fear builds as we consider what could go wrong. Tears of relief flow when the cord is cut, and a doctor delivers a newborn into a mother's arms. Talk about "joy and pain"! We may share that moment with a spouse or partner, but it will remain a largely private occasion (unless we bring too many cameras into the hospital). Momentous public ceremonies, like weddings and graduations, are also marked by shouts of triumph and tears of joy. So many elements of a lifetime are distilled into a single moment. The complexity of the occasion for parents, grandparents, siblings, and participants can barely be contained by words. Funerals elicit tears, but as stories are told and memories exchanged at receptions and wakes, laughter also emerges. We smile at what we recall—comforting joy within considerable pain.

How about the mix of emotions we experience at concerts, movies, or sporting events? Actors, singers, comedians, politicians, and athletes all step onstage as surrogates. They carry our collective hopes and dreams into an arena. We root for them as a way of expressing our highest aspirations and greatest joys. We weep with them in defeat to process our disappointment. Profound emotions can sweep over a stadium. The shrieks of delight that arose during Beatlemania haven't been equaled since. Yet how many young girls and their mothers exchanged laughter, tears, and bracelets at Taylor Swift's Eras concerts? Songs that tapped into where

we were (and who we were) when we first heard them summon all kinds of instant nostalgia. A lifetime of listening is squeezed into a sublime connection between Taylor and her Swifties that transcends barriers like cost and distance. We get a stirring sense that she's speaking directly to us even amid a packed stadium. That's why we'll go to such lengths to share in musical transcendence. We want to be seen and heard; to be part of something greater than ourselves.

Consider how much collective joy flowed from Chicago Cubs' fans when their baseball team finally won the 2016 World Series after 108 years of waiting. The seventh game of the tightly contested series was played in Cleveland, where the Indians had not won a World Series since 1948. Tension only rose as rain delayed a game tied 6–6 after nine innings. Both cities braced for the disappointment they've experienced across countless seasons. When Chicago finally secured the 8–7 victory in the 10th inning, Cubs' fans posted videos of fathers and sons embracing in living rooms. Grandparents who could still remember the last time the Cubs appeared in a World Series in 1945 were overcome with emotion. The mix of disbelief and relief left many speechless. While Cleveland fans grieved, an estimated five million Chicagoans gathered along the parade route and rally to celebrate the team that ended a century of frustration.

Our creativity draws upon these sacred occasions. It summons those extreme emotions that seared into our memories. The loss of a loved one or the defeat of our team aren't equivalent. Yet the complex emotions that blur our personhood with our community, our smallness within a grander narrative are long-term fuel. We can never reduce a lifetime to a single moment. But the creative act of crafting a scene, a song, a story, a product can crystallize our sense of calling and purpose. There will always be plenty we don't know or understand. But occasionally, we tap into the core of the human drama with such clarity that others come alongside and agree, "I've seen, heard, and felt that too." The ancient masks of

comedy and tragedy have defined theatre since the ancient Greeks. We still buy movie tickets anticipating uproarious laughter or a cleansing cry. But creativity isn't confined to performers on a stage. A cleverly designed T-shirt may illicit laughter. An exquisitely prepared meal may provide the comfort we seek amid pain. Finely aged wine may mark a celebratory occasion of profound joy. The same spirit may console us when we ponder the loss of a parent. What can you bring forth that puts a smile on someone's face today? What kind of gesture or act can alleviate the pain of a friend or coworker?

Jesus says, "He makes his sun rise on the evil and on the good, and sends rain on the just and on the unjust."[24] God distributes life-sustaining gifts across the human spectrum. We've come to appreciate tastes from around the world like Middle Eastern hummus, piri-piri chicken from Mozambique, to Vietnamese Pho.[25] The Academy Awards are slowly catching up to what has been true all along. There are profound visual storytellers like Alfonso Cuaron, Alejandro Inarritu, and Guillermo del Toro in Mexico, Bong Joon-ho in South Korea, and Chloe Zhao in China. While creativity shines in all of us, rainfall may not be distributed equally. Some locations have better soil than others. Certain countries are paying a heavier price for global warming. Some may experience more joy, others more pain, but everyone will experience both joy and pain, sunshine and rain no matter where you live or when you're born. How we express that pain, how we share that joy, is a form of worship. Creativity is a way of processing those seemingly contradictory emotions. Learning to mine life to yield laughter and tears is the artistic craft.

Whether via the invention of a joy-bringing toy or the patenting of pain-relieving medicine, we have an opportunity to respond to what's shined or rained upon us. Author Frederick Buechner described the gospel as both comedy and tragedy.[26] The horrific torture and murder of

Jesus is a haunting reality. Death is an inevitable part of life. Yet the surprising resurrection of Easter brings enduring joy. Buechner goes further, pressing beyond tragedy and comedy into fairy tale. This is the meta-story that continues to fuel our hope-filled fantasies. Buechner notes that the fantastic story of a dying God rising to resurrect us all is tragic, comic, and real. Fantasy and reality meet in a cosmic kiss.

The creative life is about dual listening—studying the text of life in all its complexity and brokenness while also imagining a different world—and ushering in a brighter future. It holds competing truths in tension: We are capable of profound cruelty as well as beauty. Our hearts and minds must be pliable enough to read depressing headlines and still forge refreshing solutions. We may be tempted to let the news overwhelm us. Apathy may set in, suggesting we throw up our hands in frustration, "Why try?" Life is tragic. Yet the foibles of baby's first steps, the loyalty of a beloved dog, the joy experienced at the altar confirm that life is comic. Alternatively, our desire to escape our confines may keep our head in the clouds. Lofty ideas may never land. Dreams can get deferred for so long that we forget what originally inspired them. This book is a guide for how to contribute to some earthly good.

Honest creativity acknowledges the tragic aspects of our experience and draws upon our joyous memories to turn our fantasies into reality. We may feel like a fraud or failure. The pain in our bodies may feel overwhelming. But I believe there is joy lurking on the edges of that sorrow that can transform it from tragedy into comedy. With enough imagination, we may even turn our frustration and disappointment of fantasies unfulfilled into an awkward, lopsided, but honest gift that connects with others.

Honest Humanity

As I emphasize how holding conflicting feelings in tension sparks creativity, scientists are actively engaged in locating the neural pathways that ignite in our moments of profound insight. As far back as the 1950s, researchers have studied how an intensity of awareness and a heightened consciousness accompany creative acts.[27] Our heartbeat may quicken, our blood pressure heightens, and vision narrows. This is why we lose interest in eating when we're in a creative zone. Cognitive scientists note how "advanced blending" in our brains produces new ideas.[28] Following research trails blazed by Dr. Margaret Boden, the neuroscience of creativity has mostly focused upon such combinational creativity.[29] Exploratory creativity plays within established forms and structures, generating new examples of existing styles, from a genre film or a musical fugue to a new benzene derivative. Transformational creativity is that shocking breakthrough that moves an entire field forward. These are the paradigm-shifting discoveries that enshrine artists or scientists in the history books. The insights of Galileo and Copernicus undermined so much conventional thinking that their ideas were considered blasphemous. We're still unpacking the implications of Crick and Watson's one-page paper, published in *Nature* on April 25, 1953, identifying the DNA molecule as a three-dimensional double helix. It opened up genetic code and the multi-billion-dollar biotechnology industry. Are we on the cusp of another paradigm shift in the age of A.I.?

This book arrives as Artificial Intelligence is scouring the Internet for every book, image, and sound humans ever generated. We marvel at how much data these programs can assimilate in combinational creativity. Some may deride A.I. as a glorified plagiarist, plundering

our collective knowledge for contemporary profits. When researchers applied Chat GPT-4 to the Torrance Tests of Creative Thinking, Artificial Intelligence outscored 2,700 college students in fluency, the ability to generate a large volume of ideas.[30] The surprise came when A.I. scored in the top 1 percent in originality, the ability to come up with new ideas. It went beyond assimilating data sets to innovating. Creatives may feel threatened by such findings. Teachers are overwhelmed, having to rewrite assignments to counteract generative A.I. How to measure cheating when prompts can summon new combinations and reports in seconds? Students who want to be honest about their sources aren't sure how to even cite engines like Bard. Over time, I'm confident we will come to see generative A.I. as just another technological tool to expand our creative output. The test will reside in how we acknowledge others' ideas that our bots have borrowed from. Yes, we will build upon the culture that preceded us (like Rob Base sampling Frankie Beverly and Maze for his version of "Joy and Pain"). Honest creativity places our work in proper perspective. We are ambitious and humble, fallen and fearless, vulnerable and open.

I encourage us to embrace our imperfect humanity as a gift that keeps us honest, acknowledging our need, developing our savvy, refining our resilience. That is the path we all walk, the challenges to which we bring our creative problem-solving. The goal may be finished projects, but the promise is only fleeting insights, moments of revelation that renew our hope and encourage us to keep experimenting.

This book is divided into three sections.[31] Creativity begins with *people*, equipped by the Creator with the raw materials and human ingenuity to put things together—physically, mentally, spiritually. In our preparatory stage, we focus more upon ourselves, how we overcome our self-imposed obstacles and rediscover a sense of play. This is the unlearning necessary to bring fresh perspectives to the task at hand. We confess

our honest fears, face our honest limitations, express our honest aspirations. Honest preparation involves study, sacrifice, and devotion to a craft or endeavor. After enough practice and planning, we're ready to enter *the process*. This has been compared to a storm, full of confusion, fury, and flow.[32] Experimentation and concentration occasionally result in a breakthrough. In the production stage, we bring honest exploration and receptivity to what comes our way. This is when we practice presence—with eyes and ears wide open, ready to embrace what is revealed in the making of our project. We also need discernment, to find the patterns within so many possibilities. Once we have a rough draft or prototype, we enter stage three—when we endeavor to sell *our product*. This is postproduction when we rewrite, refine, and polish our work. We seek investors and patrons, we open ourselves up to honest criticism, we build an honest marketing plan, and we brace for honest disappointment. If we find a receptive audience, a profitable path, and the opportunity for more, then we respond with honest surprise and gratitude. If our endeavors fail to find a loving home, we build up the personal resilience to refine our skills and restart the process with more lived experiences as a foundation for the next project.

Each chapter will celebrate a different kind of honesty, focusing upon exemplary models as well as cautionary tales. It is a mash-up of the muses who inspire my pursuits. I write with artists, architects, actors, authors, chefs, dancers, filmmakers, musicians, pastors, scientists, technologists, and entrepreneurs in mind. You need not pursue a professional creative career for this book to inspire your love of cooking, weaving, photography, or design. I will cite lots of songs because they are such compact distillations of beauty in motion. Music provides the soundtrack for my artistic pursuits. Hopefully, you'll find encouraging precursors whatever your creative outlet. Ideally, *Honest Creativity* will nurture your originality, expand your authenticity, and deepen your integrity. By the conclusion,

you will be more vulnerable, self-aware, and open to explore. The new connections made between our brains and our bodies, our spirit and the Spirit, should lead to stronger ties to our audiences. We cannot control how our stories or products are received, but we can create from a place that never panders. As we shift from competing to cooperating with machines, the balance of power also shifts. Creativity becomes a conduit for communication and communion. We will learn to embrace honest creativity *and* Artificial Intelligence as a gift to humanity, a blessing rather than a curse.

HONEST CHALLENGE

1. Ask a generative A.I. engine of your choice (like Bard or ChatGPT), what failure feels like. Which of the emotions on their list resonant with your experience of failure? Can you describe it with more vivid and personal detail? What did you learn through your experience that may encourage others? Could that be a starting point for a new project?

2. Find the live performance of "Joy and Pain" by Rob Base as well as Maze on my Honest Creativity YouTube playlist. Note the rousing response from the audiences. Have you experienced a collective moment of joy or pain that surpasses this concert? How did the moment feel? What form of expression did it take? Encapsulate that experience into your own creative expression—a poem, an image, a song, a sermon, a recipe, or a product.

I

PEOPLE

idea
"archive"

© Bethany Brainard

1

HONEST FEARS

FADE IN

An Author sits in front of a laptop, staring intently at a blank page.

> AUTHOR (V.O.)
> I should start. Just set aside a couple of hours to get something on the page. Whatever springs to mind. Hopes, dreams, aspirations. Put those intentions out there. So reality can catch up and *manifest it*.

The author looks up and out. Through the window.

> AUTHOR (V.O.)
> But it is pretty nice outside. And exercise is important. A healthy mind needs a healthy body. And you always get good ideas once you start moving. Even if I just walked around the neighborhood a few times, I'd be close enough to the computer to jot a few ideas down.

The author looks back to the laptop. The prompt on the page is blinking.

> AUTHOR (V.O.)
> How 'bout a couple paragraphs to set
> the tone. Even an outline would be
> good. Some basic notes. A preliminary
> structure to hang some concepts on.
> Goals, principles, a general flow.

A text message pops up in the corner of the screen. Identified as C. C., the text asks, "How's it going?"

The author types back, "Good. Working on the project."

C. C. responds, "Ok. Lunch?"

The author responds, "No, I'm focused."

C. C. acknowledges the process, "No prob. I get it. Tomorrow?"

The author responds, "Sure."

The curt answer is enough to quell the distraction. But the question of lunch lingers.

> AUTHOR (V.O.)
> I am kinda hungry. But what's in the
> fridge? Not much I can recall. If I
> don't look, I'll still be thinking
> about it. . . .

The author stands and heads over to the kitchen. Opens the fridge. As depressing as expected. Only the crusty ends remain from a loaf of bread. The bottom of a jar of orange marmalade doesn't look inviting. Only two, no, three dill pickles left.

And a container of Chinese takeout. A peek inside at—leftover stir-fried rice.

> AUTHOR
> Better than nothing.

As the author grabs a fork and takes a bite of the rice, the truth is revealed. *It may not be better than nothing.*

His foot pops the top of the garbage can. And drops the rice into the can.

Another glance back at the bread. And pickles. And marmalade.

He takes all three out of the fridge. Stares at them on the counter.

> AUTHOR (V.O.)
> Maybe there's a metaphor here.
> Creativity arises from limitations. It
> is about making the most out of what's
> on hand. An attitude of gratitude. The
> ability to envision the possibilities.
> Project into the future to see the
> finished product.

The author studies the elements. And reaches for his phone. He pulls up Door Dash. And finds that Chinese restaurant which makes *that* stir-fried rice. Places an order.

> AUTHOR (V.O.)
> Twenty minutes. Sweet. Just enough
> time to grab a shower. I always get
> good ideas in the shower. Why is that?
> That's an excellent question. Worth
> reflecting upon.

The author closes his laptop and heads toward the bathroom.

Cut to the shower. The author stands with his head down. The water washes over him.

```
                    AUTHOR (V.O.)
        I can't believe how much time I
        wasted. I don't know why I even
        thought I had something to say. Who
        wants to read something by a loser
        like me? I'm a big fat failure. And I
        don't want anyone to know it.
```

FADE OUT

Is this scene familiar? Have you been caught up in that cycle of procrastination and defeat? The shame and guilt that arises when our intentions fall short of reality can be crippling. The cycle of self-sabotage can be tough to break. Our dream or endeavor fails to materialize because we can't summon the courage to create.

To create or not to create, that is always the haunting question. Artists and entrepreneurs engage in a daily, hourly, and sometimes moment-to-moment struggle. As a screenwriter, I love having written, but getting those first words on the page involves a strange dance. The terror of the blank canvas or page is palpable. The range of alternatives to creating beckon me. Unreturned emails float to the surface. Long-lost friends might need a text. Laundry suddenly begs to be done. Everything else looks more attractive than attending to the real task at hand.

Author Victor Hugo of *Les Miserables* fame dealt with procrastination by taking off his clothes. He allegedly wrote in the nude or at least in only his underwear. He would give his outside garments to his servants,

instructing them not to return them until he'd finished a chapter. Hugo essentially imprisoned himself, locked up only with pen and paper, and completed pages as his only ticket to freedom. Hugo's wife recalled that while composing *The Hunchback of Notre Dame*, Hugo purchased "a huge grey knitted shawl, which swathed him from head to foot, locked his formal clothes away so that he would not be tempted to go out and entered his novel as it were a prison. He was very sad."[1] What kind of extreme measures have you taken to remove distractions and discipline yourself as a creator?

Honest creativity begins by acknowledging a painful truth: making stuff, at least good stuff, takes attention and practice. How rarely we focus amid so many distractions, whether watching TV, playing video games, or doom-scrolling. We may kid ourselves into believing we don't have time. Yet adding up the hours of streaming series or sports contests I've watched is depressing. Why was I putting off what I intended to do? It wasn't a time management problem. It was an emotional ball of fear, shame, guilt, and perfectionism that led to procrastination.

When we postpone our creative activities, we're devaluing ourselves, saying, "I'm not worth it. I don't have enough to contribute. I'm not good enough." It becomes easier to create nothing than to subject our imperfect something to critique. Picking up a paintbrush, buying those tap shoes, typing, "Fade in" is choosing ourselves, prioritizing our value, reflecting the glory of our Creator. Creating is a self-affirming, life-affirming, God-affirming, act of defiance. It asserts that I matter, I'm not alone, I have value. It casts off the judgment of others, the voice of condemnation that makes us feel worthless or less than. That's why Lorraine Hansberry's autobiographical play *To Be Young, Gifted and Black* resonated during the civil rights movement. Nina Simone penned a musical tribute, premiering her song at the Harlem Cultural Festival in 1969. Over fifty years later, Nina's live performance served as a high point in the

Oscar-winning documentary *Summer of Soul*.[2] Songs like "To Be Young, Gifted and Black," "Say It Loud—I'm Black and I'm Proud," and "Someday We'll All Be Free" remain important rally cries for those who feel unseen and unappreciated. Fela Kuti's danceable protest song "Zombie" railed against the Nigerian soldiers blindly propping up a corrupt and repressive government. Even a seemingly light, bright disco song like "I Will Survive" became a rallying cry for women and minorities and anyone feeling down and depressed (more on that in the conclusion).

Procrastination is a symptom of shame and perfectionism. All three are rooted in fear. They are forms of self-sabotage that help us feel safe. They're a way to keep judgment at bay. Yet they also keep us from seeking things we need beyond safety, like affirmation, acceptance, and love. When we withhold our true selves, we can't possibly feel fully loved. A huge part of who we are remains hidden. We settle for less, feeding on the crumbs of affirmation that come while only revealing a portion of our passion. This is how and why we slowly dry up inside. We starve our true selves to death by projecting a mere portion of our personhood into the public sphere. Our best self may only be expressed when we dive into a risky project. Safety seems like the wiser path, but it sacrifices a larger sense of fulfillment.

We may like the idea of playing piano, writing a song, performing at a local club. Somehow, practice isn't nearly as much fun. Learning scales, mastering a new software, fiddling with a mix can take so long. Author Malcolm Gladwell famously summarized other researchers who estimated it takes ten thousand hours of deliberate practice to master a craft. I'm no mathematician, but isn't that like decades? "I don't have thirty years to invest in tennis, in ballet, in rapping, in launching a business!" So, we dabble around the edges. Do just enough writing or creating to convince ourselves we're working on it.

Honestly creativity admits when we're toying with our talents. Popping in and out of projects. Stepping away for long stretches. Hopeful lightning may strike when we're far from the task at hand. Sure, we sometimes need space to gain perspective or recharge our batteries. But on those rare moments when we're in the creative zone, our strength is renewed by the sudden alignment of our intents and purpose. We're being who we're supposed to be, flowing in the gifts we've been given. And it feels far more like play than work. We may be tired afterward, drained by the substantial presence that poured through us, but we end up sleeping deeply, freed from the anxiety and self-doubt that often haunts us in a tentative day of skirting around the core truths dogging us.

I'm all for creative hacks—tricks that get our ideas flowing. The speed with which generative A.I. can craft an outline or to-do list is astonishing. We can quickly workshop an idea, get it on paper in some form that we can chip away at. But it skips over those times when staring at a blank screen can lead to a genuine breakthrough. Working through bad story ideas before we hit on the twist that brings a scene to life is an important part of the process.[3] The struggle is often what produces the most delightful and unexpected surprises. Shortcuts can shortchange us and turn us into creative hacks—those who simply recycle others' original ideas.

Dishonest creativity cuts corners. It settles for whatever Artificial Intelligence can generate. It is content to imitate, duplicate, alter just enough to claim credit. Dishonest creativity may pander to the marketplace not just for a payday but because genuine creativity feels too risky. Dishonest creativity reassures us that is doesn't really matter, no one will notice the difference, I don't have time to go deeper. Dishonest creativity may get the job done, for now. But it eats at our soul, sucks the life out of us, mires us in a mediocrity that becomes difficult to swallow. Honest creativity names the what-ifs, recognizes the missed opportunities, leans

into our fears and failures. It makes peace with our imperfections, turning them into starting points and even strengths. So, what scares you?

Fear

Pop singer Carly Simon breathes deeply in the sidelights. She's done this so many times. As a songwriter, she had the courage to write the ultimate kiss-off song, "You're So Vain." Yet here in Pittsburgh, with ten thousand fans awaiting her entrance, the panic sets in. She feels perspiration building in her palms. Her fingers start to tingle. The knees start to shake and ache. Her heart rate picks up, pounding with a force that feels akin to bursting from her chest. The stomach starts to gurgle, with a long-ago lunch threatening to resurface. Perhaps throwing up can calm her nerves. Even experienced entertainers can succumb to performance anxiety.

Simon's panic attack caused her to collapse while performing in front of those dedicated fans. Fear of forgetting song lyrics kept a Grammy-winning star like Barbra Streisand offstage for twenty-seven years! In her rare public performances, Streisand relies upon a teleprompter to calm her nerves.[4] Academy Award–winning actor Laurence Olivier regularly vomited before stepping into the theatre footlights. Even beloved performers like Adele, Rihanna, and Katy Perry acknowledge pre-show jitters.[5] What causes such crippling anxiety to overwhelm our bodies? Fear has trained our body to make a choice—fight or flight. What makes performing dangerous? We may fear failure, rejection, or losing control. We can't control the public's response to our projects. Our valiant preparation cannot counter the fickleness of an audience. Putting ourselves "out there" always involves risk and uncertainty.

So why subject ourselves to such public scrutiny? While plenty of art springs from personal practices and needs, as soon as we seek funding or

dream of turning hobbies into careers, the private becomes public. We are exposed, open to critique—whether we want it or not. The creative life is inherently dangerous. Fear is among the most primal and ancient human qualities. We have an innate tendency to hide and cover up for safety. In the biblical book of Genesis, Adam and Eve try to hide from God among the trees in the Garden of Eden. When confronted by God, Adam explains, "I was afraid, because I was naked, and I hid."[6] We don't want to be exposed as helpless and vulnerable.

When have you been scared? I remember physically shaking onstage while giving a campaign speech in seventh grade, trying out for the student council. In elementary school, I'd spoken in front of a class, doing a minor form of show and tell, maybe talking about a favorite pet or hobby. So now, why was my hand shaking so badly from fear that I literally held it up for everyone to see? It wasn't enough to be nearly paralyzed by the fear of public speaking. I pointed out the physical manifestation. The self-deprecating joke didn't land. And neither did my election. I was a political failure at age twelve.

Yet five years later, I was onstage, reading the names of all 623 members of my graduating class at East Mecklenburg High School. I had butterflies, but no violent panic attacks in my body. I took a deep breath and began the lengthy process. I'd been directed to ask the audience not to applaud for individual names, but to wait and salute our class as a graduating whole. Of course, that wasn't going to happen. Each grad deserved to be celebrated for their achievement, to have their families hoot and holler in affirmation. When it became clear after the third or fourth airhorn blast that my patient request to "please hold your applause" would not alter parents' plans, I resorted to comedic pleas instead. I met their disregard with equivalent exasperation. The names and the accompanying cheers were met with punchlines. The more outrageous the yelling, the more comic my response. As the crowd upped their game, I elevated

mine. By the time the last name was called, we'd engaged in some uproarious improv. What began as public humiliation had transformed into a community celebration. What a joyous discovery. Facing our greatest fears can also lead us to unexpected triumphs via practice, patience, and perseverance. As Ralph Waldo Emerson famously did not write, "Do the thing you fear, and the death of fear is certain."

In the age of A.I., our fears have shifted from performance anxiety to existential dread. What if I'm not good enough? Will my job be replaced? For actors and writers striking in Hollywood, the fear of machine learning was financial. Can our image and likeness be grafted into films in the future without compensation? Will my voice be co-opted for tomorrow's video games without my consent? How to retain control over how our appearance is manipulated and distributed? Writers wanted protections if the movie studios decide to ask A.I. to generate ten story ideas rather than a human. Who gets credit if that first draft was generated by a program with a screenwriter only brought in at the end to polish the script? Thankfully, early court cases have affirmed that only human authors can receive copyrights.[7] Writers will still have to wrestle with how to acknowledge how A.I. may have contributed to our finished projects.

At Grand Canyon University, we're encouraging our students to incorporate these new tools into their creative process. Graphic designers will be able to offer clients a much faster approximation of what a campaign may look like using generative A.I. Iterative changes can be incorporated almost immediately. We should be prepared for an ever-greater onslaught of images and deep fakes. Yet I still trust the human eye to distinguish between a serviceable design and something that evokes genuine creativity. There is a sublime combination of wit and empathy and color that elevates our projects from functional to fabulous. We may come to embrace imperfections as preferable to the machines' surface polish.

Those who put in the work, applying aesthetics to the soul-searching question at hand, need not fear.

Perfectionism

"It's not good enough." "It's already been done." "What will people think?" "What if I fail?" "I'm scared." There are so many ways that we sabotage our creative efforts, often before we even start. It is frightening to step onstage, to sing a song, to present our ideas to teachers or investors or even friends. It can be painful to make mistakes in public. The Japanese have a saying, "The nail that sticks out will be hammered down." It is best to conform; keep your head down. How much innovation does such a notion sabotage? There are ample reasons to fear rejection. We may say or do something that haunts us for a while. A slip onstage, a flubbed line, forgetting a song lyric can give us nightmares. In sports, the dropped pass, the missed free throw, the goal that slips past can bedevil even the greatest athletes. A mistake made upon a major stage can undermine years of practice, redefining us by a moment of weakness or humiliation.

Yet perfection remains a tantalizing possibility. The wealth of automaker Henry Ford was forged in the relentless pursuit of perfection. Predictability on an assembly line made mass production of Ford's Model T possible. One hundred years later, Elon Musk became the world's richest man by perfecting the batteries powering each Tesla. Both Ford and Musk drove their companies with an exhausting and exacting intensity. The *Hidden Figures* character like Katherine Johnson who made mathematical calculations that put NASA astronauts in space could not settle for less than perfection. Big, hairy, audacious goals drive so much innovation.

Perfection inspires divers and gymnasts to practice over and over in anticipation of that one shining Olympic gold medal moment. The

potential of a hole in one greets even the most casual golfer in the tee box of every par three. One perfect swing (and a lucky bounce) could erase all the frustrating slices and hooks that came before and after. Perfection looms on the horizon before every sports season. As a boy growing up in South Florida, I remember the thrills provided by the Miami Dolphins undefeated football season. Winning the Super Bowl to complete a 17-0-0 season was so satisfying and unlikely. Our quarterback Bob Griese needed glasses. Our middle linebacker Nick Buoniconti was undersized. Our safety Dick Anderson looked like a balding school principal. Yet Coach Don Shula figured out how to maximize his team's talent, rotating three running backs, the bruising Larry Csonka, the versatile Jim Kiick, and the speedy Mercury Morris. The Dolphins "No Name Defense" made a name for themselves that still lives on in NFL lore. Many have come close to breaking the Dolphins record, but none have achieved season-long perfection.

Perfectionism can convince us not to start. It can lead to frustration. It can cause us to quit too soon. So many students give up on projects or careers because they don't feel they are good enough. What starts as joy can turn into a joyless job. We may feel defeated even just a few hours into a new hobby. Playing banjo sounded cool. Yet learning how to pick and pluck takes much more than a passing interest in Mumford and Sons. It takes hours of investment. And so we give up early. Or we talk ourselves out of experimentation. The mountain peak looks too daunting. The road too fraught with peril. The competition too fierce.

Perfection can also be a cruel taskmaster. Author Elizabeth Gilbert of *Eat, Pray, Love* fame calls perfectionism "fear in high heels."[8] While it seems noble and may lead to many accomplishments, it also robs us of joy. Consider the struggles with body image that accompany athletes and performers. The hours spent in rehearsal, in front of mirrors, lead to comparisons and self-critique. Research shows that dancers are twenty times

more likely to develop eating disorders than the general population.[9] A survey of musicians found that over 30 percent had experienced an eating disorder. Pop star Demi Lovato laments how the dieticians, nutritionists, therapists, and wellness coaches assigned to restrict her eating confirm that "there's just so much pressure as a female in the industry to look a certain way, and to dress a certain way."[10] The subsequent battle is physical and emotional. In her *Miss Americana* documentary, Taylor Swift openly discusses her cycle of exercising without eating due to unrealistic expectations to be thin.[11] Even Elton John battled bulimia during his heyday as a performer. Perfection can be a tyrant, driving us toward exhaustion. The Korean pop industry is notoriously demanding, driving pop idols to depression and even suicide. Suga, from the massive popular K-pop band BTS, suggests, "If we know that everyone is suffering and lonely, I hope we can create an environment where we can ask for help, and say things are hard when they're hard."[12] We need to give each other and ourselves room to fail.

Shame

Instagram and Tik Tok grant us an immediate audience, a daily referendum that can convince us we're not beautiful or cool or smart enough to be respected. We may think no one really knows or sees us. So why bother trying to put anything I really care about into the wider world? We shrink back under the glare of lights or publicity. We watch, observe, but never truly engage. All these external pressures to perform, the judgments that come from audiences (and especially those closest to us), can cause us to collapse inward. Taylor Swift admits the impossible pursuit of perfection would lead her to "go into a real shame/hate spiral."[13]

Psychologist Curt Thompson notes how shame doesn't need a large public humiliation to grip us, "It only needs to show up in the barely noticed glance of derision from your mother; the tone of contempt from your spouse; your employer's silent non-response to your request for direction on the project."[14] The stories we tell ourselves about our worthlessness form deep and debilitating grooves. It builds a pattern of shoulds: "I should practice more. I should be thinner. I shouldn't be so afraid." Instead of motivating us, this cycle shuts us down, cut off from our emotions when they are often the most important source of our creativity. Vulnerability is inherent in the creative process. If we feel too insecure to take risks, then shame has caused us to freeze up before we even start.

How do others summon the panache to put themselves out there? They make it look easy to write, direct, perform. Why are they cool and I'm not? How did they learn to overcome their fear? To scramble back to their feet after being knocked down? How can some entrepreneurs fail four or five times and keep trying until their idea hits? A lifetime of misses can be transformed by one giant hit.

We may have valid reasons for being afraid of failure. We need the job or money or security that comes with both. We have been ashamed in the past by classmates or colleagues. Fear of making something less than perfect can keep us from starting. Putting ourselves out there, via our art or ideas, can be an opportunity for others to judge or even reject us. We may not feel ready. We may not feel worthy. We may not have enough confidence to open our projects (and ourselves) up for public scrutiny. Even if we create something of note, we may crumple under the pressure of doing it again. How do we top an unexpected success? Honest creativity begins by naming and facing our fears.

The path toward creative breakthroughs is loaded with anxiety. Imposter syndrome abounds in our classrooms, our stages, our churches.

Let us name and acknowledge what scares us. Rather than running from it, we must run toward it. Self-doubt isn't just part of the process. It is our creative companion and guide, the secret source of our strength. We must come to embrace anxiety as an old familiar friend. Fear can be the reassuring reason we know we might be onto something.

Fear Not

We start our days with strong intentions, committed to working on projects, serving others, making a difference. Yet more often than not, we fall short. We fail to fulfill our ideals and devolve into a circle of self-contempt and defeat. The Apostle Paul chronicled his doublemindedness: "I do not understand what I do. For what I want to do I do not do, but what I hate I do. . . . For I have the desire to do what is good, but I cannot carry it out. For I do not do the good I want to do, but the evil I do not want to do—this I keep on doing. Now if I do what I do not want to do, it is no longer I who do it, but it is sin living in me that does it."[15] How do we overcome the gnawing gap between our best intentions and our actual actions?

We disarm fear, shame, and guilt by confessing our fears, naming our insecurities, and acknowledging our weakness. When we bring our faults to the surface, they suddenly have less power. They no longer hold as much sway over our lives. Rather than being weaknesses to keep hidden, such fault lines become occasions for healing and renewal. We invite God and others into our struggle. Like the Apostle Paul, I struggle with the gulf between the good I aspire to and the realities of how I treat others (including my creative self). As we admit our shortcomings and confess our own sins, we make room for God to forgive us. The possibility of writing a new story and a different ending emerge. We also make room

for others to acknowledge their failings. In our vulnerable confessions, we all begin to feel less alone.

Fear is embedded in the human condition. Yet throughout the Bible, God reassures his people to "fear not, for I am with you, be not dismayed for I am your God."[16] In the New Testament, angels arrive in times of high anxiety. Their first words of encouragement are always "fear not." To an expectant Mary, the angel Gabriel says, "Do not be afraid, Mary, for you have found favor with God."[17] Uncertain how to respond to Mary's pregnancy, Joseph is told by an angel, "Do not be afraid to take Mary home as your wife."[18] Shepherds watching their flock at night are visited by an angel who declares, "Do not be afraid. I bring you good news that will cause great joy for all the people. Today in the town of David a Savior has been born to you; he is the Messiah, the Lord."[19] For those beset by rumors, suffering under potential scandals, and worrying about the future, the Christmas story offers reassurance. We may not be visited by angels, but we can find comforting companions along the journey. Parents, siblings, teachers, directors, and collaborators may remind us to "fear not."

Faith is the antidote to fear. It is what compels us to press on, to keep trying, to get up again. It is a kind of seeing, in our mind's eye, what's possible. It is the visioning part of our brains that hopefully compels us to action: to step onstage, to enter the contest, to raise our hands, to volunteer. Fear shrinks back. Faith steps out. Fear withholds. Faith puts it all out there, on the line. Fear analyzes what could go wrong. Faith acknowledges the dangers but takes the leap anyway.

The Assignment

The challenge sounds simple: "Communicate something through a medium you've never tried before." Perhaps it is the open-ended nature of

the call which strikes my students as terrifying. When we're invited to do something without specifics, we realized that could include almost anything. We can end up overwhelmed by too many choices. Creative freedom can cause us to shut down.

Maybe it is the dare to communicate that hampers our progress. While social media can be an ongoing competition for attention, it doesn't necessarily mean we know what to say with the microphone in hand. The spotlight can cause us to freeze in that pitch meeting. Many students respond with trepidation: "I'm not sure what I want to say." We demand our freedom to speak and yet often end up unsure what it is we're trying to unpack for others to hear. Inchoate hunches or feelings are often the starting point for our creative process. We discover what's bugging us as we begin to play with clay or canvas or words. Color reflects our mood. An image or meme may communicate jumbled emotions too complex to describe.

Yet it is the second half of the assignment which flummoxes most. A few have already explored so many mediums, they wonder what arena to explore. Others are far more comfortable staying in lanes they've already traveled. The business minded want to hold onto a spreadsheet. The artistic are afraid of numbers. Introverts don't want to present in public. The actor and performance driven are frustrated by the quieter forms of communication. Why do I insist we try something new, something we're not polished or even good at? Because perfectionism is the enemy of creativity. We like to master our mediums, polish our presentations, make sure we've put our best foot forward. We lead from our strengths. Insisting upon a new, unvarnished means of communication ensures that we won't rely on what we know, what's worked in the best, what feels comfortable.

Only when we get past our perfectionism can we start to enter new territory, to concentrate on the message rather than the medium. Starting

with our weaknesses often leads to stronger results because we do not edit our efforts and seek to burnish our reputations. We perform without a net. It isn't safe, but it is exhilarating. It is a discovery of what our minds are capable of, what our hands may fashion, what our souls seek.

The resulting projects are fascinating. Raw and unfiltered. Funny and heartbreaking. Josh did a stand-up comedy routine, aimed squarely at satirizing the class (including me!). He cracked us up and launched an unexpected career for himself. Katie tried painting, an activity she'd been discouraged by in years before. Chris baked hot cross buns, asking questions about whether a sign or symbol makes something inherently spiritual. A native Hawaiian, Destin learned how to play the flute to accompany his Caucasian roommate's spoken word poetry.

It is only five frightening minutes in front of peers. Yet it can unlock so much. Josh eventually went from stand-up comedy to managing a performance space to founding the Better Cities Film Festival.[20] They've screened their award-winners for the United Nations. His commitment to New Urbanism and sustainable cities has included becoming an Episcopal priest and transporting his daughter everywhere in a basket attached to a bicycle (in the car capital of Los Angeles). Katie worked in casting for Fox and became a member of the Writers Guild but eventually made her way to South African townships. She met a young man who considered himself a filmmaker even though he'd never held a camera or been on a set. She founded Film School Africa in Joburg and has launched hundreds of young people toward a career in entertainment.[21] Chris has been at the forefront of Apple's photography and imaging department in Silicon Valley for two decades. After graduation, Destin worked with foster kids. Their pain and resilience inspired him to make the stirring film *Short Term 12*.[22] He cast Brie Larson, Ramy Malek, and LaKeith Stanfield years before they walked across the Oscars' stage. Destin has gone on to direct massive and

powerful films ranging from *Just Mercy* to Marvel's *Shang-Chi*. Not bad for a homeschooled kid from Maui.

I mention their accomplishments not to brag (although I'm definitely proud of my former students), but to suggest how powerful getting beyond our own self-imposed parameters can be. None came from lofty backgrounds. Washington state; Fresno, Indiana; and Hawaii are a long way from the corridors of cultural power. They were also dealing with complex personal issues—the suicide of a beloved brother, the struggle to tell your family that you're gay, and traumatic sexual abuse. They managed to turn pain into possibilities, to forge a creative path despite their setbacks or rather rooted in life's challenges. Their superpower is empathy—seeing the world through others' eyes.

Empathy is the starting point for Stanford University's acclaimed D-School.[23] Design thinking starts by identifying a wicked problem. We set aside biases by stepping into others' pain. Plenty of reflection upon the origins of a dilemma, who it impacts, how it has already been addressed proceed the ideation stage. As we sit with that complex question, enter into that struggle, we start to see the cracks and fissures that can lead us out of the cavern. As poet and songwriter Leonard Cohen explained: "There is a crack in everything that you can put together. Physical objects, mental objects, constructions of any kind. But that's where the light gets in, and that's where the resurrection is and that's where the return, that's where the repentance is. It is with the confrontation, with the brokenness of things."[24]

We start our projects with our brokenness rather than our strengths. My former student Katie puts her film students in South Africa through the same kind of exercises and assignments. These young people know what they don't have. They know how much poverty surrounds them, how few of their peers survive township life. Everyone has a level playing field when you start with what you don't know or haven't tried. If

we're all picking up a tuba for the first time, only one or two of us will be drawn to it in a natural way, but we can all blow. How can we know if this kind of physical and musical test will compel us if we've never given it a try? All too often we self-sabotage before even trying a new art, technique, or idea.

My sharpest students learn to find light amid dark circumstances. They seize the opportunity to say something personal, powerful, and transformative. To move from pain to possibilities, we need perception—eyes to see the situation clearly. We can engage in self-efficacy. We can create. We were made to innovate. Our projects are more attainable when we break the work into stages with tangible rewards along the way. Our challenge requires emotional vulnerability as well as project management. We also must know that we have permission to fail, to be less than perfect. We are human and we are loved, irrespective of our performance.

Here are a few basic agreements we need to make with ourselves as we begin.

1. I'm not lazy. I'm scared of failure, success, not being perfect.
2. I forgive myself for being scared, procrastinating, and seeking safety.
3. I will put my bully brain and self-critic to rest.
4. I will start. I won't worry about the end product. I will take small, incremental steps rooted in actions rather than emotions.

HONEST CHALLENGE

1. "Communicate something through a medium you've never tried before." Set a due date for yourself. Identify an audience. It could be a friend, family member, or nearly anonymous public. Think about your message. Pick a medium. And put your idea into the marketplace.

2

HONEST ASPIRATIONS

"Go to the Limits of your longing."

—RAINER MARIA RILKE

AFTER THE ROUSING OPENING SONGS OF "Miss Americana" and "Cruel Summer" on her record-breaking Eras tour, Taylor Swift pauses to offer her first words to a stadium full of adoring fans. In Las Vegas, Taylor declared, "You're making me feel like I'm the first woman to headline Allegiant Stadium."[1] She was. In Dallas, she shouted, "I'm the first artist to play three nights in this stadium." She flexed her biceps and pumped her arm in victory and the crowd roared their approval. Taylor Swift's unabashed pride in her accomplishments sent a powerful message to so many women (and men) in the audience. Massive ambition fulfilled is rare, beautiful, and hugely gratifying. And it shouldn't have to be qualified by false humility and self-deprecation. It is good to be strong, to want to shatter box office records. Yet her next song in the setlist revealed how often a different standard is applied to ambitious women. As the stage transformed to an office setting, Taylor chronicled the sexist double standards in "The Man." Why are men who

behave badly or madly called complex and cool, yet women with ambition are considered bad?

© Bella Bowman

She underscored the challenges in her 2015 Grammy acceptance speech for Album of the Year. Taylor told the audience, "I want to say to all the young women out there: there are going to be people along the way who try to undercut your success or take credit for your accomplishments or your fame."[2] (She already experienced that when Kanye West infamously ambushed her acceptance speech at the 2009 MTV Video Music Awards.) She challenged those listening, "But if you just focus on the work and you don't let those people sidetrack you, someday, when you get where you're going, you will look around and you will know—it was you, and the people who love you, who put you there. And that will be the greatest feeling in the world."[3] This chapter will consider the proper balance between ambition and frustration, aspiration and satisfaction.

How much do you want to succeed? How much rejection are you willing to endure? It is tough to predict who will develop the armadillo hide that will endure all kinds of slings and arrows. Successful creators and entrepreneurs may not have the most talent or best ideas. They often have a different kind of X factor: drive. As a professor, it is hard to determine who will be the most resilient. In sports, the killer instinct of

a Michael Jordan or Steph Curry set them apart as era-defining champions. Their commitment to winning caused their teams to rise to the occasion in surprising ways. They box above their size or weight class. The same kind of tenacity applies to auditions and pitch meetings. How badly do you want the job? Enough to overcome countless rejections? Our drive may be connected to childhood trauma, poverty, or a need for love. These complex reasons can be helpful companions or bottomless pits of needs.

Honest Creativity acknowledges our ambitions. It also admits that our motives may not always be noble or pure. Getting in touch with the roots of our ambitions will help us stay in the game longer. Because we know more why we really seek a certain level of affirmation, recognition, and even comfort from our generative work.

It is easy to be overwhelmed by delusions of grandeur in creative fields and business endeavors. "This project is amazing. People will love it. I am a genius. I'm gonna be rrrrrrrich. And famous. I can picture myself on that billboard. On the cover of that magazine. Sitting across from Oprah. Answering questions about my creative process. Humbling acknowledging the mystery of it all. Giving God credit for my glory. I'll be satisfied with one masterpiece that outlives me. Or maybe two."

It is also easy to devolve into a puddle of disappointment when our dreams aren't realized along our timelines. Others' success may push us toward bitterness and resentment. The Green Monster of Jealousy may consume us when the scale of our ambition isn't aligned with our talent or rooted in a larger sense of calling. How to ensure our creative impulses do not wilt before they have time to really bloom?

Envy

Have you seen *Amadeus*, the Academy Award–winning Best Picture of 1984? *Amadeus* endures because it depicts the thin line between ambition and envy. It shows how we long to be acknowledged and seen. When we work hard to polish our craft, we anticipate some validation along the way. We labor with some expectation of reward. We may wrap our ambitions in a sense of duty or even humility: "I don't want to be famous. I just want to sing my songs or tell my stories." Yet let's be honest, we don't practice for hours and hours because we're hoping *not* to be noticed. We study the masters who've gone before us—in arts, in business, in technology with an eye toward our own breakthroughs. We press on with the hope that our investment will be worth it—the hours, the money, the emotions—we've poured into our pursuit. If we're going to be honest about our fears, we also should be honest about our ambitions. If we don't get in touch with our loftiest dreams, we may open destructive doorways to jealousy, bitterness, and even vengeance.

For *Amadeus*, director Milos Forman and his team re-created eighteenth-century Vienna when fame and money flowed toward composers. A young Mozart dashed off one musical masterpiece after another under the patronage of Holy Roman Emperor Joseph II. Yet before Mozart captured the Austrian king's affection and coffers, an Italian composer named Antonio Salieri was the creative prince in the king's court. He was *Kapellmeister* in the Imperial Chapel from 1788 to 1824, overseeing the music composed and performed in the court chapel as well as the instruction in the attached school. Salieri's real-life students included Franz Liszt, Ludwig van Beethoven, Franz Schubert, and the youngest son of Wolfgang Amadeus Mozart, Franz. *Amadeus* overlooks plenty of historical details, portraying Mozart as a profane young fool

and Salieri as an older, embittered rival. It doesn't depict the years of practice that Mozart put in from age four, taking lessons from his talented father, a composer who'd written one of the first books on music instruction.[4] Mozart wasn't born a genius; he was trained by an expert to master a craft. The movie *Amadeus* is based upon a Tony Award-winning play by Peter Shaffer, which was based upon a Russian play from 1830, *Mozart and Salieri,* and a subsequent opera.

Salieri serves as the narrator in Peter Shaffer's Tony Award-winning play as well as the 1984 film adaptation. He engages in a confession that draws the audience in—he poisoned Mozart as an act of protest toward an unjust God. What drives Salieri toward the assassination of this gifted musical prodigy? He is vexed by his own piety in contrast to the obscene foppery of Mozart. As a boy, Salieri makes a vow with the Divine: "Lord, make me a great composer. Let me celebrate Your glory through music and be celebrated myself. Make me famous through the world, dear God. Make me immortal. After I die, let people speak my name forever with love for what I wrote. In return, I will give you my chastity, my industry, my deepest humility, every hour of my life, Amen."[5] I've heard so many versions of this type of bargain. If I win a Grammy, a Tony, or the Super Bowl, I will give God the credit in every one of my acceptance speeches. I've made such pledges as well—imagining how humbly I'd accept the Oscar when I won an Academy Award. We'd make sure to thank our parents and teachers and the patrons who enabled us to go "on with the show." But the core motivation is embedded in the prayer—"make me great . . . make me famous."

For years, my wife and I served as the welcome wagon for a circle of writers, directors, and producers in Hollywood known as Premise. People found us via word of mouth but arrived with a similar sense of calling. They may have been the best actor in Omaha or the funniest comedian in Eau Claire. Now, they were here to share their gifts with the entertainment

industry and get discovered—quickly. We didn't want to tell them how un-special their story was, how long the line of aspirants was before them. Their hopes sounded so pure; their aspirations so noble. But we saw over time how the conflation of Hollywood dreams could turn into anger at God after a few years without a breakthrough.

Actors who invested years in classical training might be frustrated to learn how a rock musician like Johnny Depp accompanied a friend to an audition and got cast in his first film. Natalie Portman was interested in ballet before a Revlon agent spotted her eating pizza and signed her as a child model. Why would a high school dropout and video store jockey like Quentin Tarantino vault to the top of Hollywood's A-list while my highly educated colleagues and I at USC Film School were paying for our education? When it comes to creativity, the usual social recipes for success don't apply. When we wrap our aspirations up in prayers, it can get quite confusing when things don't work out as planned. It seems far healthier to be honest about our ambitions.

When we're dishonest about our ambitions, hiding them under a cloak of nobility or calling, we create a theological conundrum for ourselves. Salieri confesses to a priest, "All I wanted was to sing to God. He gave me that longing . . . and then made me mute. Why? Why implant the desire?"[6] If we don't succeed, it isn't because we overestimated our talents or underestimated the competition, it could be God's fault for not upholding *His* end of *our* deal. Salieri is troubled by how a faithful Catholic, eager to glorify God via his compositions, could be unseated by a rude, unrefined fop like Mozart. What kind of Divinity bestows such profound creativity upon one seemingly so ill-equipped to steward it? While Salieri exercises responsibility and decorum, Mozart seemingly squanders his talent in alcoholic excess. Frustrated by his own mediocrity, Salieri vows to defy God, to eliminate the faulty vessel chosen to pour out transcendent music. He addresses Jesus on a crucifix, "From now on, we are

enemies—You and I. Because You choose for Your instrument a boastful, lustful, smutty, infantile boy and give me for reward only the ability to recognize the incarnation. Because You are unjust, unfair, unkind, I will block You, I swear it. I will hinder and harm Your creature as far as I am able. I will ruin Your incarnation."[7] Salieri's plots both the assassination of Mozart as well as the theft of his musical requiem. Since Salieri cannot beat Mozart, he will bury him and claim his masterful composition as his own. An aspirational prayer for greatness descends into a bloodthirsty pursuit of fame. *Amadeus*'s frightening depiction of how we respond to others' elevation in the worst possible way remains painfully spot on. The green monster of envy can bedevil us all.

So, what does healthy ambition look like? How can we be more like a Taylor Swift and less like a Salieri? How do we make our hopes and dreams sustaining rather than draining? Can anger or revenge be used constructively?

Anger

The 1981 Broadway musical *Dreamgirls* is also about what can happen when one musician is more talented than another. It follows the heartbreak behind the transformation of the Dreamettes, led by full-figured lead vocalist Effie White, into the more polished and profitable Deena Jones and the Dreams. Effie may have the most innate talent, but their manager still elevates the slimmer Deena to top billing. Notice the conscious similarities between "the Dreams" and "the Supremes." Effie's downfall in *Dreamgirls* mirrors the real-life struggles of singer Florence Ballard when Motown impresario Berry Gordy turned Diana Ross into the primary vocalist and face of The Supremes. So much pain and bitterness can arise when gifted singers discover the recording industry is

more about appearances than musicality. Ballard missed performances and recording sessions, gained weight, and was fired from the group just like Effie. Even worse, Ballard descended into alcoholism, depression, and poverty before she died of a heart attack at the tragically early age of thirty-two.

As with *Amadeus*, themes of envy, greed, and anger are woven through the musical sequences in *Dreamgirls*. Like Salieri, Effie makes a vow. The volcanic pain of the jilted and pregnant Effie is poured out in the defiant, show-stopping song, "And I'm Telling You I'm Not Going." She swears to her manager and the father of her unborn child, Curtis, that, "You're gonna love me." The song became an anthem for all who have been slighted, overlooked, spurned, and passed over. Justifiable rage and anger become defiant, musical resolve. Yet Curtis moves on with Deena Jones and the Dreams without her. The original first act of *Dreamgirls* concluded with the tragic death of Effie. However, the young actor portraying her, Jennifer Holliday, pushed the composers of *Dreamgirls*, Henry Krieger and Tom Eyen, to write a different ending for Effie, something beyond Florence Ballard's tragedy. In the new act two, Effie raises her daughter, relaunches a recording career, and triumphs despite Curtis's efforts to derail her. The Dreamgirls are reunited for "One Night Only" as Effie finally tops the charts.

The fantasy within *Dreamgirls* became Jennifer Holliday's reality. She went on to win the Tony Award for Best Leading Actress in a Musical and the Grammy for her chart-topping performance of "And I'm Telling You I'm Not Going." The same pattern followed for Jennifer Hudson in the 2006 cinematic adaptation. Hudson's rise in show business had surprising parallels to Effie's story. Her considerable vocal range was noticed while competing in season 3 of American Idol. Yet she finished a distant seventh in the competition won by Fantasia Barrino. Her early exit is considered among the most shocking in Idol history. While Fantasia

topped the charts with her first single, Hudson was competing against her (and hundreds of other hopefuls) for the part of Effie in the movie *Dreamgirls*. Cast opposite Beyoncé as Deena, Hudson's rendition of "And I'm Telling You I'm Not Going" riveted audiences and galvanized critical acclaim. She won the Oscar as Best Supporting Actress and was signed to a record deal by Arista Records. Whatever anger she channeled into Effie catapulted the American Idol star into the musical stratosphere and eventually Emmy, Grammy, Oscar, and Tony awards.[8]

"And I'm Telling You I'm Not Going" has also become a door-opening anthem for actor Amber Riley. She performed it for her *Glee* television audition. After winning the part of "Mercedes Jones," she delivered a rousing rendition in the midseason finale of *Glee* season one.[9] After the TV series ended, Amber Riley was cast as Effie in the 2016 West End debut of *Dreamgirls*. Her performance in the London production earned her the Olivier Award for Best Actress in a Musical. For the third time, the transformation of anger into strength and resilience written into "And I'm Telling You I'm Not Going" launched a career.

One of the more famous automotive rivalries was fueled by an argument over a single piece of equipment. Ferruccio Lamborghini grew up in a family of Italian grape farmers. Ferruccio was more interested in machinery than vineyards, though. After studying mechanical engineering and serving in the Italian Royal Air Force during World War II, Lamborghini launched a tractor business in 1947.

Enzo Ferrari had a lifelong obsession with speed. He worked with Alfa Romeo cars in the 1920s and '30s and started his own supply company for racing teams in 1939. Enzo's passion for racing expanded and he opened his Ferrari S.p.a. automobile factory in Maranello, Italy, in 1947. By the 1950s, Ferraris were among the most stylish and sought-after sports cars in the world.

Lamborghini's tractor business also prospered, bringing additional wealth with his expansion into heating and air conditioning. He began collecting sports cars from the Mercedes Benz 300SL to the Maserati 3500GT. Lamborghini traveled to Maranello to buy a 1958 Ferrari 250 GT. The only problem with his new purchase? The clutch on his new Ferrari broke repeatedly, leading to expensive repairs at the Ferrari factory. Frustrated by another broken clutch, Lamborghini instructed his mechanics to disassemble the engine and transmission. They discovered that that broken clutch was the same one used in their tractors, making Lamborghini furious. Why was he paying one thousand lire to fix a clutch that he knew only cost ten lire? He allegedly drove to Ferrari's house and knocked on the door in a fury.

Lamborghini complained to Ferrari, "You build your beautiful car with my tractor parts."[10] Enzo is said to have retorted, "You are a tractor driver, a farmer. Let me make cars. You stick to making tractors."[11] An enraged Lamborghini fired back, "Correct, I am a farmer, but I'll show you how to make a sports car and I'll do it myself to show you how a sports car has to be."[12] Within four months, Lamborghini had created a small factory and his first sports car was presented at the annual car show in Turin. It was called the Lamborghini 350 GT.

How could an angry tractor maker create his own sports car so quickly? The quick-tempered Enzo Ferrari had other enemies. Two years earlier, Ferrari's chief engineer, his development manager, and three additional employees complained about Enzo's wife, Laura Ferrari, making decisions on the factory floor in Maranello. They wanted Laura to stop interfering in their production. An angered Enzo sided with his wife and fired his key employees on the spot. They formed a competing design agency for racing and sports cars in Bologna called ATS. Guess who recruited them for his new car company? Ferruccio Lamborghini. These former Ferrari engineers ushered in the revolutionary idea

of putting the engine in the center of the car. The 1967 Lamborghini Miura altered the sports car market, giving Ferrari a competitor that rivals them even today. While the founders of Ferrari and Lamborghini have long since passed away, the rivalry fueled by a cheap, ten-lire clutch lingers on. Ferruccio Lamborghini knew, "Mechanics was in my blood, and I knew I could beat Ferrari. . . . You don't mess with a farmer."[13]

Anger can be a solid motivation for an artist to build a project upon. Plenty of songs and stories are generated as payback for a jilted lover, a kiss off to an ex like Carly Simon's "You're So Vain," Taylor Swift's "We Are Never Ever Getting Back Together," or Jazmin Sullivan's "Pick Up Your Feelings." Marvin Gaye famously delivered a double album of original songs, *Here, My Dear*, to pay off the cost of his divorce from Anna Gordy. Righteous anger at injustice has fueled painting, poetry, literature, and scripture. Psalm 137 was written by the Hebrew people in exile—by the waters of Babylon. Those who had been conquered and marched into a foreign land ask God to bash the heads of their oppressors' children upon the rocks. Pablo Picasso's *Guernica* conveyed the horrors of the Spanish Civil War on a massive canvas. Rachel Carson's *Silent Spring* railed prophetically against the environmental disaster we were inflicting upon ourselves as well as God's creation. On his seminal protest album, *What's Going On*, Marvin Gaye appealed for "Mercy Mercy Me" on behalf of the ecological system. Poet Emmy Pérez makes her declaration clear near the Arizona border when she proclaims, "Not one more refugee death."[14] Pérez turns a news headline we've heard far too many times, "10-Year-Old Shot Three Times, but She's Fine," into a poetic plea for sanity and comfort for the parents of those murdered in their playgrounds and schoolyards. We need people of conscience to rise up and question our barbarous ways. Protest art endures when it chronicles not just the heat of the moment but enduring truth about the human condition—our capacity to maim, our potential to comfort.

Longing

We all long to be seen and heard, to have a sense that our lives matter. What resides behind our longing for recognition, our desire to be noticed? Fame offers a kind of immortality. It suggests that our name or art will live on after our death. The estates of musicians who died early like Elvis, Michael Jackson, and Prince often become even more valuable after the star has passed on. Plenty of artists toil in obscurity during their lifetime but find their reputation rising posthumously. A 2023 exhibition that gathered the largest number of Johannes Vermeer's thirty-four known paintings attracted throngs of museum goers to the Rijksmuseum in Amsterdam. Admission to see these small and sedate interiors was sold out for the entire run of show. Such drawing power invites us to ponder the beauty contained within Vermeer's modest visions. He painted small canvasses of Dutch domestic life with precision and care. His handling of light is subtle and exquisite. Yet when he died at age forty-three, his wife inherited his considerable debt and the burden of raising their eleven children. Four hundred years after his birth, Johannes Vermeer is more renowned and his paintings more priceless than ever before.

The job of social media influencer is of remarkably recent vintage. Companies seeking to put their products in front of a new generation have found recommendations and endorsements to be a cost-effective form of advertising. Celebrities have been paid to hawk products for decades. Yet the rise of the social influencer represents a shift in ethos. The ability to number our followers on Instagram allows us to monetize our platform. Book editors now look at a potential authors' social media numbers before they extend a contract. People are being paid to write even if they don't necessarily have something to say. Katelyn Beatty rightly questions whether our obsession with numbers has been

unhealthy for churches. In her award-winning book *Celebrities for Jesus*, she chronicles how the elevation of a pastor to a higher plane via book sales, social media followers, and streaming numbers has misadjusted us. The prevalence of one church scandal after another (and the painful accompanying docuseries) should cause us to pause. She suggests, "The right kind of fame arises from a life well lived, not a brand well cultivated."[15]

The longing to build a platform is not a new concept. In ancient Babel, the people build themselves a city, "with a tower that reaches to the heavens, so that we may make a name for ourselves."[16] This ziggurat is among the first self-aggrandizing building projects reported (but certainly not the last). The desire to be God-like, revered far and wide, is an enduring temptation. I am not opposed to leveraging our platforms or galvanizing our followers for good. Plenty of celebrities have figured out how to redirect the press's attention from them to a corner of the world that needs our attention. Yet the question that dogged Babel should cause reflection for us as well. In building our platforms, who or what is being elevated?

It is far too easy for preachers to claim credit for building a following or fanbase. The Apostle Paul dealt with competing claims and aspirations among those in ministry. He chides the Christian community in Corinth for playing games of one-upmanship and factionalism. "Who says you are better than others? What do you have that was not given to you? And if it was given to you, why do you brag as if you did not receive it as a gift?"[17]

We may hog the spotlight due to our yearning to be recognized. Yet recognition of our talent and hard work may still prove elusive. Restlessness and dissatisfaction are inherent in our souls. The pursuit of the next gig, a new relationship, a higher plane of consciousness are all connected to a longing for love, satisfaction, purpose, and meaning. I've pursued

transcendence in art and experiences. Innovation excites me. I'm energized by the shock of the new. Each mountaintop experience makes me long for another. Consequently, it is easy for that longing to consume us. The time offstage can bring a performer down. Melancholy can arise after a triumph. Love and satisfaction may feel unattainable, a fleeting desire that always escapes our grasp.

The wisdom literature of the Bible acknowledges the depth of human longing. Proverbs 13:12 notes how "hope deferred make the heart sick, but a longing fulfilled is a tree of life." How do we tap into those deep roots? The psalmist describes the thirst which resides in our soul. Where can we find relief? Psalm 42 suggests, "As the deer pants for streams of water, so my soul pants for you, my God." Psalm 63 addresses our desperate need, "You, God, are my God, earnestly I seek you; I thirst for you, my whole being longs for you, in a dry and parched land where there is no water." In the Sermon on the Mount, Jesus addressed the hunger and thirst in the crowd gathered around him. In Matthew 5:6, he declared, "Blessed are those who hunger and thirst for righteousness, for they will be filled." A deep spiritual hunger and ennui is to be expected. But those who long for a more just world will eventually be filled. How do we handle the gap between what has already been promised and what is yet to come? Our prayers, songs, and stories enable us to endure.

My wife, a trained gerontologist, encourages daily creative practices for our mental health and well-being. These are generative activities, from solving a crossword puzzle to writing a poem. Through a pen, a brush, or a loom, we express our feelings and process the world around us. Via a spreadsheet, a baking sheet, or a negative sheet of photographs, we gain perspective on those events that feel random or disorienting. We can channel our anger or longing into generative outcomes for our mental and spiritual sustenance.

Craig Detweiler

A Sort of Spy

Vivian Maier (1926–2009) was a nanny in Chicago who processed her life experiences via a Rolleiflex camera. This traditional box camera allows a photographer to look down at their subject via a mirror. The camera doesn't reside in front of our eye, but below, often at waist level, creating the possibility that our gaze will not be noticed. Our observation may be anonymous.

A trove of Vivian's photographs purchased after she let the payments on her storage locker lapse enabled her unique perspective to be noticed. Of the three collectors who bought Vivian's negatives at auction, John Maloof gained the most traction by posting her work on the photo-sharing website Flickr. While she lived almost anonymously, Maier was also developing a discerning eye. She captured so much pathos with her camera—the daily ennui that characterizes so much of modern life. Children at play, aspiring to be superheroes are juxtaposed with images of people being arrested and passed out drunk on park benches. She was praised for "her alertness to human tragedies and those moments of generosity and sweetness."[18] This is clear-eyed documentation of the human condition. Yet *none* of her 140,000 street photos were exhibited in her lifetime. The Oscar-nominated documentary *Finding Vivian Maier* (2013) featured interviews with the children she cared for and raised haunting questions about her life. Why was she so secretive about her work? Was she satisfied working as a nanny? Why hide such a voluminous creative oeuvre?

Appreciation of her artistry and speculation about her highly private life exploded. Maier evidently adopted many different nom de plumes when developing her film. She was also elusive about her roots, lying about her birthplace and adopting an inconclusive continental accent. The families she looked after were not allowed in her room. What was

she hiding? The six hundred self-portraits in her photographs suggest a surprising level of self-awareness. While often depicting herself in shadows, Vivian clearly had a sense of self that belied her humble appearance. When asked what she did for a living, Vivian reportedly said, "I'm a sort of spy."[19]

Genealogist Ann Marks carefully reconstructed Maier's roots, finding traumatic reasons for her reticence. In *Vivian Maier Developed*, Marks vows to piece together the real story of the photographer nanny.[20] She finds that Vivian's grandmother was born out of wedlock. She speculates that her parents' divorce and her mother's narcissism caused Maier to be treated "as if she were wallpaper."[21] Marks chronicles how her brother battled drug addiction, was dishonorably discharged from the military, and was hospitalized for schizophrenia. The camera becomes a way for Vivian to process her hidden trauma, to maintain a safe distance between the world and her family secrets. The Hardy children that she nannied recall Maier as "cold, unapproachable, and disengaged." Marks describes her as possessing "linebacker arms and dark circles under her eyes." Her "oily face" was "off-putting" and "unattractive." Her biographer suggests that "her dispassionate demeanor worked to her photographic advantage by diminishing her own presence as she sought honest and unaffected pictures of her subjects."[22]

Did Vivian consciously seek social invisibility?

Writing about Vivian Maier for *The New Yorker*, Rose Lichter-Marck challenges the narrative of the tortured artist, especially the problem of "difficult women."[23] The familiar trope insists, "She couldn't possibly have been satisfied as a nanny. Or as a single woman. Why didn't she approach a gallery to display her photographs? Was she mentally ill?"[24] Yes, Vivian hoarded newspapers and failed to pay her bills. Yet when John Maloof went through her possessions, he discovered thousands of dollars in uncashed social security checks. Perhaps she wasn't motivated

by money. Her life challenges our notions of how an artist and a nanny should behave. Maier didn't seem especially fond of children. The job was more of a means to an end. Caring for kids gave her freedom to roam on any given day to street scenes in Chicago which captivated her eye. However, Lichter-Marck notes how "she didn't try to use her work to accumulate cultural or economic capital." She walked away from her job when some of her family's property was sold in France. She never married and chose to travel alone, photographing the world. Does this make her a sad or tragic genius? Or simply someone whose ambition seemingly did not equal her talent? Vivian wasn't compelled to share her work. It was amassed as a daily discipline, part of her working routine.

We may seek clues behind her motivation. Yet her sphinxlike self-portraits maintain the mystery. Perhaps she had more inner satisfaction than our speculative biographies allow. She kept photographing her surroundings, commenting upon injustices, even if no one was noticing her work. Taking pictures must have been its own reward, a way of seeing and being that sustained her. What compels your creativity?

Drive

The biggest differentiator among the thousands of aspiring artists I've taught is drive. I can test students for competence and creativity, but I cannot measure drive. How big a fire burns in a person's belly will only appear over time. What drove Vivian Maier to take over a hundred thousand photos and yet not even develop countless rolls of film? After graduation, when the rejection letters pile up, is when the depth of students' resilience will be revealed. That's when basic biological needs kick in. How will we pay the rent? Where's my next meal coming from? How much sleep can be sacrificed to finish that personal project before or after work?

I cannot predict how much time my students will put into mastering a craft. Taylor Swift started writing songs as a professional when she was fourteen years old. The Eras tour celebrated seventeen years of craftsmanship and polish. Those with innate potential may also squander it (see *Amadeus*). Those with fewer God-given skills may work harder but see modest results (also see *Amadeus*). Sometimes the least talented will be elevated due to other attributes like beauty (see *Dreamgirls*). A slight or rejection can turn into a massive grudge (as with Lamborghini). Ferrari underestimated the drive in a farmer's heart. Few will ever attain the fame of Taylor Swift. Yet our attention to craft may result in posthumous recognition like Johannes Vermeer or Vivian Maier.

Early on, I recognized that my parents could not afford to pay for my college education. So, getting good grades was a form of self-preservation—a way out of the literal basement. Those who have struggled with safety and security may be more motivated to make a sale or land an audition. Autonomy and self-determination can take many forms. For Vivian Maier, working as a nanny paid the bills and enabled her to pursue her passion for photography. Her innate curiosity exceeded her ability to literally process her experiences. Budget constraints may constrict what is possible or inspire you to pursue a more profitable profession. You may be content being known by a few close friends. Or your longing for social connection may push you toward every spotlight in your community. Who we are today isn't necessarily what will satisfy us in years to come. Drive is its own kind of blessing or curse.

I'm all for personal growth, the development of our skills and the fulfillment of our potential. No one had me pegged as a writer. I developed this craft thanks to strong teachers and hours (more like years) of practice. My filmmaking career began as a fan. Growing up, I had no vision of living in California and working in Hollywood. I've seen more places, tasted more flavors, and met more people than I ever expected. It has

been risky at times. There have been plenty of public embarrassments, but few regrets.

Balancing our ambition with our satisfaction is never easy. I've met miserable rich people. And dined with ridiculously restless success stories. Contentment can be hard to come by for creatives. A prophetic eye may cause us to weep at newscasts and rail against alleged leaders. It is okay to want better or long for more. As long as we can turn off those ambitions at night.

Lofty aspirations have propelled humanity to profound breakthroughs in art, science, and business. While we may decry the colonization that accompanied plenty of Christian missionary activity, it also expanded education, healthcare, and food supplies. We need a new generation of leaders who love mercy to pursue justice. More conscience capitalism can generate jobs and more opportunities for humanity to thrive. We desperately need sustainable practices in our transportation and power grids. Creative solutions to caring for our soil, our air, and water supplies are essential to our survival. If we find personal fulfillment and satisfaction in serving others along the way, our happiness index may rise to the levels of the mountain nation of Bhutan.

It is easy to get discouraged during the journey. We need songs and stories to refresh us during dry seasons. Aspirational art can challenge us to change our behaviors or to continue pursuing lofty goals. That drive to achieve embedded in our brains and bodies should be nurtured. I am continually astounded by those who build and create despite the setbacks that life has dealt them. Traumatic experiences may squelch our dreams— but it need not have the final word.

When we externalize our goals, we may give too much power to others. It is lovely to have social media followers to interact with. But managing our profiles and projecting a certain image can be exhausting. What intrinsic motivations can we tap into instead? Our creative endeavors

may not yield the fame or fortune we seek. Can we take comfort instead in the daily, generative activity itself? Making a sweater to give to a niece is a rewarding act of kindness. Baking for friends, coworkers, or the bereaved is a profound gift. Remembering birthdays and anniversaries with cards reminds the recipients that they are loved. I still cherish my parents' handwritten letters because they communicated such care. Vivian Maier took photographs for herself, an audience of one. Her images are odd, unusual, and powerful. While we wrestle with public reception, let us consider the source of personal satisfaction. May our longings be met in the quenching river of life.

HONEST CHALLENGE

1. Many of us may carry the ambition of Salieri. Yet few of us will have the early training and resources to develop the composing skills of Mozart. What is a goal or aspiration that would bring deep satisfaction? Name it. And figure out three small steps to head toward it.
2. What kind of daily creative activities do you practice? What is a hidden discipline, a quiet observing you can do in your community? What form will your reactions to injustice or longing take?

3

HONEST LIMITATIONS

"Sit down. Be Humble."

—KENDRICK LAMAR[1]

BEWARE OF A CLAGGY BAP OR A STODGY SPONGE. Only the proper fold and sufficient proving can prevent a soggy bottom. An even bake can turn a fool into a showstopper. The delightful television show *The Great British Bake Off* has expanded our family's culinary vocabulary.[2] After binging several seasons on Netflix, we can now distinguish between saucy puds, a puff *choux*, and a runny *crème pat*. Rechristened as *The Great British Baking Show* for American audiences, *GGBO* builds tension via limitations. The frazzled contestants must juggle time, space, and resources to become a star baker. They create within the same time frame. And they are evaluated according to preexisting standards of the form. Taste, texture, and presentation all register in the judges' ledgers. The refined palettes of Mary, Paul, and Prue coexist with playful innuendo. A handshake extended by host Paul Hollywood is the ultimate compliment. Yet winning isn't everything. The focus is upon camaraderie, growing as a baker and as a person.

An overly ambitious contestant may crash with concoctions that are too big or lopsided. The overly creative may mismanage—failing to get the cake out into the oven on time. Aspirants may miss the core assignment—doing something too original that fails to satisfy the basic constraints of what a trifle should be. Too sweet, too salty, too spongy: the perils of high stakes baking are legion. Delicious results require discipline, planning, and creativity. Yet the tent feels less like a competitive arena and more like a place of self-discovery.

Star bakers must embrace limitations, shifting their mindset from constraints to creativity. They must focus quickly, prioritizing what's possible. They must be resourceful, but unlike pressure-packed shows such as *Cupcake Wars*, they are allowed to select their own ingredients. It is more comparable to our kitchens. What shall I make from what I have and know and love? They adapt prior experiences and personal tastes to the current situation. The assignment may be sweet or savory. Their stories surrounding their ingredients and inspiration matter. Self-expression must be balanced with practicalities. Is their vision attainable? What time-saving alternatives or shortcuts can be employed while the clock is ticking? Creativity must be balanced by efficiency and simplicity. A finished, even bake will always surpass a claggy, half-baked entrée. Limitations force contestants to turn obstacles into opportunities. *The Great British Bake Off* is all about creative problem-solving.

Setbacks are expected. We'd likely crumble under similar conditions. Will contestants learn from their mistakes without becoming defensive or discouraged? Will they develop enough resilience to persevere in the face of criticism? Will they incorporate the judgments of Paul and Prue into the next challenge? Steady improvement is key. Star bakers are willing to learn from others. They seek input, appreciate diversity, offer each other a hand. Studying the success and technique of others is crucial. Appreciating what others did right is just as important as embracing our

mistakes. What refreshing camaraderie within a competition! Star bakers learn to flex and pivot. A mindset rooted in curiosity, an openness to experimentation, and a sense of our strengths and weaknesses serve all bakers well. Humility emerges as a virtue within the heat of the ovens and the glare of television lights.

The Great British Bake Off inspired our family to experiment with our own meringues and bread doughs. We've enjoyed our successes (vegan brownies) and learned from our failures (homemade bagels). We've attempted coulis, fondants, but never a spotted dick. Our commitment to vegan recipes makes frangipanes a challenge. Yet creating healthy desserts is deeply satisfying for our souls and our stomachs. Friends have also engaged in their own culinary competitions. We all win when we're devouring the resulting scrumptious scones. GBBO is that rare TV show that educates and entertains, inspiring creativity among devoted followers. The relatable contestants inspire us to try new things even amid our own limitations.

Far too often we feel like we can't create because we don't have enough time, space, or capital. How many entrepreneurs apply to *Shark Tank* hoping for an infusion of cash to turn their invention into a new industry standard? It is an aspirational show, rooted in what I could do *if only* I had the money. The same wishful thinking can sidetrack artists. Musicians may covet the gear (and history) residing in London's famed Abbey Road Studios. Aspiring filmmakers may have a vibrant vision that can't be accomplished for less than $200 million. We know that nepo babies have access to agents, publicists, and execs. I went to film school with a guy whose father literally ran Disney. Of course, the children of the rich and famous will get more opportunities to succeed faster. That's doesn't mean we shouldn't continue to hone our craft or polish our pitch decks.

We can pine away, waiting upon capital investments, or we can embrace our honest limitations. While we're waiting for a banker or studio to give us the green light, why not create with whatever is already in our

hands? *The Great British Bake Off* shows us what is possible within established parameters. It stretches our ambitions but suggests that excellence is attainable. Creativity can thrive under constraints. Innovation arises amid honest limitations. Even large language models are aided by parameters. The more specific our prompts, the more accurate our results. Working with limits can be a profound gift in a world of overwhelming options.

The Burden of Limitlessness

The size and scale of so much of our entertainment can be daunting. Our students at the College of Arts and Media at Grand Canyon University often freeze up when they consider how perfect award-winning songs, shows, and bakes appear. It can be intimidating to compete with miniseries or sequels. How to even begin constructing the complex world of a video game or a fantasy novel? The options are so endless, the creative journey so arduous, that it can keep us from commencing. Philosopher Soren Kierkegaard compared anxiety to dizziness; "the dizziness of freedom" arising from so many choices.[3] Too much freedom provokes a haunting sense of dread. We've never had more creative tools at our fingertips, yet the pressure to make something original can be intimidating.

Why did it take Hollywood so long to bring an epic fantasy like *The Lord of the Rings* to the big screen? The creative vision of J. R. R. Tolkien, forged in the horrors of World War I, exceeded the studios' ability to approximate it. The scope and scale of Tolkien's trilogy proved daunting. Few could afford the years of development, production, and effects that diehard fans of the books would expect. Describing an alternative world of hobbits, wizards, and orcs was easier than bringing the characters to the big screen. In 1977, the Rankin/Bass animation studio teamed with the Japanese animation studio Topcraft (a precursor to Studio Ghibli) to

bring *The Hobbit* to life. I remember watching the eighty-minute television premiere as a young boy. It was weird, eerie, and yet slightly uninvolving. Gollum made an impression, but the heart of Bilbo Baggins's temptation was lost in the rush to cover the basic plot. Indie animator Ralph Bakshi drew the first half of *The Lord of the Rings* for United Artists as a planned, two-part journey into Middle Earth. Yet the studio declined to identify the 1978 feature release as part one, thereby frustrating both Tolkien purists as well as those who wondered why it had such an unresolved ending. Bakshi never received the funding to finish the story he started.

Twenty years later, digital effects had advanced far enough that director Peter Jackson could bring Tolkien's vision to vibrant life. New Line's financial risk achieved handsome commercial and artistic rewards. The original trilogy was so deeply satisfying. Now, thanks to digital innovations and generative A.I., we can all potentially create a magical world that conforms to our imagination. A massive digital toolbox can still feel overwhelming. The problem doesn't reside in the tools, but in the teller of the tale. Few have Tolkien's literary chops to craft a compelling story that carries audiences across three novels or almost nine hours of screen time. Note the mostly abysmal failure of Amazon's costly prequel, *The Lord of the Rings: The Rings of Power*. It looked great, but it was definitely less filling. The ability to make more doesn't mean we should yield to that temptation.

We may have the ambition of Tolkien but lack his perspective. He considered his creative work a subcreation, a mere emulation of the true creation performed by God. On a walk in Oxford, Tolkien told his friend C. S. Lewis, "We have come from God, and inevitably the myths woven by us, though they contain error, will also reflect a splintered fragment of the true light, the eternal truth that is with God. Indeed, only by mythmaking, only by becoming 'sub-creator' and inventing stories, can Man aspire to the state of perfection that he knew before the Fall."[4] Catherine

McIlwaine, curator of the *Tolkien: Maker of Middle Earth* exhibition, notes how this notion of subcreation "is tied into his religious belief that all talents and gifts come from God. God is the one creator, and what we do is in imitation of that. Tolkien was a very humble man."[5] Even in our most grandiose worldbuilding and mythmaking, we need to remember we are just "little makers."

The pressure to be original shifts when we recognize the original source. The Greeks attributed inspiration to The Muses. In Norse tradition, Odin gave the first humans soul and life, Vili gave wit and intelligence, while Ve gave humanity faces and speech, hearing and sight. Indigenous peoples envision the creative process behind the universe as a form of thought involving many sacred actors, from animal-like coyotes, ravens, and great white hares to forces of nature such as wind/breath.[6] The Hebrews referred to *ruach*—the Spirit, the breath, the wind of God. It was hovering over the water at creation.[7] It is that spark that crosses our mind when we're not looking for it. It may arrive in the shower. Insight may arrive while jogging. Our inner wheels turn even when we're staring at the wall. Creativity is associated with the unconscious bubbling up when we least expect it. We may catch a vision in a dream—waking or sleeping. We can't control it, but we can attend to the vision. It's that guitar riff we stumbled across, that groove that a band locks into, the hook that crawls into our ear and won't let go. When we humbly receive these gifts, the pressure to perform drops.

The concept of "artistic genius" is of relatively recent origin in human history. In *Disputationes Camaldulenses* (1472), Florentine poet Cristoforo Landino connected his craft to divinity, noting, "There is no kind of writer equal to the poets, either in greatness of eloquence or in divinity of wisdom." Compared to the more liberal arts, poetry "is a more divine thing."[8] Art historian Erwin Panofsky found, "The words *creare, creator, creatis,* and their vernacular equivalents seem not to have been applied

to artists until the sixteenth century."[9] Classical pianist Franz Liszt was among the first rock stars.[10] In his 1839 tour of European concert halls, Liszt introduced the notion of striding out on stage to applause even before he took his seat. He placed his piano in profile, so audiences could see his face. Liszt played without sheet music, rejecting the humble reminder that someone else had composed the music. His aggressive technique made his long hair fly and beads of sweat pepper the audience. Liszt destroyed the pianos as he played them, causing women to rush the stage, tear his clothing, snatch locks of his golden hair and fight over the broken piano strings. Prior to Liszt, orchestra conductors were facilitating sounds, serving the composition. After Liszt, the conductor was playing the orchestra, reflecting his mastery.

Perhaps we need to recover the notion of ourselves as makers or fashioners rather than creators.

We create because we come from the Creator. We bring forth bright ideas because we had the breath of life placed in us. Playing is as natural as breathing. Making up jokes, stories, and dances are how we deal with pain and loss and longing. We may have an inkling of what needs to be said. Creativity is the process through which we get in touch with those hunches. It is how we express what's bugging us. When we give ourselves to the process, we discover what's bubbling up within us. As we release those thoughts and feelings into the wider world, we hopefully discover points of connection between ourselves and others. We're really just a conduit. We're the one who saw it and decided to snap a photo or make a painting. We're the lucky musician or aspiring author who heard it and wrote it down. Entrepreneurs and scientists see the potential, do the research, acquire the investors, prototype the product, and bring it to the marketplace. We may not get the credit, patent, or payday, but creating is a way of honoring the gift of life. It is fundamentally human *and* divine.

We are not creating *ex nihilo*—out of nothing, but rather out of something. We are the latest in a long line of creators. We arise from within centuries of human expression. Archaeologists date the French cave paintings featuring artful horses and animals to thirty-three thousand years ago.[11] Who crawled into these jet-black spaces with an oil lamp to paint with a charcoal stick? What drove such hunger for expression? Did the light in the cave make the images appear to dance or move as the shadows shifted? Were these early moving pictures an attempt to touch something mysterious and divine? Handprints on the wall give evidence of multiple artists across centuries. Images were applied to these limestone walls for a span of over five thousand years. The location and the techniques were handed down across generations. Yet these prehistoric masterpieces were hidden from us until Jean-Marie Chauvet and a team of cavers discovered them in 1994. Small flutes made of ivory and vulture bone were also found in the Aurignacian caves nearby. We crafted music and images for thousands of years before we had a written language. How shall we connect to that time-honored tradition of entrepreneurs and artists—to get back to where we once belonged? Creativity arises out of need; the need to say something, the awareness of a problem, a feeling of isolation and a desire to be known.

Why do we create and innovate? We forged tools for survival, with breakthroughs like the bow and arrow for hunting, the plow for farming, and the reel and net for fishing. The control of fire and the crafting of clothes made seasons much more bearable. After work, we created as a form of relief, from beer to lighten our moods to jokes told around the campfire. Dutch historian Johan Huizinga called us "homo ludens," humans as players.[12] He noted how ball fields and sports rules create a magic circle that holds the daily troubles of life at bay. Children in all cultures engage in play whether with toys or games. Boomerangs, robots, and rockets all began as toys before they were turned into weapons.[13]

As communal creatures, we create to communicate and commiserate. We pass along collective wisdom via songs, paintings, dramas, and books. Personal communication devices like phones now allow us to distribute our thoughts across digital platforms with remarkable (and sometimes detrimental) speed. Another reason we create is to distinguish ourselves. Body ornamentation ranges from neck elongation practiced by Padaung and Kayan peoples of Thailand and Myanmar to indigenous jewelry and onto Pacific Islanders' tattoos. Self-decoration occurs in all ancient cultures—it distinguishes us as human.[14] Adornment is not a commandment but a choice. Anthropologists call these status-conferring inventions "prestige technology."[15] There have always been designer clothes and handcrafted jewelry to communicate our social standing and wealth. While separating ourselves from others with our aesthetic choices, we also constantly copy each other, engaging in social learning. As Cody Cassidy notes, "We watch each other, we learn, and we copy. Essentially, we are a species of shameless intellectual plagiarists. But this is a feature not a bug."[16] Perhaps generative A.I. is just the latest iteration of our plagiarizing tendencies. Embracing our limits, acknowledging our influences, recognizing the source of creativity can keep us humble and productive.

The Joy of Limits

Limits can be helpful. Small can be beautiful. A tiny budget could be the starting point for our creativity. What can we make *within* our limitations?

Poets have long prospered within the structures provided by sonnets and haiku. When our word choice is limited, we focus our attention, employing the most resonant descriptors possible. Six-word memoirs also challenge us to boil down our lives into succinct summaries. It began

as an online project, inspired by the urban legend that Ernest Hemingway once wrote a heart-rendering, six-word short story: "For sale: baby shoes, never worn."[17] Such potent brevity inspired others to summarize their lives in an equally compact way. Activist Gloria Steinem penned, "Life is one big editorial meeting." Irish author Frank McCourt wrote, "The miserable childhood leads to royalties." Other clever life summaries included "Found on Craigslist: table, apartment, fiancé" by Becki Lee and "Alzheimer's: meeting new people every day" by Phil Skversky.[18] How might you summarize your work or calling in a potent six-word story? When it comes to words, less is sometimes far more.

From a few vivid details, our imagination can complete the story. *60 Minutes* reporter Scott Pelley plugged the "baby shoes" story into Google's Bard chatbot.[19] Within seconds, Bard produced a poignant tale of a husband and wife struggling with infertility and a stranger grieving after a miscarriage, longing for closure. Pelley then prompted Bard to transform the story into a poem. Eight evocative lines arrived within seconds, concluding with this spiritual couplet, "She knew her babies soul / Would always be alive." If we're struggling with how to turn a title or concept into a short story, Artificial Intelligence can generate a version almost instantaneously. It can also transform your prompt into a poem, a song, or a graphic novel. Our ability to create fresh, dramatic prompts for A.I. will increasingly be a valued skill. We will also benefit from generative A.I.'s ability to edit our sometimes rambling reflections. Bard can take a longer autobiographical piece we've penned and generate a six-word story from our prose. A.I. offers us speed. What we bring to the process is the equally important aspect of wisdom and reflection. It takes time to ponder the meaning of our lives and the emotional events that can comprise a six-word short story. We will increasingly see how the power of a few potent words or images can come to encapsulate complex human emotions.

We do not always have the luxury of finely tuned machines or instruments to assist us. Faulty or limited equipment can also spark creative problem-solving. Navigating our physical world with ingenuity and expertise will set us apart. Bad or limited equipment can also spark creative problem-solving. Jazz pianist Keith Jarrett composed his most famous album on a lousy piano. Known as an exacting perfectionist, Jarrett was tapped as the first jazz performer in Cologne, Germany's opera house. Unfortunately, the Bosendorfer 290 Imperial grand piano he requested was replaced by a much smaller, broken-down baby grand. Pedals were stuck. Some keys didn't work. It was out of tune. Yet Jarrett soldiered on, pounded out riffs on the bass keys to compensate for its tinier sound. He moans, sweats, and cajoles as much soul as possible from the limited instrument. Jarrett's powerful, improvised performance at the potentially disastrous *Koln Concert* became the best-selling solo piano album of all time.[20]

The Golden Age of Hollywood movies in the 1930s and '40s arose within strict limits placed upon screenwriters. A Production Code limited how much sexuality, profanity, and violence could be depicted onscreen. Filmmakers had to suggest rather than spell out. The resulting sexual tension between actors unleashed a new genre, the screwball comedy. Directors like Ernst Lubitsch, Billy Wilder, and Preston Sturges used witty wordplay instead of sex and nudity. Actors like Cary Grant and Katharine Hepburn bickered and bantered onscreen, establishing the conventions for decades of romantic comedies that followed.

The spare Italian neorealist films of the 1940s arose from the limitations created by World War II. A decimated country did not have the resources to erect epic sets. Budgets could not even support professional actors. Directors like Vittorio De Sica took to the streets, telling stories of everyday struggles in post-war Rome. *The Bicycle Thieves* (1948) follows Antonio, a father desperate to support his young family. His wife, Maria,

pawns their prized wedding gift, a set of sheets, to recover his bicycle from a pawn shop. Yet just as Antonio starts his new job posting advertising bills, the bicycle is stolen out from under him. The frantic search of Antonio and his son, Bruno, becomes a harrowing study of heroism and loss. This profoundly simple film, made for $133,000, is generally regarded as among the ten finest of all time. Iranian filmmakers constrained by the Islamic Revolution of 1979 also turned the struggles of children into poignant classics like *The Runner* (1984) and *Where Is the Friend's House* (1987).

There will always be low-fi breakthroughs that defy conventional wisdom. Before the *Spy Kids* movies, director Robert Rodriguez jumpstarted his career with *El Mariachi* (1992). He raised production money by donating his body to science, locking himself up for an experiment that allowed him to work on the script. He built a story around the elements available to him—a guitar, a friend with a bar, and a school bus. The resulting chases and gun battles were taut and thrilling in their simplicity. It was much ado created with almost nothing. Rodriguez entitled his behind-the-scenes how-to *Rebel Without a Crew: Or How a 23-Year-Old Filmmaker with $7000 Became a Hollywood Player.*[21]

Danish director Lars von Trier mastered digital techniques in his early films that he has been trying to unlearn ever since. In *The Five Obstructions* (2003), he challenged his mentor, Jorgen Leth, to remake his influential experimental short, *The Perfect Human* (1968). Von Trier placed a series of restrictions upon Leth, from reshooting the film in Cuba, with only twelve frames allowed per scene, to reimaging it as a cartoon. Ever the provocateur, von Trier also sends Leth to Mumbai, where the difficult conditions will challenge and potentially defeat him. Leth rises to each challenge, prompting reflections on the nature of art and friendship. Could obstructions make our storytelling sharper? The proliferation of 48- and 168-hour film festivals suggests that creating something under

constraints is preferable to merely talking about our plans to make a movie.

Some of my favorite artists began with found objects.[22] Over thirty years, welder Simon Rodia constructed the massive Watts Towers in his South Los Angeles backyard. He started with scrap rebar, adding items found along the nearby Pacific Electric Railway. Neighborhood children brought pieces of broken pottery and soft drink bottles to Sam. Growing up in Watts, artist Bettye Saar was "fascinated by the materials that Simon Rodia used, the broken dishes, seashells, rusty tools, even corn cobs—all pressed into cement to create spires. To me, they were magical."[23] Eventually, Bettye incorporated racist signs and symbols from the past to create biting social commentary. She turns derogatory stereotypes like Aunt Jemima into potent figures for righting past wrongs. Saar combines "the remnant of memories, fragments of relics and ordinary objects, with the components of technology," calling it "a way of delving into the past and reaching into the future simultaneously."[24] Saar's prolific artistic daughters, Lezley, and Allison, also extend the family tradition.

Ron Finley was a successful clothing designer for Nordstrom and Saks in Los Angeles when he became increasingly irked that it was easier to purchase alcohol than an organic banana in his neighborhood. As a "Gangsta Gardener," Finley transformed his backyard swimming pool into an oasis for plants and artwork. His greenery crossed into the street, where he turned the median strip into an edible garden. When he was fined and arrested for his work, Finley's fame as an urban gardener grew into a celebrated TED Talk. Finley quips, "This is definitely a lemonade story."[25]

Inspired by the temporal beauty found in nature, British artist Andy Goldsworthy makes site-specific, seasonal installations. He may arrange fallen leaves into colorful patterns, gather twigs into a delicate sculpture, or balance rocks in the most precarious and poetic manner possible.

Then time enters the equation, with the elements of wind and rain, snow and ice, determining how long his art remains visible. Goldswor-thy's four-dimensional work is inherently ephemeral, captured only in a photograph or documentary.[26] Justin Bateman achieved surprising Insta fame via his pebble portraits. Bateman recreates classic paintings like The Stona Lisa using the rocks available on sites from his native England to Southeast Asia.[27] The land art of Goldsworthy and Bateman calls atten-tion to the glory of creation and the fragile state of our environment. It is a call to cherish what we've been given, to work within our abundant limitations.

Scientific innovation also arrives when budgets constraints are imposed. General Electric execs realized they needed to practice "reverse innovation" in emerging markets. Rather than making high-end health-care products in the West for countries like Brazil, China, and India, they shifted research and development toward rural areas where erratic power, space constraints, heat, and dust were daily realities. GE engineers aimed to create a low-cost electrocardiogram (ECG) that was durable, reliable, and easy for any physician to use.[28] It had to be portable enough to be brought to patients. The team of ten engineers based in Bangalore had to make thousands of changes to the software and electronics interface to unite the user experience around one large, visible button. They stud-ied lithium-ion cell phone batteries to ensure that 100 ECG scans could be performed after three hours of charging. The coordination of design, electrical, mechanical, and software engineering ultimately packed 230 components into the 6 x 5-inch Mac 400 printed circuit board. Priced at $1000, GE Healthcare's MAC 400 Electrocardiograph (ECG) enabled doctors to screen cardiac disease for 700 million people in rural India. By starting with affordability and portability, GE's Dynasty engineering team proved that less could accomplish much more.

Recycling

The ancient wisdom in Ecclesiastes declares, "What has been will be again, what has been done will be done again; there is nothing new under the sun."[29] This is both a comfort and a challenge. While there may be nothing new under the sun, there are always fresh ways to arrange songs and stories we've heard before. Languages, settings, and circumstances shift. Technology gives us access to more choices and conveniences than ever before. Screenwriters draw upon plots established by ancient Greek dramatists. In 1895, Georges Polti published *The Thirty-Six Situations*, which linked classic Greek drama to contemporary French plays. Those same thirty-six plots fuel what we watch on our streaming services today. The faces may change, but the conflicts remain largely the same: revolts, remorse, abductions, adultery, crimes of love and vengeance, recovery of a loved one, self-sacrifice for kin. Fathers battle sons, mothers fight with daughters. Jealousy and revenge accompany our journey from adolescence to adulthood.

After winning the 2021 Oscar for his jazzy, original soundtrack to Pixar's Soul, Jon Batiste connected classical composers like Johann Sebastian Bach to Duke Ellington and Nina Simone. What did they have in common? Batiste said, "God gave us the same twelve notes."[30] They may be spread across eighty-eight keys on the piano, but the building blocks of Western music are just twelve notes![31] How can so many songs, so many moods, so many memories arise from rearranging just twelve notes? When I was figuring out how to play the guitar, I was surprised and delighted by how many classic rock songs I could play with only three or four chords. The rhythms and patterns may have shifted slightly, but sounds fell within a remarkably limited range. Even rudimentary A.I. programs can approximate the sacred music of Bach or the beats of J. Dilla.

What's the future of creativity when Artificial Intelligence can generate a respectable approximation of those thirty-six plots or twelve notes of Bach? In a crowded marketplace, do we want to compete with robots? What will separate our songs, stories, or businesses from a savvy computer program? Amazon undercut thousands of bookstores by building a better algorithm and delivery system. The Netflix recommendation engine anticipated our tastes better than any video store clerk could approximate. Google and Facebook make billions via targeted ads tailored to our web searches and likes. We can see how many patents, how many books, how many shows have already been created. How can we stand out amid so much creativity? What will it take to distinguish ourselves? It can be depressing; so much noise to cut through. It is tough to innovate under that kind of weight. Diamonds may result from pressure-packed situations, but we're more fragile. Our egos may wither under an avalanche of options. How can a creative person compete with machine learning?

Artificial Intelligence culls from all existing forms of creative expression. It can render prose in the style of Jane Austen, images that borrow from the films of Wes Anderson or the photographs of Cindy Sherman, and music that riffs on Beyoncé. The potential for creative mash-ups is almost endless—if you know what kind of sources you're combining. Generative A.I. gives today's students a better reason to study art history and literature. While Picasso could readily borrow from African art and imagery for his ground-breaking *Les Demoiselles d'Avignon* without attribution, aspiring image makers would be wise to push further into Picasso's sources to spark a new take on beauty and culture. Deeper, more specific dives will yield more original, still derivative results. Those who skim across the surface will likely see superficial results. Yet students who know what kind of artistry has preceded us will forge brighter combinations for the future. African American artists like Kerry James Marshall, Kara Walker, and Kehinde Wiley have distinguished themselves

by reaching back for images from across art history. They question the Eurocentric worldview that has limited our museums' collections and our collective imagination. Their work demonstrates a mastery of classical forms along with a scathing critique of our prejudices. Knowing how our perceptions have been skewed allows a new generation to avoid the biases and blind spots that will be reinforced by generative A.I. Beware of making a copy of a copy of a copy. Deeper, more specific dives will yield more original, still derivative results.

For a new generation that hasn't established their brand on the Internet, A.I. offers an interesting conundrum. How to protect your property and artistic vision as it is being created? It is encouraging to know that people can't replicate your style and voice before it arrives. There is plenty of opportunity to distinguish ourselves. Yet the ease with which machines will generate songs, stories, and shows will be dizzying (and perhaps distressing). How can we admire earlier sources, drawing upon their wisdom, while still crafting a new path? Consider how Brazilian-born, Brooklyn-based photographer Vik Muniz reaches back across art history to forge his empathetic images.

A strong, shirtless Afro-Brazilian dons a sparkling gold chain. His left hand holds a large, white sack. His right hand opens toward the sky as he scatters a handful of possibilities. He could be a leader of nations, tossing roses or candy to adoring crowds. But the title of the picture, *The Sower (Zumbi)*, narrows our gaze. What kind of harvest will arise from the seeds this sower is spreading? A closer look at the majestic Zumbi reveals a surprise. His fields and seeds are made of garbage, more properly identified as recycled materials. Scraps of food packaging, cleaning products, and electronic devices surround Zumbi. The filters, socks, and cans are cast-offs from a disposable society. This moving portrait of our strength and dignity as people is made of garbage.

Zumbi is one of the thousands of *catadores*, "pickers," who wade through the largest landfill on earth, the Jardim Gramacho outside Rio de Janeiro, Brazil. The massive white statue of Christ the Redeemer can be seen from the Jardim, his back turned to this garbage dump. Christ's open arms extend to the source of the landfill, the wealthy side of Rio, including the beaches of Ipanema. Over 70 percent of Rio's trash, eight thousand tons, was dumped at the Jardim daily. Imagine the stench and noxious fumes arising on this former wetland. Glass shards can rip through a shoe. A mosquito bite can lead to dengue fever. So many toxins seep into the Guanabara Bay below. A natural wonder has been defiled and ruined. How could a mountain of garbage stacked six stories tall, across three hundred acres, have ever been labeled a "garden"?

Yet Zumbi and his colaborers found worth amid what the wealthy discarded. *Catadores* made more than the Brazilian minimum wage by wading through the trash in search of treasure. The five thousand plus workers eventually formed *favelas*, living beside the landfill. They became Brazil's national recycling system, building a community alongside the refuse. Children were born and raised at Jardin Gramacho, following their parents into a lifetime of waste-picking. A twenty-five-year-old Brazilian who started working at age eleven, reflected upon the tension, "It wasn't so difficult living with the garbage, rather it was difficult to not become garbage."[32]

Zumbi developed an eye for a particular form of treasure: books. He found enough discarded books in the refuse to turn himself into a philosopher-scholar and organized a lending library for the Jardim Gramacho Cooperative of Collectors. Zumbi is named for a renowned African-Brazilian resistance fighter who protected the mountain kingdom of Palmares against Portuguese invaders over three hundred years ago. Slaves escaping the colonists lived freely in these hilltop *quilombos*, organized according to African tribal principles. Zumbi reigned until he

was murdered in 1695. He has become a powerful symbol of the ongoing fight for justice among African peoples in the Americas. This contemporary Zumbi leads a different kind of resistance, finding beauty and books within refuse.

Who found Zumbi in this garden and composed this dignified portrait of *The Sower*? Vik Muniz is a Brazilian-born artist, based in Brooklyn, who is fascinated by the limits of our perceptions. In his Sandcastle and Earthworks series, Muniz plays with scale and perception, putting us in our place as dust in space, one of many lights. His photographs close "the gap between the scales of reality and representation" via unlikely stand-ins.[33] They reveal how easily we can be fooled and how limited our perception can be. We need humility and fresh eyes to see who and what surrounds us.

Muniz reimagines famous images from art history via unlikely materials like sugar, cotton, tomato sauce, and molasses. He references masterpieces by Rembrandt, Goya, and Da Vinci. The resulting photographs aren't tricks but more like riddles. Why are these everyday objects standing in for things we've come to think as masterful? Muniz admits, "I want to create the worst possible illusions so it doesn't really fool people, but give people a measure of their own belief. It makes them aware of how much they need to be fooled in order to understand the world around them."[34] He embraces limitations and relies upon everyday objects to drop the scales from our eyes. Can we reawaken our understanding of what is masterful and what matters? Muniz exalts the humble within his portraits and humbles the art collectors who have an elevated notion of their importance. Muniz's collapses the distance between high art and his seemingly lowly subjects. He explains his goal: "I don't want people simply to see a representation of something; I want them to know how it happens. I consider that moment of consciousness the embodiment of a

spiritual experience."[35] Muniz leans into his modest roots to elevate the meek and humble the haughty.

I discovered Vik Muniz via the compelling Oscar-nominated documentary *Waste Land* (2010). Muniz devoted two years to living among the Brazilian *catadores* for his next project. He was accompanied by a film crew, led by British director Lucy Walker. Muniz reflects on his goals: "I'm at this point in my career where I'm trying to step away from the realm of fine arts because I think it's a very exclusive, very restrictive place to be. What I want to be able to do is to change the lives of people with the same materials they deal with every day."[36] As Muniz and the film team document the *catadores'* daily lives, we come to respect them as warm, generous people practicing a craft and making a living. We watch Muniz turn his newfound friends in the Jardim into the iconic focus of his next series of photographs. Muniz placed the *catadores* in poses rooted in old artistic masterpieces. Their self-perception shifts when a photographer like Muniz portrays them as glorious and noble. The background detail on those images is filled in with the recycled material the waste-pickers found. He dignifies their work as well. Muniz follows *their* pattern, turning discarded things into objects of significance and worth. In titling the series Pictures of Garbage, Muniz makes a cutting commentary. Those who consider these people, their work, and their findings as worthless are wrong. While Zumbi and his colleagues toiled in the Jardim, Muniz and the film crew were revealing their God-given beauty and dignity.

As the *catadores* recycled the waste of Rio, Muniz was also recycling the history of Western art, offering new takes on seemingly dead subjects. We've seen many images of "The Sower" before. Vincent Van Gogh portrayed "The Sower" more than thirty times, most famously with a glorious sun beaming in the background. The landscape pulses with a blue and orange glow. The Sower's work is solitary and idyllic. Van Gogh's

portrayed his rural farmers as close to the ground and near to the heart of God. His 1888 portrait of *The Sower* places the sun directly behind the farmer's head, an obvious allusion to the halos that identify saints in traditional religious paintings. Why did Van Gogh see farmers as especially blessed? He spent plenty of time in pastoral settings, depicting the people and rhythms of rural Holland and France. As a former minister, Van Gogh was also quite familiar with the biblical parable of the sower.[37]

While Van Gogh focused upon the farmer distributing seeds, Jesus's story and interpretation spotlights the four distinct soils. Due to birds, dryness, and thorns, 75 percent of the seeds a farmer spreads will fail to take root. Yet the faithful sower continues to toss out prospects to all. It is an act of loving generosity that becomes a litmus test. The onus placed on the listener is to plant the seeds of God's word in fertile soil that yields a substantial harvest. Jesus identifies good soil with those who hold onto the word of God "in an honest and good heart."[38]

Van Gogh's sowers were copied from a more realistic French painter he admired, Jean Francois-Millet. As the son of a farmer, Millet rebelled against the more idealized painting of his era by committing himself to social realism. His depictions of daily laborers were viewed at the time as crude and inappropriate for large-scale canvasses. Yet Millet elevated the workers who toiled in the fields as an expression of his faith. He saw the inherent worth in those who were often overlooked or even derided as peasants. The connections between Millet's sowers and Muniz's pickers are quite palpable. They are variations on the same theme, an example of artistic individuality rather than originality. Millet didn't invent or patent sowers. Van Gogh and Muniz studied his work and came up with their individual response to what preceded them.

The romantic images created by Millet or the vibrant brushwork of Van Gogh are no longer considered radical or political. We may even view their work with a sense of nostalgia for a rural past. Vik Muniz reclaims

their radical roots by casting a garbage picker as his sower. Affluent city-dwellers may rhapsodize about their weekly farmers' markets, but the urban poor have none of their own land to farm. They do not begin with fertile fields but with toxic waste. Their harvest isn't consumable but recyclable. The seeds of our postindustrial society are mountains of trash from which urban pickers piece together a living. As consumers, we're not only cut off from the land that produces our food, but removed from the refuse we generate. Muniz puts *catadores* from the bottom of socio-economic ladder, at the center of his frame, finding beauty amid what the wealthy have deemed worthless. Muniz's photographs invite viewers to look closer. It causes us to question what we consume and who we discard. Vik Muniz found fertile soil for his portraits in an unlikely garden. In recycling art history, Muniz invites us to reconsider the seeds we're sowing and the harvest we're reaping. A.I. can remix art history, but can it make us consider our complicity in the mess we've made of God's Garden? Vik Muniz uses the most common, everyday, and even discarded objects to quicken our hearts and reawaken our senses. What is beautiful? Who is valuable? And am I fertile soil for receiving the seeds of faith, hope, and love we've been given?

HONEST CHALLENGE

1. How can we describe our creative calling in a concise way? Compose a six-word story that summarizes your credo. If you're uncertain how to compact your mission and values into a few words, compose your core thoughts and principles and see how Bard might turn it into a six-word short story. Now, think about how to illustrate or depict it. Would you use calligraphy, photography, or even an A.I. engine to generate a logo or look for your six-word story?

2. What can bloom from the seeds you've been given? Consider materials you already have. A paintbrush. A smart phone. Some leftover supplies. What can be made of what surrounds you? It could mean pasting together a collage from old magazines. Cook a tasty meal to share with others from what's already in your pantry or refrigerator. Create a temporary art installation out of a pile of leaves, a mass of pebbles, or garbage scattered around your neighborhood. Invite others into the process and see what blooms.

II

PROCESS

© Leah Cesario

4

HONEST PREPARATION

"Attention is the rarest and purest form
of generosity."

—SIMONE WEIL[1]

WHAT DOES MASTERY LOOK LIKE? WHICH MASTERS should we study and learn from? Who enabled those who had time to write and paint and create? Read Lucille Clifton's compact poem "study the masters." She juxtaposes her Aunt Timmie's handiwork, her artful ironing of sheets and bedmaking, with the "master poet" who rested and dreamed upon her labor. Didn't she also have vivid dreams and profound words to share? Perhaps they were in different languages, from Cherokee to Masai. They may not have been written down, but they were still uttered in songs of hope. They had plenty of meter and shape, discipline and order that we would call art. Yet the historic circumstances were such that American history may include the master poet and forget or ignore Aunt Timmie. Mastery takes on many forms and encompasses many cultures, both written and oral traditions. It is available for those with ears to hear and eyes to see.

Why study history? Because we need to know who and what preceded us in all its messy complexity. *Sankofa* is a Twi word from the Akan Tribe of Ghana that roughly translates as "Go back and get it." For Africans, the Sankofa bird looked back toward what may have been forgotten, noting what needs to be brought forward for the journey. The bird carries an egg in its mouth, a symbol of wealth and wisdom. We all mine the past for riches, finding surprising veins of gold and silver. We can plunder and exploit those resources, claiming them as our own. Or we can honor them by admiring their beauty, shining a light on our sources, connecting the next generation to the forerunners who forged a path for us.

I learned how to write by reading, then writing (and rewriting). I learned how to paint by studying art before I picked up a brush. I learned how to make movies by analyzing them for years prior to picking up a camera. Honest preparation begins by sitting with the best and brightest. Paying attention to those who paved the way. We humbly drew upon the many cultures that passed on rich traditions of storytelling, whether audio or visual, recorded or merely remembered. We devote ourselves to respecting and mastering a craft.

Studying a discipline like dance, cooking, or business gives us a context. It locates us within our specific time and place when we can see how others responded to their surroundings. In an often rootless culture, it is important to feel a sense of continuity, to see ourselves within a tradition that has foundations, that is built upon something rather than nothing. When we feel lost or discouraged, it is helpful to know we're not alone. Others have experimented with our medium, pressed through tough times, and found a way forward. We are not the first and we will not be the last. Rather, we are part of a divine handoff—as God gives us the gift of colors, materials, and each other, so we are now blessed to hand our craft down to those who will pass it on to their children's children.

If art keeps us from feeling alone, then studying past masters allows us to sense we have mentors. People we've never met can still be traveling companions. When we feel lost or isolated, the creative trail forged by others can provide the daily bread we need during a journey across a desert. Songs, images, and shows may get us through divorces, diagnoses, and defeats. Analyzing why particular projects resonated with us may also reveal what made the specifics of their story feel so personal and powerful. Why does their self-expression speak so strongly to my heart? What begins with inchoate emotion, feelings we may not quite be able to name, can evolve into instruction. As scientist Louis Pasteur said, "In the fields of observation, chance favors only the mind which is prepared."[2]

Precursors

Adolescence is riddled with angst. We have so much confusion regarding our bodies and ourselves that we turn to others to express our complex emotions. I resonated with the sometimes-ragged sounds of Bruce Springsteen. The howls on his acoustic album *Nebraska* both scared and attracted me. Springsteen's home tape spoke into my own ambivalence better than his more polished records that followed. Authenticity cut through all kinds of polish that may have dominated the radio. His primitive music gave me a "Reason to Believe" in that emotional season of life. In tracing the inspiration behind Springsteen's unplugged album, I traveled back to Neil Young, Bob Dylan, and Woody Guthrie. I discovered Leadbelly and Robert Johnson and Elizabeth Cotton, distant African American voices whose spare recordings still crackle with life. Their primitive sounds and warbly vocals drew me in. The money they didn't spend refining their music made it even more powerful. Low-fi resulted in high

impact. Eventually, I realized that with a few primitive guitar chords, I could also become a songwriter. Would I devote the hours necessary to becoming a great musician? Probably not. But studying the chord structures of my favorite singers suggested to me that with enough time and effort, I could create original music too.

I encounter students who've been so inspired by filmmakers like Martin Scorsese or Spike Lee or Greta Gerwig that it leaves them stymied. They admire the faces on an artistic Mount Rushmore but can't imagine climbing to those heights. It seems so daunting that students buckle under the pressure sparked by a masterwork like *Taxi Driver* or *Do the Right Thing* or *Lady Bird*. Yet plenty of pressure could be relieved if they studied history with even more rigor. To emulate the result, follow the path. Go back and look at the early, student work of these masters.

Consider Scorsese's simple short film from his NYU student days, *The Big Shave* (1967). It was one actor, one location, with one big idea behind it. How might a simple nick on your face lead to massive, fatal bleeding? This violent six-minute movie was taken as a razor-sharp commentary on the Vietnam war. How did Americans dip our toe into an overseas conflict that left thousands of soldiers bleeding out on both sides? Something that appears clean and clinical can escalate into deadly carnage. Yet aren't the cumulative effects of a bad choice the theme of almost every Scorsese film that followed? The lure of becoming a hero in your own mind in *Taxi Driver*. The gangster lifestyle that looks so appealing in *Goodfellas*. The temptation to shave a little illegal easy money off the top for a short-term profit that bedevils Jordan Belfort in *The Wolf of Wall Street*. Over and over, we see men compromise, falling further and further into a foggy moral cesspool with disastrous results. What begins as a little slipup results in blood all over our hands. Far too often, my students think they need to make *Goodfellas* by age twenty-two, when *A Big Shave* will do.

Spike Lee's student thesis *Joe's Bed-Stuy Barber Shop: We Cut Heads* (1983) is also about a moral quandary. Taking a page from his NYU predecessor's work, Spike begins his master's thesis with a cold-blooded murder. Joe's Barber Shop doubles as a site for the numbers racket. You can get a haircut and/or place bets. In the opening sequence, Joe pays for his double-dealing with his life. Now, his surviving partner, Zach, is faced with a choice—to go legit, "We cut heads," or face the consequences of dealing under the table, "our heads get cut off." Like Sal's Pizzeria in Spike's masterful *Do the Right Thing*, an entire neighborhood of colorful characters enters and exit the shop. The many requests that don't involve haircuts or pizza illustrate how a business serves as a community center. The proprietors do not want to become priests, prophets, or psychologists while trying to turn a profit. Yet the neuroses of the neighborhood are unavoidable. The acting in Joe's is somewhat amateurish. The pacing is plodding across the sixty minutes, but it offers a vivid snapshot of a specific place and time. Survival is a daily struggle in New York City. Spike Lee won a Student Academy Award for *Joe's*. He didn't win his second, "grown up" Oscar for writing *BlacKkKlansmann* (2018) until he was sixty-three years old.

Native Californian Greta Gerwig aspired to be a playwright. She experimented with ballet, with musical theatre, long before she found her voice as a filmmaker. She majored in English at Barnard College in New York but was rejected by several MFA programs in playwriting. Instead, she cut her artistic teeth as an actor in a bunch of boys' movies. She served in the ensemble for directors like Joe Swanberg and Jay and Mark Duplass. As a cowriter and codirector on Swanberg's no budget movies, Greta became associated with the mumblecore movement. These talky films about twenty somethings were distinguished by their lack of style. They didn't need special effects to entertain. Witty repartee and relational tension could suffice. Yet many film critics hated her codirectorial

debut, *Nights and Weekends* (2008). It chronicles the struggles of maintaining a long-distance relationship between New York and Chicago. Only eighty minutes long, the film was shot with a one-year gap, mirroring the separation of the characters. Still, a critic from the *New York Times* loathed Gerwig and Swanberg's onscreen personas, complaining of their "shallow, infantile neurosis with next to no hint of a complex—or even legible—inner life."[3] It was derided as an especially obnoxious example of mumblecore's "whimsical tics and insouciant solipsism."[4] *Nights and Weekends* earned only $5,430 at the box office.[5] Many young actors and filmmakers would have quit after such a drubbing. Her expected breakthrough role in *Greenberg*, directed by Noah Baumbach, also failed to find an audience. Greta recalls, "I was really depressed. I cried a lot. It was a hard year. I was 25 and thinking, 'This is supposed to be the best time and I am miserable.'"[6]

Yet Gerwig kept writing, collaborating on a new screenplay with Baumbach (who also became her romantic partner). *Frances Ha* (2012) navigates the challenges of life of a young woman's life in New York City with considerable aplomb. Their free-spirited follow-up, *Mistress America* (2015), made it apparent that Greta's characters exhibited a consistent voice. They had similar issues and obsessions, a carefree spirit that floated above the circumstances. She earned enough favorable reviews to finance a story set in her hometown of Sacramento, California. *Lady Bird* (2017) follows a student's journey from a private Catholic high school to college in New York City. The warmth it conveys toward adolescents' separation from parents struggling to let go is so refreshing. A nun helping Lady Bird construct a college essay points out her love for Sacramento despite the current conflicts with her mother. Lady Bird shrugs it off, "I guess I pay attention." The nun turns the teachable moment into a question, "Don't you think maybe they are the same thing—love and attention?"[7] Alone and confused in New York, she finds solace within a church and

reconciles with her mother by embracing her given name, Christine, and conveying love and gratitude. *Lady Bird* was nominated for Best Picture, Best Director, and Best Original Screenplay, making Greta only the fifth women ever nominated as Best Director (and at only age thirty-four). She was nominated again for Best Adapted Screenplay for *Little Women* (2019). What a rapid rise and yet, consider how many projects she'd completed as actor, writer, and director before her Oscar nominations arrived. By the time *Barbie*'s massive budget landed in Greta's hands, she'd had ample opportunities to learn from mistakes and polish her craft—by paying attention. The empathy Greta brings to Barbie's (and Ken's) longing for humanity has always been there, coming to fruition in a billion dollars of box-office on behalf of Mattel's plastic dolls.

Devotion vs. Dilettantism

So many students want to do character animation for Disney and Pixar. Yet scribbling out a few sketches and crafting some characters with tails will not be enough. It takes sustained practice within the parameters of the craft. As an undergrad, my student Kai Akira invested thousands of hours into storyboarding. They majored in fine art because we didn't even offer a single class in animation. Kai's senior showcase demonstrated how much dedication preceded their professional preparation. Within seven years of graduation, Kai was directing their eye-popping animated series *My Dad the Bounty Hunter* for Netflix After School. Kai is now head of story for Warner Brothers Animation before celebrating a thirty-fifth birthday. Tales of overnight success are mostly myths because for almost all enduring artists, practice is what made them nearly perfect. Honest preparation is the wellspring of honest creativity. Study, practice, and perseverance distinguish the devoted from the dilletante.

When we see a multi-hyphenate creator, we may be intimidated. The protean talent of Lin-Manuel Miranda revived Broadway with the rap musical *Hamilton*. Yet Manuel had been polishing his songcraft since college. He wrote the first draft of his homegrown musical *In the Heights* as a sophomore at Wesleyan. After graduating in 2002, Miranda started revising it with director Thomas Kail. A premiere in Connecticut led to an off-Broadway production in 2007. *In the Heights* opened on Broadway in 2008, a decade after its genesis. What remarkable, sustained attention to craft. Those Tony Awards for Best Musical and Best Musical Score were earned through perseverance and hard work. How did Manuel juggle the demands of writing and directing and performing? It doesn't seem fair that so many talents reside in a single person. Yet perhaps such juggling of roles prepared him for success.

How many hobbies have you had? What arts or crafts have you experimented with? Are you more interested in new experiences than mastering a particular arena? I've always been a dilettante. That's a fancy French word meaning dabbler. Someone easily distracted. Or at least too curious about many things to settle for any one thing. When I was little, I loved cars. All my early artwork focused on the dragsters and stock cars I saw with my father. My Hot Wheels car collection provided hours of enjoyment, racing those outrageous designs across the bright orange track. *Vroom vroom.*

I sang along to enough songs on the radio that my mother thought the piano might interest me. How gracious were my parents to buy an upright piano at a yard sale. My elderly teacher, Mrs. Jordan, ran my fingers through the scales. I didn't like to practice. The choppy rendition of "Good King Wenceslas" I played at the recital for all her students proved it. I still love music, but I never devoted myself to the medium.

When I discovered Lincoln Logs and Lego blocks as a boy, building became my focus. I constructed so many houses and towns. The

versatility of the blocks offered endless potential. My parents suggested I might want to be an architect. Yet the architectural drawing class I took in tenth grade didn't feel inspired or inspiring. The profession felt technical rather than creative. Were these creative activities a waste of time? Yes, in the best sense of the concept.

They were lovely, nearly unstructured, experiments without an agenda. They were a form of playing around. Manipulating an object, messing around with sounds, ordering my private world. They weren't auditions. There weren't prizes. These hobbies never got me anywhere. But they loaded my brain and body with potential. Trying on many roles may be the preparation you need to sharpen your focus (or accept that a variety of interests may be a blessing rather than a curse).

Some of the finest car designers in the world are trained at ArtCenter College of Design in Pasadena. Their grads bring the fantasy of Hot Wheels into aerodynamically advanced realities. I've met designers who work for sleek auto start-ups like Lucid. What a remarkably cool and lucrative job. But I stopped drawing cars when I was eight years old. I put in less than a thousand hours into that craft.

When my son was three, he would hum tunes days after hearing a song for the first and only time. We encouraged his natural ear for music with instruments, from toy drums to an electric keyboard. He advanced from the pianica at ten to the clarinet at twelve to the soprano sax at fourteen to the tenor sax at sixteen. Teachers invested hours in his instruction. Theo taught himself how to play drums, to pluck the electric bass, to pick a guitar. He played in bands, orchestras, a jazz combo, and rock groups. He's far more than a dilettante, but he never practiced for ten thousand hours on any one instrument. Theo doesn't expect to have a career as a professional musician. He's not that devoted, but I expect he'll always play *something*. Because it brings him joy rather than money.

Theo plays sitar, photo by the author, 2023

My daughter dabbled in so many mediums. She loves writing, reading, painting, drawing, weaving, and photography. Art teachers encouraged her to experiment with watercolors, acrylics, and oils. Zoe made a cool sculpture of a hammer at age nine. Her sense of perspective was pretty sophisticated by age twelve. She served as editor of her school newspaper and graduated from the most acclaimed journalism school in America. No artform captured Zoe's heart and mind until she discovered landscape architecture. Sensitized by the wildfires that regularly threaten California's built environment, Zoe sought to be part of a long-term, sustainable solution. The sophistication of the software intimidated her. Yet the variety of skills necessary to craft a compelling design drew her in. Onsite, plein air sketching was important. Photography was helpful. The building of 3D models was essential. Her love of nature, curiosity about plants,

and attention to rocks and soils all came in handy. Aesthetics, engineering, soil sciences, and botany all form the groundwork of landscape architecture. It nurtures both the built and the natural environment for the public good. By the time she finishes three years of her master's program, Zoe probably won't want to think about how many hours the professional certifications required. Yet dilettantism was a precursor to devotion.

Practice, Sacrifice, and Mental Health

We hope our children will be happy in whatever careers they develop. Working to pay the bills is a noble endeavor. So many do not have the luxury of choice. Financial hardships may require sacrifices that do not involve dreams and aspirations. Yet we still experience this gnawing hunger for significance. It feels good to be good at something. We like being noticed, whether serving as waiters, cooks, or dishwashers. Those who stand out in their dedication and excellence may be promoted to chef or maitre d'. It is inspiring to watch the cooks crammed together in the television series *The Bear* slowly raise their culinary aspirations. They refine their skills by studying with masters, learning how to serve diners rather than their own interests. What does it take to move from good to great? Devotion and drive are distinguishing words. To practice, we need knowledge of precedents—scales, masterpieces, recipes, reference points.

In his book *Outliers*, Malcolm Gladwell famously tied extraordinary success in most creative fields to ten thousand hours of practice. Gladwell built upon the research of psychologist Anders Ericsson who studied how expertise develops in a variety of domains.[8] Whether in business, arts, or athletics, those who rise above the competition have tended to invest at least ten thousand hours mastering their chosen field. Talent can get us started, but it is focused, deliberate practice which separates the great from

the good. Deliberate practice improves the skills we already have (via muscle memory) and extends the reach and range of our skills (via thought and concentration). Examples cited by Gladwell include the Beatles' years of club gigs in Hamburg, Germany, prior to their breakthrough with "I Want to Hold Your Hand." Bill Gates started computer programming as a high school student in Washington well before he launched Microsoft. There are countless examples of the undersized athlete like gymnast Simone Biles who earned their spot on an Olympic roster through years of practice.

I'm intrigued by how a pioneering female rapper like Roxanne Shante perfected her craft. She was inspired by rhyming comedian Nipsey Russell who answered questions on a TV show like *Hollywood Squares* using comedic couplets. As a girl, Roxanne would try to rhyme her way through an entire day, from getting out of bed, while brushing her teeth, or even doing dishes. The acoustics in the hallway of her family's apartment in Queens, New York, had just the right echo. Roxanne recalls, "The beat sounds really good when you bang on the wall in the projects, or on a stair railing, even in the elevator. We would just rhyme, which is what I nicknamed the Nipsey Russell syndrome, because sometimes you can't cut it off."[9] By the time she was fifteen, Roxanne's raps were such a steady source of income for her household, she wasn't allowed to enter M.C. contests anymore. Shante was too locally renowned: "Is this the little girl with the braces? No, she can't enter." Her breakthrough record "Roxanne's Revenge" occurred shortly thereafter. She recorded it for her neighbor, hip-hop producer Marley Marl, while doing laundry. "I just did a freestyle, using my Nipsey Russell syndrome. I finished it, and I went back downstairs and did laundry. I never wanted to make records or pursue a hip-hop career."[10] Accidental mastery may arise while we play with language, instruments, or blocks.

The rise of A.I. suggests that hours of songwriting practice or honing computer programming skills can be replicated by a computer almost instantaneously. Creativity is now associated with computer prompts

rather than years of practice. Only if we wish to manipulate the material world via musical instruments and paintbrushes and glassblowing may we need actual practice. Woodworking, weaving, and throwing pottery will still require a comfort with materials that arises from hours of investment. Theatre and dance may also be poised for a comeback if we seek to experience awe via onstage moments. When TV and film resort to all sorts of digital trickery, the leaps we witness onstage or on a basketball court may feel even more impressive and rare. The craft of comedic improv may also rise in popularity when computers fail to offer the surprise and delight that a subtle joke can generate. Those who can alter our physical world through their own accomplished physicality (like plumbers or electricians) may prove more valued than ever.

For digital artists, the rise of A.I. may suggest that practicing a craft is no longer necessary. A filmmaker can describe a scene and see the results, a photographer or designer can manipulate an image, a video game maker can approximate a scene. So what kind of practice would they need? A sense of history, an understanding of craft, the fundamentals of light, sound, and storytelling will still prevail. What attracts our eye? What has moved the human heart across time? What makes audiences laugh and cry? A primer on film history may be more important than ever to know who to study and borrow from.

At a time when endless creative options are at our fingertips, we will need an even greater sense of connection to those who've gone before and what's been written on the margins, out of the mainstream, that moved a medium forward. How did the previous innovators develop their craft and deepen their character? How did they feed their inner fire? What kind of provisions will you need to stoke a deep well of creativity? We need to know what prompts we are building upon. What artists and images and ideas inspire you? What mash-ups do you want to see? Only if we

know what preceded us can we prompt the machines to make original and arresting combinations for us to expand upon.

For those interested in manufacturing, basic business sense, buying and selling, economies of scale will still apply. 3D printers may accelerate the production process, but the challenges of printing and distribution physical products will still face hurdles that require careful planning. The creativity of those who know how to coordinate supply lines and delivery schedules (especially for artisanal food or time sensitive products) may depend upon experience as well as A.I. enhanced decision-making. When a musician like Grimes makes her voice available for A.I. knockoffs via open source, she is actively encouraging a new kind of distribution strategy.[11] She is expanding her audience and reach by being open to this new technology. In splitting any subsequent profits, she is also expanding her revenue without any additional labor. Grimes is essentially franchising her voice, actively encouraging the next generation to sharpen their craft on her behalf.

How many hours will you devote to polishing your skills? How many opportunities for entertainment and distraction will you turn away from to practice something you love? Sacrifice and dedication will remain key distinguishers in the age of A.I. As many tasks become easier, those who can focus their attention on a particular medium will stand out. Someone will commit even more time, maybe by refining their understanding of A.I., to write a better song or polish more scripts or prototype more designs. They will be distinguished by their attention to detail, their wisdom and experience, rooted in sheer practice. Natural talent and aptitude are always helpful. Some will make it look easy. But the apparent effortlessness often masks the hours of devotion that put performers onstage, accepting the award or execs in the board room, making the pitch.

If you knew that a long, arduous journey was ahead of you, how would you prepare? How many hours would you spend getting your mind and body in shape? How much study and planning would you do before

scaling Mt. Everest? What kind of companions would you assemble for a trip to Mordor? The route to creativity is riddled with peaks and valleys, deserts and flood waters, monsters and mementos. It is tough to know how much you'll need to pack. The conditions change. You'll undergo shifts in space and time that alter your ability to create. You'll have busy seasons of abundance and fallow periods when you're struggling to pay the bills. You can't anticipate how your perceptions will shift. Youthful energy and enthusiasm may succumb to cynicism and despair. Things that come easily early may be tougher to summon later. Or enough practice may make early struggles look silly or simple. You may become more fluent, seasoned, and astute—working smarter, maybe even faster.

Of course, there are plenty of creators who overdo it. We've discussed how blind ambition can lead us astray. Those who engage in unhealthy habits may not have the strength for the long haul. Video gamers have been known to forgo food in their efforts to finish a game. So many dancers' aspirations are cut short when their bodies give out. The most accomplished athletes may burn out early, seeking to reclaim their lost childhoods. What if we achieve our goals and still don't feel satisfied? How do we sort out what we've trained to pursue from what gives us satisfaction?

Grand Slam Tennis champion Naomi Osaka and Olympic gymnast Simone Biles achieved award-winning status before they questioned the sacrifices required to remain on top. They practiced and performed for years under immense pressure to succeed. Biles was among the hundreds of gymnasts sexually abused by a doctor assigned by USA Gymnastics to protect her. Naomi endured the jeers of tennis fans who rooted against her at the U.S. Open when she defeated Serena Williams. At the 2021 French Open, she asked to be excused from press conferences that treated her more like an object than a person. After being fined, Naomi chose to drop out, placing her mental health above another championship pursuit. Her message: "It's okay not to be okay."[12] After a case of "the twisties" knocked

Biles out of the Tokyo Olympics, Simone stepped away from competition and the expectations accompanying it. Even as the greatest gymnast of all time, Biles said, "We also have to focus on ourselves because at the end of the day, we're human, too. We have to protect our mind and our body, rather than just go out there and do what the world wanted us to do."[13]

These champions baffled fans by choosing mental health over more medals and silver cups. The everyday pleasure of life proved more attractive than more accolades within their chosen mediums. Biles married professional football player Jonathan Owens. The birth of Naomi's first child also suggests that she does not have regrets about foregoing additional fame and fortune. Via social media, Osaka wrote, "I realize that life is so short and I don't take any moments for granted, every day is a new blessing and adventure. I know that I have so much to look forward to in the future, one thing I'm looking forward to is for my kid to watch one of my matches and tell someone, 'That's my mom.'"[14] At the 2023 World Artistic Gymnastic Championships, Biles returned to lead her USA teammates to victory while also winning gold medals in balance beam, floor exercise, and women's all-around. What an affirmation that self-care and winning can go together.

Places

Honest preparation involves study and practice. It requires our sustained attention to those who preceded us and learning from their mistakes. We must figure out how to pace ourselves, to invest the time to master our crafts without burning out or injuring ourselves. Jesus encouraged his followers to establish a firm foundation, like building a house upon a rock rather than sand.[15] Rain, wind, and floods will inevitably arise and threaten to wash us away. For creatives, there will be seasons of abundance and drought, too much work and too little opportunity. We may

get swamped by failure or overwhelmed by success. How do we develop that solid foundation, rooted in bedrock, that will enable us to weather the storms of life?

Here are three things I've found that sharpen my creativity:

Dedicated Place

Where do you create? Do you have a place, no matter how small, that is set aside for you to make things? A writer needs a desk and a comfortable, supportive chair. Check the height and distance between the desk and chair. Develop a space and place for ideas to flow. Franz Kafka embraced his confines, "You do not need to leave your room. Remain sitting at your table and listen. Do not even listen, simply wait, be quiet still and solitary. The world will freely offer itself to you to be unmasked, it has no choice, it will roll in ecstasy at your feet."[16] Designate a space to create.

Teen musicians have gathered in basements and garages—bothering the neighbors as much as their parents. Painters depend upon good light. Dancers need mirrors to assess their form. Inventors may need a table to tinker on. A white board and sticky notes may suffice for a creative team. Creators may also need room to move; a neighborhood where they can get their ideas flowing. Cramped spaces can limit our thinking. Too many objects or files may cause our thoughts to wander. A standing desk may be better for our backs. I know a video editor who lost work because his shoulder got out of whack from engaging in the same scrolling and clicking motion on a computer mouse. Finding a comfortable place sets us up for sustained periods of creativity. Can you set aside a place to create on a regular basis?

We must balance the discipline offered by a dedicated space with the importance of varied inputs. You may be surprised by how many writers prefer to work in coffee shops and bars, to draw upon the characters and dialogue surrounding them. There is a certain kind of creative energy that

arises from a crowded room, of people on the move. Great ideas also arise when we're away from our routine spaces. I find walking or biking a welcome change of pace and place. Even if I traverse the same path, the slight changes that arise with the seasons sharpen my senses. Variations in shadows, in sunlight, in trees and leaves, all make an impression when I'm paying attention. Temperature changes place my body and my ideas on a different timeline. They're all a physical reminder of the 525,600 hours per year that Jonathan Larsen turned into a "Season of Love" in *Rent*. The arrival and departure of migratory birds also jogs my thinking. They cause me to reflect on what I was thinking and feeling the last time I saw them. What has happened to their flock in the interim? What's shifted in my family and friends?

Returning regularly to the same places, whether inside a domicile or around our neighborhood, trains our brain to pay attention. A place to create encourages us to find a time to create.

Structures

Creatives also need structure. To press through dry spells. To work whether we feel like it or not. To simply show up, start playing, and see what arises. The act of picking up a brush, typing on a keyboard, moving your body before the choreography kicks in opens us up to possibilities. We show up, expectantly, doing our part of the work, waiting for the muse to arrive. Setting aside a particular time for rehearsal, for drawing, for writing out our daily thoughts makes such a long-term difference.

Dividing up a big project into incremental tasks can also lessen the intimidation of a completed project. Yet not enough creatives are good at production management. We may need others to set deadlines for us. That's what clients and book editors and studio execs are for. They provide the external pressure that artists often need to press through our self-sabotaging tendencies. That's also why many of us may perform better

with a creative collaborator. We're more inclined to show up on time, ready to work, when there's a team expecting us. We don't want to be the one who is hungover, half asleep, or unprepared. Peer pressure can be a great source of structure for entrepreneurs, entertainers, and execs. I've written so many screenplays with different collaborators. Their presence keeps me focused for longer periods of time. We may go further when someone shares the creative journey with us. Structure starts by showing up.

Routines

Honest preparation means setting appointments for ourselves, to carve out regular creative time in our daily routine. So many artists have been inspired by Julia Cameron's notion of "Morning pages."[17] It is three pages of longhand, stream of consciousness writing, done first thing in the morning. This is a daily discipline that unlocks our subconscious, makes space for the things that trouble us to bubble up. The goal isn't to present these random thoughts to anyone. Julia considers them comparable to a dust buster, cleaning up the grumpiness and dark corners of our psyche that may block our creative recovery. Morning pages are a clearing exercise. Recording our concerns, putting them on paper, makes more room for generative ideas to emerge.

When is your most creative time? Can you set aside a few hours of each day to nurture your craft? One of fellow screenwriters dedicated his mornings to writing before he started work. Martin would rise at 6 a.m. to squeeze in a couple of hours of typing before his paying job commenced. Six months later, he had completed a hundred-page comedic screenplay about parents who turned to a life of crime to pay for their daughter's college education. He made enough from the sale to quit his day job and become a full-time screenwriter. We may also benefit from proximity to our pursuit. While working as a security guard at Sony

Studios, Antwone Fisher was also pitching his eponymous screenplay to whomever he encountered. Derek Luke, the young man who debuted in the title role as *Antwone Fisher*, was working as a clerk in the Sony store when he slipped in for an audition.[18] Working near the people `you hope to become allows us to prepare for opportunities when they arrive.

If you have a child in school or a baby who takes a nap, then you know how rare and valuable creative time can be. You may drop them off at school and head straight to the studio. Writer Wendell Berry developed a routine on his rural Kentucky farm. After church, Sundays were set aside to compose "Sabbath poems." It was an extended act of worship, associating creativity with the sacred. Sundays off turned Wendell Berry's creativity on.

When the Hebrews' God insisted that his people observe the Sabbath, He also chose two craftspeople to set a sacred space apart. God filled Bezalel with his creative breath, the Spirit, as well as wisdom, understanding, knowledge, and all kinds of skill.[19] Wisdom is rooted in seeing the big picture. We study others' artistry to develop our understanding and knowledge. Skills arise when we apply our know-how to a specific arena.[20] This is the kind of mastery that comes from practice. Bezalel's skills were applied to metalwork, masonry, and woodwork. His creative assistant was Oholiab and together, they led a creative team that made tables, lamps, basins, and garments set apart for holy purposes. We craft as a form of worship, a dedication of time and labor to honor the Creator.

Have you set aside a day for worship and rest? Perhaps that could involve practicing your craft, doing something that pleases God and delights you as well. Can you envision a dedicated season? For documentary films, I've edited footage shot in the summertime during the subsequent school year. What if you renewed your interest in acting by committing to a fall production? As an author who is a parent, you may have to schedule time away from the kids. Seek out a friend with extra space. Maybe a guest room

above a garage. Lock yourself inside until you finish the song or chapter. Gift yourself the luxury of a day off or a writer's retreat.

Removing Distractions

We may show up at the same time and place, prepared to dive into our projects, but still get easily distracted. So much of our lives revolve around our electronic devices. If we're composing music or writing a screenplay on the same computer that gives us texts, notifications, and emails, then we're fragmenting our attention. Producer Emma Thomas revealed how her husband, Christopher Nolan, wrote the dense screenplay for *Oppenheimer*, "He doesn't use the internet on the computer he writes scripts on, so there's no danger of him getting distracted and going down rabbit holes."[21] The power of concentration, to get lost in thought, or caught up in reverie, is key to creative breakthroughs. Our brains may never achieve the kind of flow needed to free associate if we're constantly pinged by friends or family. Shut the door. Turn off the notifications. Unplug the Internet if necessary to disrupt the interruptions.

When I challenge students to turn off their cell phones for a day, they freak out. "How will I do my homework?" "My mom will panic if she texts, and I don't respond." Obviously, it takes some planning to attempt a total digital detox. Some get immediately bored. They miss the sense of connection, the constant stream of news and information. Others are struck by the silence. It feels weird to drive without directions or a soundtrack to accompany our mood. Runners can't believe how they get more in touch with their bodies. Most finish reading assignments that usually take hours in mere minutes. They are shocked by how much they can accomplish in a short time. In fact, the challenge becomes filling the time. Many take much needed naps. Days that once felt too pressurized suddenly pass

slowly. They seem to have more time for a walk or to experiment with a book or canvas or idea that they didn't realize they had. Reprioritizing becomes possible. A day without electronics can be clarifying.

We have more time than we thought. We have more thoughts than we thought. We are more dependent upon our devices to entertain us than we realized. Who do we want to be? What do we want to prioritize? Set aside a place, develop a structure, build creativity into your routine. Honest Preparation, whether in the form of study or practice, is the precursor to creating.

HONEST CHALLENGE

1. Do you struggle to find time to create? Turn off your electronics for one day. It may not seem possible given jobs, family, commitments. Do some planning. Make the time a gift to yourself. Ask a spouse or parent to cover for you. No need to take a pad and pencil, an easel, or a whiteboard with you. A day long hike may be enough. To soak in a bath. To catch up on rest.

2. Prepare for unexpected ideas. A reframing of priorities. A solution to a problem you didn't realize you had. Or maybe the gift of nothing special. Sense that you're not alone. You're seen and heard and loved just the way you are. That's enough to hold onto. Once a year. Or once a month. Or whenever you can carve out the digital detox we all need.

3. What kind of creative nurture can we carve into our regular routine? Can we set aside thirty minutes each day to read a book, write a poem, sketch a design? It doesn't have to have an intended purpose or audience. The regularity of our practice starts to shape who we're becoming. Reward yourself every time you complete three sessions for your creative soul with some form of delight. A candy bar, a movie, a bike ride. Breath and receive the joy of preparing for more.

5

HONEST RECEPTION

"I need to be silent for a while, worlds are forming in my heart."

—MEISTER ECKHART[1]

WE WOKE UP EARLY. WE HAD TO GET IN LINE. TICKET demand was high. Without reservations, visitors were let in on a first come, first served basis. We hustled through Hyde Park. The Serpentine Gallery appeared to be in the center, but it was a surprisingly small dot on our digital maps. The queue didn't seem too daunting at 8:30 a.m. Ninety minutes until the doors opened and the artist was present.

Marina Abramović had committed to 512 Hours of presence in the summer of 2014.[2] We were teaching film history to a group of under-graduates from Pepperdine University at their London campus. None were interested in an early trek to the Serpentine Gallery. Or if interested, they were unwilling to sacrifice sleep for the vague promise of an artis-tic happening with a Serbian conceptualist. Perhaps the specter of sitting across from the artist, locked in a silent gaze, was a bit daunting. Yet our

children, ages fourteen and twelve, were up for the adventure. My son barely passed the minimum age limit.

One hundred and sixty of us had our hands stamped when the doors opened promptly at 10 a.m. We had to lock our bags and devices away. We were to be unencumbered by the things we brought with us. The experience could not be recorded or summarized by a selfie. There were three gallery spaces inside sans decoration. We were all exceedingly quiet, as if entering a chapel for prayer. Abramović had maybe ten assistants, all dressed in black, ushering us into the spaces set before us. They took my daughter by the hand, separating her from us. My son wandered into his own corner of a different room. I decided to watch and wait. Eventually, the artist appeared, also dressed in black, which further highlighted her pale skin. It could make her an angel or a ghost, something approaching pure spirit.

We were being invited into an experiment in mindfulness. Facing walls. Turning from our companions. Going inside. I suppose someone could have shouted or danced or rebelled in some way. But the peer pressure to sit or stand still was substantial. Why disturb the peace settling over us in the middle of London?

The artist moved among us, saying nothing out loud. She paused, every now and then, to whisper in someone's ear. How were they singled out? What caused them to be chosen for a close encounter with the artist? Perhaps she was looking for compliance. Maybe her words were only reserved for the suggestible. Abramović led my wife, Caroline, by the hand to another corner of the gallery. I was alone.

I could worry about where my family members were and how they were doing. Or I could elect to be present to my own situation. My breath. My pulse. The sound of silence. As I settled in, I noticed the artist heading toward my daughter. And then it happened. A whisper into her ear. What did she tell Zoe? And how was it received? I wanted to know. And yet,

what right did I have to intrude upon *their* moment? What was happening within me to make me focus upon their experience rather than my own? I struggled to be present for even one of the 512 hours. Being and receiving is a struggle for me.

The artist's suggestions were mild. "Breath." "Relax." "Slow down." Why did we lose sleep for this? Perhaps because being fully awake is such a rare state. It is tough to be present—for our friends and family and even ourselves. There are so many other inputs vying for our attention. Marina Abramović's 736-hour performance *The Artist Is Present* at the Museum of Modern Art in New York City moved participants to tears.[3] Sitting across from the artist, locking eyes, knowing they were being noticed and maybe even seen felt like such a rare gift. Yet it was reserved for only one person in the chair across from Abramović at a time. What did three months in the chair communing with others mean?

In her memoir *Walk Through Walls*, Abramović lets us into her cumulative experience:

During the final month, as this piece became one with life itself, I started to think intensely about the purpose of my existence. Eight hundred fifty thousand people in all had stood in the atrium, seventeen thousand on the final day alone. And I was there for everyone there, whether they sat with me or not. Suddenly, out of nowhere in the world, this overwhelming need had appeared. The responsibility was enormous. *I was there for everyone who was there.* A great trust had been given to me—a trust that I didn't dare abuse, in any way. Hearts were opened to me, and I opened my heart in return, time after time after time. I opened my heart to each one, then closed my eyes—and then there was always another. My physical pain was one thing. But the pain in my heart, the pain of pure love, was far greater.[4]

This is creative as conduit, doing public service, something akin to priestly sacrifice.

How did Abramović respond to this collective pain and longing? She describes being lifted toward a kind of transcendence:

> The sheer quantity of love, the unconditional love of total strangers, was the most incredible feeling I've ever had. *I don't know if this is art*, I said to myself. *I don't know what this is, or what art is.* I'd always thought of art as something that was expressed through certain tools: painting, sculpture, photography, writing, film, music, architecture. And yes, performance. But this performance went beyond performance. This was life. Could art, should art, be isolated from life? I began to feel more and more strongly that art must be life—it must belong to everybody. I felt, more powerfully than ever, that what I had created had a purpose.[5]

In being present to whoever appeared before her, Abramović rose above performance or craft into a feeling and experience beyond the normal parameters of art—a collective transference. Her epiphany arrived when she realized how much she didn't know about art or life. As we let go of our preconceptions and expectations, we make room for honest creativity to enter.

This was the abundant backstory informing her experiment in London. She was inviting all of us to step outside our everyday concerns—to transcend with her. At the Serpentine Gallery, we could be jealous that the artist touched him or spoke to them, but we were invited to see ourselves as equal participants. Maybe a few people got more attention, but that didn't mean they experienced more presence. Abramović works with absence. She invites us to enter a void. And to fill it for each other. If 512 Hours didn't "work" for me, it was probably because I was too busy

focusing on what the Artist was doing, rather than realizing the call to be an artist. I was expecting something to happen to me. Yet the invitation was to be the happening. Honest reception arrives via unlearning, unknowing—receiving inspiration as an unearned gift.

My family arrived early enough and stayed long enough that we needed to use the restroom before we left the building. In the women's room, my daughter had an even more surprising encounter. Zoe stood in front of mirror, washing her hands, beside Saoirse Ronan. Saoirse earned her first Academy Award nomination at age thirteen in *Atonement*. Her ferocious role as *Hanna* demonstrated to my daughter how young women could kick ass. Ronan's charming turn in *The Grand Budapest Hotel* made Zoe a lifelong fan that was cemented even further in *Lady Bird* and *Little Women*. The finest actor of my daughter's generation was in the same small circle within the Serpentine Gallery. They were present in the same moment to the same artist. It elevated the experience to another level. An actor who expresses universal longings for a generation of filmgoers went to the same "show." They were sojourners on the same path if only for one hour.

The Artist Is Present

What does "The Artist Is Present" mean? When the Artist Is Present, I am awake and alert, but relaxed. I may not have checked my phone lately. The "to-do" list hasn't kicked in. Caffeine hasn't jumpstarted my heart. I pay more attention to my breath than my surroundings. I am sensitive to the feelings of others. Every look and gesture registers. But I try not to judge. Instead, I'm open and receptive. Curious. Anxieties are released. Expectations cease. Open hands coincide with an open heart. Breathe. Receive.

© Christopher Chase

When we're relaxed and not paying attention, we're more likely to experience epiphanies. That's why showers or baths become occasions for insight. The alpha waves rippling through our brain allow us to turn inward, away from what our eyes can see. When we aren't focusing upon a problem, more creative breakthroughs appear.[6] That's why running, biking, and cooking also make room for insight. When we're not actively thinking about how the world works, we suddenly have much more clarity. Stimulants designed to increase our attention, like caffeine, Adderall, and Ritalin, suppress the kind of activity in the right hemisphere of our brain that leads to epiphanies. Holly White, a psychologist at the University of Memphis, found that students with ADHD scored much higher in creative tests. They were more likely to have won prizes in art contests and science fairs.[7] I am all for the power of medicine to even out our moods and enhance our concentration. But there are times when our finest dramatists and engineers may find ADHD to be a creative blessing.

When I rise above efficiency with a relaxed sense of presence, I am prompted to consider, "Who is the artist?" I might be. They might be. Or perhaps the Artist is unseen. Making space for us to perform. Coordinating our arrival. Eager to see what happens. We become an experiment. Raw material that can be modeled and shaped. But we can also act on and within our environment. Marina Abramović didn't do much. She didn't have to. There was already so much on our hearts and minds. To make room for reflection in a mediated, caffeinated age, *that* was a miracle.

When we enter artistic production, the temptation is to focus upon what isn't happening. We can fret about supplies we may be missing. We can wonder if our poem or essay will be published. The specter of bills that still need to be paid looms in the background. These distractions must be set aside for the work to proceed. On a film set, the conditions are almost always less than ideal. There may be planes flying overhead, ruining the sound. The sun may be darting in and out of the clouds, impacting the lighting. Hair and make-up can need constant adjustment under hot lights. A director's drive to control the situation bumps up against crew members focus on their lunch break.

Yet all that preproduction and planning is an effort to account for all the variables. That long list of credits at the conclusion of a movie demonstrates how much thought and effort and investment was made in setting the stage. Producers hire experts in sound, lighting, and costume design so that the even more expensive artists (otherwise known as actors) may be present. We bring state-of-the-art cameras to record their potential moment of movie magic. The director's job is to focus the actors' and crew's energy around a single scene or exchange that may tell us more about human love, longing, and loss than we ever imagined. When we hear the directive "quiet on the set," we anticipate what is to follow. When the call of "action" arrives, all the pent-up creative energy contained in costumes, camera angles, and rehearsals is unleashed in a

burst of planned spontaneity. The crew is present for the actors who are present to each other and to the words that the writer was present to as well. An imagined moment of meaning becomes something else, hopefully elevated, into far more.

I think of the sublime conclusion of a truly moving picture from A24, *Past Lives* (2023). Playwright Celine Song drew upon her experience immigrating from Korea to Canada to craft the character of Nora. She has a deep bond with her first childhood crush, Hae Sung. It is best expressed by the Korean concept of *in-yun*. Song defines it as "that ineffable feeling of being connected to someone without there being a simple way to explain it."[8] What would happen if they were reunited twenty-four years later? In a film full of longing and loss and what-ifs, we build toward their face-to-face encounter. Will they or won't they express their love? Will they kiss and cling to each other with all the emotion they've suppressed over two decades? So much has been unsaid, held back, and restrained. To avoid spoiling this stirring finale, it is safe to say we experience all the conflicting feelings swirling within the characters. Did Celine Song know how or when their emotions would break through? The camera captures each gesture, glance, and detail in one painfully long shot. We track with the would-be-lovers' footsteps as our hearts rise to our throats. Actors and crew are fully present in the moment, inviting us all into this haunting scene.

This is when happy accidents arrive. The actor may tilt their head in a way which raises all kinds of unexpected complexities. A bird may take flight just as the scene concludes, lifting it to a higher plane. A ray of sunlight may blast into the camera, creating a moment of blinding beauty and refraction. These are the moments as directors we pray for and then gratefully receive. In the conclusion of my documentary *Purple State of Mind*, it was the voice calling out at the end of a hot summer day of filming in Brooklyn, "You've got to see this."[9] My cocreator and I instinctively

responded, "What is it?" As we stepped down to the couple's apartment stoop, they pointed to their cactus, more specifically, a night blooming cereus. It was indeed night, and the cereus was open wide, spreading the most glorious fragrance. When they told us it only blooms once a year, we beheld it with even more wonder. We didn't ask how the cereus got from the Sonoran Desert of Arizona to a Brooklyn brownstone. Such extravagant beauty, unfolding before us, as we concluded a day of discussion, humbled us. It cut through all the aspirations and plans, arriving as a gracious gift. Our cameras and crew were all present. We suddenly found a unifying and unscripted ending to our documentary about religious and political division. Beauty builds bridges.

Honest creativity arises when we get out of the way. We set aside our script or agenda long enough to see and hear the bounty before us.

As workers stopped commuting to work during the pandemic, a new question emerged in our top Internet searches. "Why are the birds so loud?" Author and musician Andrew Peterson noted the birds weren't louder, but there was less noise to distract people. Our senses were reoriented. Peterson suggests, "We must fight to pay attention to the birds—the elements of real life so often obscured by what feels so urgent or important. Because there's a lot going on to crowd that out."[10] Tuning our ears and eyes to our surroundings takes discipline. It is a way of unknowing that is refined by practice. Walking by the same places everyday can sharpen our perception because we aren't actively paying attention. We know the route. Recognize the houses and stores. Slowly, we start to notice slight variations that occur with the seasons. The leaves turning from green to yellow, preparing to fall. The first blooms emerging in the spring. The same subtleties occur in liturgical worship services. A change in the vestments or the altar may catch our eye when we don't expect it. A priest's robe and stole shift with the church calendar. Plenty of ordinary Sundays pave the way for the colors of Advent or Easter. Red

in the sanctuary augurs in a singular Sunday, Pentecost, when the Holy Spirit descended upon Jesus's disciples. The sounds of birds, the falling of leaves, the color of a robe are all subtle calls to attend to the changes afoot. "Winter is coming." "Spring has arrived." "Unto Us a Child is Born." If we're willing to receive the signs of life.

Discovery

What does presence and curiosity look like in science and technology? Lonnie Johnson was working on an environmentally friendly heat pump, trying to figure out if water could replace freon in the refrigeration process. He was experimenting with various nozzles that he had machined. When he attached one to the bathroom sink, a powerful stream of water shot across the room, straight into the bathtub. Lonnie had a moment of recognition, thinking, "Geez, maybe I should put this hard science stuff aside and work on something fun like a water gun. Maybe I could make enough money to support my habit."[11] Dr. Johnson recognized the potential within what he wasn't looking for.

Lonnie had always been a tinkerer, even as a boy playing with rockets. While making rocket fuel atop his parents' stove, Lonnie nearly burned the house down. His parents could have been furious, but instead, they encouraged his creativity, buying him a hot plate and suggesting he experiment outside. Their faith in Lonnie was eventually affirmed, when his compressed-air-powered robot "The Linex" won a high school science fair sponsored by the University of Alabama. As an African American student in a segregated era, Lonnie defied expectations and humbled his competition. He graduated with bachelor's and master's degree in mechanical and nuclear engineering from historically black Tuskegee University. Five

years later, Lonnie was serving as a power systems engineer at NASA's Jet Propulsion Laboratory, working on the Galileo Mission to Jupiter.[12]

That blast of water in the bathroom inspired Lonnie enough to create a prototype. He gave his water gun to his daughter. It was literally a big hit with all the neighbors she blasted with water. Over the next seven years, Lonnie worked on the top secret Stealth Bomber for the Air Force and perfected his "Power Drencher" water gun at night. After countless sales pitches and rejections, the Larami Corporation eventually bought his water gun. A name change and revised marketing campaign turned Lonnie's invention into a best-selling toy for years to come. Laramie sold $200 million worth of "Super Soakers" in 1991.

Lonnie's profits from an "accidental" toy enabled him to found Johnson Research and Development. As an entrepreneur, Johnson has acquired dozens of patents, from air-powered nerf guns to a ceramic battery to an advanced heat engine that could convert solar energy into electricity.[13] His call to invent, to forge a more sustainable future for the planet, was fueled by a water toy. Noticing the potential presented by that first water blast in a bathroom brought joy to thousands of kids and opened the doors to so many more inventions.

How to practice presence in the age of Artificial Intelligence? Our computers are always present. Blinking. Waiting for a prompt. Given a command, they are ready to reply as fast as possible. No time is devoted to waiting or wondering. They sort through the ones and zeros of human history collected on the Internet as fast as possible to satisfy your request. Their speed is literally superhuman. They can read far more, scan far more quickly, traverse more time and space and place, than our bodies ever will. Yet that superpower is also a curse. Or at least an inescapable fact. A.I.'s job is to predict, to anticipate, to offer a best guess. It is an approximation. But computers aren't built to ponder. They can analyze and atomize, but they can't really dwell in the moment. In their relentless pursuit

of efficiency, they lack being. They don't waste time (unless they get into one of those spinning balls of death that signal a shutdown ahead). Being present as an artist is a form of wasting time. It focuses on our breath, our surroundings, our companions, our soul.

We're better than A.I. because we can take almost any prompt from the world and make it into art. We can spot a tree, a bird, or a beluga and turn it into a poem, a song, or a dance. A.I. can scan the database of all that's come before and forge an amalgamation. But it can't bring what your eye brings to the scene, what pathos and poignancy you perceive *within* the image.

A human can take a simple prop like a sled from childhood and turn it into a symbol of love and loss. The whispered, final breath of newspaper scion Charles Foster Kane sparks a search for clues. What did the word "rosebud" mean to the richest man of his era? The speculation forms the dramatic spine of *Citizen Kane*, director (and star!) Orson Welles's cinematic masterwork.[14] While the word remains a mystery to the characters onscreen, a final shot reveals how primal Kane's attachment to his mother remained amid his affluence. A close-up on the word, revealed by the heat from a furnace, provides a tragic and painful coda. An overlooked object becomes a potential symbol of all the longing that lurked within the lonely millionaire. Those who have surrendered to the story, overlooking what now feels like ancient black and white cinematography are rewarded with a deeply humanizing story of love and loss. Tears may flow on Citizen Kane's behalf when we realize that the wealth which shipped him off to boarding school also robbed him of the idyllic childhood that was reflected in the snow globe he was holding when he uttered his final word.

A.I. could attempt to imitate such dramatic moments, but can it capture the bittersweetness of the reveal? One of the greatest movies ever made relies upon the magic that happens in our brains—when we assign

extra meaning to an object that bears the weight of our story. We infuse the time and the place with all the drama that is conflicted and unaddressed in our heart as well. We all hunger for love and comfort.

Dreams and Drugs

Being present can also involve times when we're asleep. How many weird dreams have you had? Moments of being lost in mazes, confused, and frustrated by your inability to get out. We search for open doors, we pursue those we've lost long ago, we long for love and comfort and satisfaction. We seek resolution in our dreams, but it rarely arrives. Sometimes we wake up in a cold sweat. It all felt so chilling and real. Other times those dreams fade quickly, with little recall. Have you ever tried documenting your dreams? Consider keeping a notepad beside your bed. Having a pen handy allows us to scribble our recollections down. Maybe just a phrase or image from the dream will suffice. We can return to slumber once we've caught that snippet of subconscious thought that might be significant. Our dreams are often puzzles. Yet they aren't logical. They have their own internal dream logic. Our rational, waking mind wonders, "How can they be solved?" We may approach them like a hidden key, which unlocks unresolved issues, lurking in our subconscious.

The road from the psychology of Sigmund Freud to the paintings of Salvador Dali or the films of David Lynch is loaded with signs and symbols and secrets. They bring our nighttime obsessions to the surface, presenting all our sexual picadilloes and self-sabotaging horrors to the light of day. Dali's monstrous "Soft Construction with Boiled Beans" depicts two naked bodies ripping each other apart amid a gorgeous Spanish sky. A massive hole is left in the middle, as a dismembered arm and leg tumble to the ground. A tiny figure of Freud himself observes the wreckage

littered with boiled beans. Painted in 1936, Dali described his painting as a prophetic precursor to the Spanish Civil War that devastated his homeland, leaving citizens surviving on scraps like beans. In *Blue Velvet* (1986), director David Lynch interrupts the blue skies and white picket fences of American suburbia with the discovery of a severed ear in the grass. Ants crawl across it, sending a shiver across Jeffrey, the naïve young man who found it (as well as the audience). The indelible image recalls the shot of ants emerging from a severed hand in Salvador Dali's surrealist short film *Un Chien Andalou* (1929). Jeffrey's efforts to solve the mystery of the ear leads him down a decidedly dark path. Once Jeffrey is hiding in the closet, watching a masochistic dance between a naked lounge singer, Dorothy, and the gassed-up sex trafficker, Frank, who controls her, David Lynch has enveloped all of us in a collective nightmare. We want it to end, but we also can't look away. The paintings of Dali or the films of David Lynch are extreme, grotesque, and fascinating. The signs and symbols they employ have been unpacked in extensive essays. These creators demonstrate how attending to our darkest dreams can reveal so much about human longing and self-deceit. We tell ourselves stories to provide comfort. But often the stories we ignore reveal just as much about what lurks in our hearts of darkness.

Dreams can also be sources of comfort and connection. Sir Paul McCartney acknowledges the subliminal source of his greatest songs, from "Yesterday" to "Let It Be." He affirms that "I'm a great believer in dreams. I'm a great *rememberer* of dreams."[15] Paul recalls composing "Yesterday" in his sleep, "I woke up with a lovely tune in my head. I thought, That's great, I wonder what that is? There was an upright piano next to me, to the right of the bed by the window. I got out of bed, sat at the piano, found G, found F sharp minor seventh—and that leads you through then to B to E minor, and finally back to G."[16] It emerged so fully formed that McCartney didn't think he wrote it. For weeks, he'd

play it for others, asking if they'd heard it before, thinking maybe it was an old pop standard that he'd merely remembered.

What was stirring in his subconscious that prompted such a renowned melody? McCartney's mother, Mary, lost her battle with breast cancer when he was only fourteen. He poured his grief into his guitar playing. In his book *Lyrics: 1956 to the Present*, Paul reflects upon how her death shaped his songwriting. The title of his first song, "I Lost My Little Girl," reveals plenty. He admits, "You wouldn't have to be Sigmund Freud to recognize that the song is a direct response to the death of my mother. She died in October 1956 at the terribly young age of 47. I wrote this song later that same year."[17] How did her death influence "Yesterday"?

The lyrics to accompany the poignant melody eluded him. For over a year, the working title was "Scrambled Egg" until Paul experienced a breakthrough on a long journey from the airport in Lisbon, Portugal, to a friend's villa. While his girlfriend Jane Asher slept in the car, Paul noodled on one-word titles, from "Suddenly" to "Funnily" through "Merrily." By the time they arrived, Paul had finished the song we've come to know, love, and cover countless times. Beatles fans made connections between his mother's sudden death and the shadow hanging over him before Paul did. McCartney recalls:

Every time I come to the line, 'I'm not half the man I used to be,' I remember I'd lost my mother about eight years before that. It's been suggested to me that this a 'losing my mother' song, to which I've always said, 'No, I don't believe so.' But, you know, the more I think about it—I can see that might have been part of the background, the unconsciousness behind this song after all. It was so strange that the loss of our mother to cancer was simply not discussed. We barely knew what cancer was, but I'm now not surprised

that the whole experience surfaced in this song where sweetness competes with a pain you can't quite describe.[18]

If his mother's absence influenced "Yesterday," her presence inspired "Let It Be." During the winter of 1968, as the Beatles were beginning to disintegrate as a group, McCartney's Mother Mary appeared to him in a dream. "The band, me—we were all going through times of trouble . . . and there didn't seem to be any way out of the mess. I fell asleep exhausted one day and had a dream in which my mum (who had died just over 10 years previously) did, in fact, come to me." What did her presence communicate? McCartney writes, "In this dream, seeing my mum's beautiful, kind face and being with her in a peaceful place was very comforting. I immediately felt at ease, and loved and protected. My mum was very reassuring and, like so many women often are, she was also the one who kept our family going. She kept our spirits up. She seemed to realize I was worried about what was going on in my life and what would happen, and she said to me, 'Everything will be all right. Let it be.'"[19] McCartney talked about it on *The Late Late Show with James Corden* during a poignant "Carpool Karaoke" segment.[20] Her simple admonition provided the title not just to the song but to the Beatles final album. Mother Mary offered comfort and inspiration to millions of listeners around the globe even from beyond the grave.

Teresa of Avila, founder of the Carmelite order of nuns, famously encountered an angel during a dream. Her description of the encounter merges pleasure and pain, with the angel plunging a golden spear into her heart. After removing the spear, the angel left her "utterly consumed by the great love of God."[21] The pain caused her to moan with a sweet intensity. She talks about a gentle wooing between God and the soul. The Ecstasy of St. Teresa inspired numerous painting and sculptures, most notably the rapturous work of devout Catholic Gian Lorenzo Bernini. His sculpture of a swooning Teresa blurs the lines between sexual and

spiritual transverberation. We may all get transported via our dreams to such heightened states of religious ecstasy. Paul McCartney and St. Teresa devoted the utmost attention to their dreams. Are we present enough to note the inspiration and even act upon it?

We may be tempted to pursue a heightened presence. For creatives who like intense experiences, alcohol and drugs are a quick path to altered states. They're associated with the Dionysian spirit that loosens our tongues or frees us from inhibitions. A few shots of alcohol may provide the liquid courage that helps us overcome our stage fright. For those who are self-critical or scared, a higher plain may be preferred to our current pain. Stimulants and depressants may open pathways to our subconscious. They can also numb our broken bodies or aching soul.

Psychoactive drugs like ecstasy and LSD enhance our senses, making us literally feel everything in more extreme ways. In a club or concert setting, the lights, colors, and beat envelop us with waves of love and affection. The sense of euphoria that kicks in can be quite intoxicating, keeping us dancing all night long. We hope the party never ends. And yet, the dehydration, fatigue, and depression that can follow are a rude awakening. Too much MDMA may cause our attention to wander, our memory to fade. We may lose access to our source material, the wellspring that fuels our creativity.

Plenty of artists turn to alcohol to assuage our traumas. It can take the edge off a stressful day. It can offer a time of bonding with friends. As a depressant, it can also send us into a downward spiral that can be tough to escape. We drink to rise above painful realities yet end up ushering even more debilitating circumstances. We may neglect basic duties of work or parenting. We become unreliable, focused more upon the comfort ahead rather than the cost of such escape.

Once we're dependent upon stimulants or depressants to manipulate our moods, it becomes increasingly tough to be present. Only a portion

of us is dialed in. The other side of our self is checked out, on a another plain. We may feel more powerful or fearless, but over time our performance suffers. We start to deceive ourselves. It may take the intervention of loved ones to wake us from a self-imposed stupor.

The romanticized notion of the artist/addict burnished the legend around Beat poets like Jack Kerouac and William S. Burroughs. Kerouac's free-flowing prose may cause us to overlook his death from cirrhosis at age forty-seven. We also may not recall how Burroughs murdered his common law wife, Joan Vollmer, during a drunken reenactment of William Tell's stunt. Burroughs took up writing as a form of sorcery to evade what he identified as the Ugly Spirit that had possessed him. Some may seek a similar kind of artistic fame through hard living and self-destructive choices. Researchers confirmed that while we may feel more creative while under the influence, this is largely a myth. Psychologist Paul Hanel from the University of Essex found, "It doesn't do anything for creativity. People don't benefit from it. It just has no effect at all."[22] His coauthor Haase, from Berlin's Humboldt University, concluded: "Ideas generated under the influence often seem disjointed or ill-suited as solutions later on. Given the numerous side-effects associated with drug use, it is scientifically unsound to recommend their consumption in pursuit of enhanced creative output."[23] The freedom to receive that arises from unknowing isn't found through being unconscious.

The lessons for creatives: lean into our pain and grief. Attend to these intense feelings. And perhaps even more importantly, pay attention to our dreams. They may reveal important things we struggle to express, inchoate longings, our deepest needs. Be present whether awake or asleep.

The pursuit of transcendent moments is a worthy goal. But creative epiphanies cannot be planned for or coerced. We may long to be swept up in a holy vision like St. Teresa in Ecstasy. Most breakthroughs arrive amid the mundane. Moses was attending to his father-in-law's flock in

the wilderness when an angel appeared within a burning bush. He caught a glimpse of glory that compelled him to take a closer look. A bush that burned but was not consumed defied explanation, existing beyond his prior experience. That will often be the case when we receive inspiration outside ourselves. As he draws near to the flames, God calls his name, "Moses! Moses!" God instructs him, "Do not come any closer. Take off your sandals, for the place where you are standing is holy ground."[24] This is the kind of sacred moment we may seek. We want to encounter the miraculous, to have an encounter with the Divine that causes us to hide our faces like Moses. Learning how to sit with the miraculous, to respect the results that God brings, is a particular art form. Creatives give shape to things that are often beyond our comprehension or grasp. There is a sublime element to life that should cause all of us to pause. It is good to document such high points as Moses does. But how to attend to the daily and the lowly in between? That's harder. Peak experiences are real and life-changing, but in between highs, they're lived out among the routine. Honest reception arrives beyond our timelines, expectations, or control. Inspiration is a gift we receive with gratitude, acknowledging The Source beyond us.

HONEST CHALLENGE

1. When is your mind most relaxed? In the mornings or evenings? While exercising? Taking a shower or bath? Set aside time each day when you're not scrolling or solving a problem. Make space to receive inspiration and insights.

2. Have you ever kept a dream journal? Place a notebook and pen beside your bed. Ask for inspiration before you sleep. See what arises. Attend to it without expectation. Ponder what your dream or vision may mean. See how you can incorporate it into your latest work.

6

HONEST PERCEPTION

"To invent is to discern, to choose."

—HENRI POINCARÉ, FRENCH MATHEMATICIAN[1]

WHERE WE LIVE, THE WIND BLOWS IN FROM OFFSHORE.
Every night, a cool breeze wafts over our hills, often bringing a foggy sea
mist that generates a unique microclimate. Good wine can be grown in
southern California, aided by winds that bring a refreshing mix of mois-
ture at night that burns off as the sun rises. For surfers, there is nothing
quite as satisfying as having the wind at your back, while you roll in on
the waves. Both the waves and the wind propel you forward in a seamless
dance. Your job is simply to go with the flow, to ride it as long as possi-
ble until the wave breaks, potentially slamming you into the ocean floor
(which can be quite unforgiving). Studying the conditions by assessing
the waves and wind is an essential way to start each session.

A few eerie days each year, the direction of the wind changes. Sud-
denly, the breezes turn from the desert to the sea. A spray of mist blows
off the waves, creating white caps that make surfing a chore. These Santa
Ana winds clear out the heat that builds up in the desert. It is a sign that

the season is changing. Fire often accompanies the Santa Ana winds. Power lines can be knocked down, setting off sparks after a dry summer. The winds stoke the embers, turning a modest brush fire into an inferno racing through canyons. So many of our neighbors lost their homes and even their livelihoods from the fires caused by a shift in the wind's direction.

You can try to surf in difficult conditions, but it isn't much fun. The Santa Ana winds make it tough to maneuver and stay on your board. The water kicks up in your face. The waves fight the wind with both exhausting themselves in the process.

Creators must assess which way the wind is blowing. When the headwinds are strong, you may want to reverse direction—to go with the flow. Or at least recognize the intensity of the forces pushing against you. Sure, you might be able to catch a wave or two, but you'll likely face hours of frustration. Things that are usually easy become remarkably difficult to pull off. When the conditions are prime, the surf session takes on a magical quality. Time is suspended. Our worries are held at bay. The endorphins rush through our body. Freedom reigns.

We've all experienced those moments when we're so immersed in something we love that we lose track of time. It may have happened in childhood when you were drawing. A box of crayons and some paper may have engaged you for hours. Did you play with Duplos or Mega Bloks? These building toys may have come with suggestions, but the interlocking pieces enable the curious to erect elaborate structures. Kids today may lose track of time while building their own private worlds in *Minecraft*. Teens (and adults) can easily get wrapped up in *Fortnite*, interacting with players from across the globe. Time recedes when we play. We rise above our everyday concerns, riding on the wind.

When we're experiencing something pleasurable, dopamine delivers a blast of energy to our prefrontal context. We get stimulated, energized,

and focused.[2] For the screenwriter, the ideas start to pour forth, the setting becomes clear, and the characters take on a life of their own. An architect's vision may spill out from her mind through her pencil, materializing on the drafting table in minutes. For an athlete, it may arise during a championship game, when we no longer notice the sweat pouring from our body, just the goal ahead. An accountant may feel a rush that comes from a report that finally adds up, every item aligned. The entrepreneur who has been noodling on a problem sees the opening in the market, the angle on a product that will distinguish it in the marketplace. For the mechanically inclined, it may arise while underneath a car. After struggling for hours, suddenly the solution appears: the gears mesh, the engine is in sync. Our intelligence and perception sharpen. Patterns become clear. Our attention is fixed.

Hours of practice and rehearsal is in preparation for those magic moments when it all flows together. Our perspiration aligns with inspiration as we go with the flow. Onstage, on the field, during a film production, we're fully present in the moment. We attend to what's before us. We open to the Wind blowing. This is the *ruach*—the Spirit which inspires us. But inspiration often involves collaborators, teammates. It is getting in place to receive the pass. It is memorizing your lines so that you can forget them (or forget that you know him) so you respond with genuine emotion to your scene partner. It is about learning how to dance with others without stepping on their toes. Even our most creative expressions are aided by rules.

Improv

Improv is among the clearest expressions of our faith in action. It is where all that hidden preparation, the hours of practice and rehearsal pays off.

We respond to a prompt with our own interpretation. Not as a mirror, but as a reflection. With nuance. Improv is the personal touch we add to a skit or scene or riff. Neuroscientists found that jazz pianists turn off the dorsolateral prefrontal cortex in their brain during improv.[3] This is the neural restraint system that governs our impulse control, that keeps us from stealing food or making inappropriate comments. Jazz musicians must inhibit their inhibitions to explore new musical territory. Yet they do so within an established key, tempo, and mode. John Coltrane blows past the familiar melody of "My Favorite Things" for almost fourteen minutes of improv on his soprano saxophone.[4] His bandmate, pianist McCoy Tyner also takes an extended turn, playing within the structure, experimenting with sound on the same musical theme. Their interplay bends Rodgers and Hammerstein's beloved song into something we've never heard before (or since).

For comedy troupes, improv is saying "yes" to whatever we've been given. The volley is received with the word "And." "Yes" to what you've offered up, "and" this is what I add to the scene. It is dependent upon listening to your scene partner, building upon what they've provided. It often involves prompts from the audience. For example, "Yes, I am a camel, and my hump is filled with bubble gum. Yes, and that bubble gum allows you to blow big bubbles which also allow you to fly. Yes, I am a flying camel. And I prefer beaches to deserts. So, my bubble gum hump takes me away to the finest shores where the waiters serve me. All the boat drinks I can suck up. I'm the camel at Margaritaville you've been looking for." It comes out like playful nonsense, but it is made possible by an agreed upon set of rules.

Honest creativity arises from a receptivity to the collaborators we've been given. I've penned screenplays with five different writing partners over the years. The amount of patient give and take required to spend hours together, hammering out an idea, breaking a scene, is quite

comparable to an artistic marriage. Conflict is inevitable and usually beneficial in arriving at something more honest and enduring. To create the album *Ghosteen*, Nick Cave would play the piano and sing, while his musical partner Warren Ellis played electronics, loops, violin, and synth "with neither one of us really knowing what we were doing or where we were going. We were just falling into the sound, following our hearts and our understanding of each other as collaborators, towards this new-ness."[5] Their "mindful improvisation" was informed by twenty-five years of working together. Nick Cave says, "The nature of improvisation is the coming together of two people with love—and a certain dissonance."[6]

Improv is also refined by our perceptive skills, thinking on our feet. We may have our ideal situation, but when reality kicks in, we must perceive what's at hand. Can we shift with the circumstances? Pablo Picasso's paint-ing method was open-ended: "A painting is not thought out and settled in advance. While it is being done, it changes as one's thoughts change. And when it's finished it goes on changing, according to the state of mind of whoever is looking at it."[7] The same spontaneity happens in our kitch-ens daily. Can we make something tasty from the ingredients we've been given? This is the premise of our favorite cooking shows. What kind of culinary masterpiece can be whipped up from elements we haven't chosen?

In movies, there are those moments on set when the actors and director diverge from the screenplay. They may have already performed the scene as written, but with extra time, they toss in alternative lines of dialogue or acting choices. The scripted portions get us in a mood to experiment, to take chances. Perhaps the sunlight is fading in a partic-ularly beautiful way. Filmmakers refers to the golden glow that illumi-nates a sundown scene as magic hour. This is when projects like Terrence Malick's ravishing *Days of Heaven* are filmed—at a particular time of day designed to capture maximum beauty. The elements in the scene itself— the wind, a shadow, a prop—spark a spontaneous reaction. The actors

go off script and the director may encourage the camera crew to go with it. A tear may fall, a gesture may communicate what words overexplain. This is the elusive movie magic that all that practice, rehearsal, and planning prepared the cast and crew for. Famous improvised moments range from Robert DeNiro in *Taxi Driver* staring in the mirror, asking, "Are you talking to me?" to a weary, under-the-weather Harrison Ford in *Raiders of the Lost Ark* deciding to use his gun rather than this whip.

Onstage, it may involve performers doing dangerous or surprising things. Comedians riff on what the crowd is giving them, often with a spontaneous joke that surprises even themselves. The unrehearsed thing that pours out of their mouths is rooted in first impressions and honest perceptions. I saw Steve Martin and Martin Short bring a fan onstage to make up a song at the Santa Barbara Bowl. Little did they realize this was Bernie Taupin, lyricist for hundreds of songs with Elton John. His words had prompted Elton's most soulful melodies. While Elton gets most credit as the visible singer of the song, his creative process started with an openness to Bernie's lyrics. In his autobiography, Elton admitted:

> I'm not a musician who walks around with melodies in his head all the time. I don't rush to the piano in the middle of the night when inspiration strikes. I don't even think about songwriting when I'm not actually doing it. Bernie writes the words, gives them to me, I read them, play a chord and something else takes over, something comes through my fingers. The muse, God, luck: you can give it a name if you want, but I've no idea what it is. I just know straight away where the melody's going to go. Sometimes a song only takes as long to write as it does to listen to.[8]

Bernie's words gave Elton the structure he needed to compose pop classics.

Sometimes honest perception takes place onstage in a seemingly spontaneous moment. Elvis Presley responded to the shrieks of his fans by shaking his hips on the Ed Sullivan Show. A young James Brown blew Mick Jagger and the Rolling Stones off the stage at the T.A.M.I. show, revealing himself as equal parts boxer and dancer.[9] Jimi Hendrix igniting his fame in America by setting his guitar on fire at the conclusion of his set at 1967's Monterey Pop Festival.[10] I still vividly recall that first time Michael Jackson went moonwalking across the stage of Motown's twenty-fifth anniversary special.[11] No one had seen such an effortless flow. Think about U2 live at Red Rocks, when Bono pulled out the white flag, matching across the smoke laden stage to the sounds of "Sunday Bloody Sunday."[12] Eddie Vedder climbed the stage scaffolding and dangled above thirty thousand nervous Pearl Jam fans at Seattle's Drop in the Park concert in September 1992.[13] These musicians may have practiced or rehearsed these moves many times. Yet the presence of cameras enabled these risky behaviors to be burned into our collective rock consciousness. These performers knew enough about the rules of performing to break them.

While these men saw their career profiles elevated, an equally bold musical protest from an Irish punk torpedoed her burgeoning fame. Sinead O'Connor pulled the ultimate improv before television cameras on *Saturday Night Live* in 1992.[14] Fueled by rage at how Catholic priests and nuns had abused Irish children in their care, Sinead diverged from what had been rehearsed. Her acapella rendition of Bob Marley's "War" burned with defiant intensity. After her musical declaration of victory against evil forces that hold others down or in bondage, Sinead held up her abusive mother's picture of Pope John Paul. To Sinead, "It represented lies and liars and abuse."[15] Then, in a shot heard round the world, Sinead ripped the Pope's picture in half, inviting the audience to "fight the real enemy." This visible and visceral protest left the studio audience in a stunned

silence. The blowback against O'Connor was fierce. Her public cancellations almost complete. This unrehearsed moment undercut all the good will and fan base she'd built. In her autobiography *Rememberings*, O'Connor writes how she considered her prophetic act clarifying. She put it into perspective, "I feel like having a No. 1 record derailed my career, and my tearing the photo put me back on the right track." Although traumatized by the backlash, it also freed her to "do what I love. Be imperfect. Be mad, even." She wrote, "I define success by whether I kept the contract I made with the Holy Spirit before I made one with the music business."[16]

What are we to make of these ecstatic moments that break through the mundane? They may be comparable to when Israel's King David danced before the Ark of the Covenant. Second Samuel 6:14–22 describes how "David danced before the Lord with all his might. And David was wearing a linen ephod," which is a kind of priestly garment. Shouts of joy and the blowing of rams' horns accompanied the procession. Yet not everyone reveled in David's free-flowing act of worship. Saul's daughter Michel is disgusted by what she considers a shameless and vulgar act. David acknowledges the political tensions between the previous king, her father, and his new status as leader of Israel. Yet David defends his dancing before the Lord as a celebration that may make him look foolish. Getting swept up in the moment, being open to inspiration, is scary. We cannot control others' response. David is willing to be humiliated while engaging in an improvised dance with the Divine.

Creativity is a combination of reception and revision. We open ourselves up to divine inspiration. The skills we've honed align with a vision. We may get caught up in the process, losing track of time. Clarity arises in hindsight when we can assess what we've been given. Our projects will morph and change through so many iterations. Context and timing and resources will alter the results. As we apply craft and care to that inspiration, we move from probable to operable, from potential to reality. We

may end up far from our original intention. Creativity is a process that starts with a willingness to be surprised. Happy accidents arrive by being open to shifts, suggestions, and changes. As we apply our intelligence to the task at hand, the patterns begin to emerge. When perspiration meets inspiration, a new paradigm may arise.

A Building That Breathes

La Sagrada Familia, Barcelona, Spain, designed by Antonio Gaudi, photo by the author, 2019

The spires rise above the streets of Barcelona from blocks away. They are impossibly tall but not straight. They have a gentle curve that suggests

something akin to an asparagus. Rather than rising to a single point, they blossom at the top like a fruit or flower. The form suggests a bishop's staff, the sign of a spiritual shepherd. Exultant words like *Hosanna*, *Sanctus*, and *Excelsis* are carved into the spire. What kind of structure is this? And what is it hoping to inspire? MIT architecture professor Kyna Leski taught me that "the English word *spire* comes from the Latin word *spirare*, which means, 'to breathe.' It shares its roots with *spirit* as well as with *spiral*—a form that expands and contracts like breath."[17] Even from a distance, the Basilica of the Sagrada Familia makes us stop and pause because the building seems strangely alive. It pulses with life, as if breathing. The straight lines of modernist skyscrapers can often feel cold, akin to their steel structure. The naturalist spirals envisioned by architect Antonio Gaudi convey a different kind of spirit. The stones of Sagrada Familia mimic nature, conveying the life that animates us all. What did Gaudi perceive that so many other architects seem to have missed?

On the east entrance that faces the rising sun, the walls spring to vibrant life. A sea turtle and a land tortoise each support a massive column, dividing the façade into three porticoes. The left entrance resembles the Nile riverbank, where ducks and geese cavort among reeds. Dragonflies dance amid lotus flower, calla lilies, and papyrus. The right side depicts a drier setting. Hens and roosters roam among hardy century plants, associated with dry farming. A chameleon clings to the wall, eyeing a bee. An apple tree, symbolic of the original temptation in the Garden of Eden, rises above it all. In the middle, turkeys and their chicks shelter under ferns. Cherry, peach, and almond branches undergird almonds, wisteria, and gladiolas. Sparrows, squirrels, and nightingales have a home amid irises and white lilies. Spring has clearly sprung. Atop the main doorway, a pelican rests at the base of a crowning cypress tree. Doves of peace nestle among the leaves. So many lively, organic detail carved out of inanimate stone.

Above this extravagant natural setting, sacred scenes from the Bible emerge. Moments from Joseph's life on the left, the immaculate conception of Mary on the right. And in the middle, under the star of Bethlehem, three magi, four shepherds, and a band of angels join Mary and Joseph in celebrating the birth of Jesus. This is the Nativity Façade, three portals representing Faith, Hope, and Love (as well as Mary, Joseph, and Jesus). It covers biblical history from creation in the Garden of Eden, to the birth of Jesus, through the family's flight to Egypt to escape the slaughter of the innocent children. We're already overwhelmed by the faith-fueled story-telling of Catalan architect Antonio Gaudi, and we haven't even entered the Basilica yet.

Inside, the columns rise like a forest of trees. We're under a canopy as well as inside a church. This is soaring Gothic architecture without the flying buttresses to support the stones. What makes these double twist columns possible? Gaudi mimics the geometric shape of oleander, where three leaves grow out of each stalk.[18] As each of the leaves reach for the sun, they make space for each other, allowing all to thrive. The branch twists to accommodate and feed the leaves. Gaudi incorporates natural principles to forge an architectural innovation. He believed, "Nothing is art if it does not come from nature."[19] His columns on the outside of the western entrance borrow from sequoia trees, where each rib spreads out into the subsoil. The wide bases of the columns transfer the force and pressure from above into the foundation below.

Today, we call such attention to nature "biomimetic architecture." Having imposed our will upon nature in devastating ways across the centuries, more architects are now studying the natural world to learn about simple and sustainable structures. For example, the roof of the Sagrada Familia schools is a series of waves.[20] Gaudi didn't need to rely upon a pitched roof with rafters to deal with rainfall. Instead, his peaks and troughs resemble the leaves of a magnolia tree that channel waters off

via an undulating surface. The roof was thinner, requiring less materials. Simplicity leads to efficiency—so important for sustainable building practices. Gaudi wasn't intentionally founding an architectural movement one hundred years ahead of his time. For Gaudi, "originality is returning to the origin." As a devoted Catholic, Gaudi traced the origins of nature to the God of Genesis. Mimicking nature was Gaudi's way of honoring the Creator. The physics behind the Sagrada Familia's catenary arches, spiral stairways, conoid-shaped roofs, and hyperbolic paraboloid bases stem from God's creation. Mechanical engineer Adrian Bejan described Gaudi as "a tightrope walker on the line of bridging art and science. He understood that nature is constructed by laws of mathematics. What is strongest is inherently lightest and most efficient."[21]

How did Gaudi put his architectural concepts to the test? A different architect had started building the Basilica according to Gothic architectural standards before Gaudi was hired to replace him. Gaudi studied the principles of Gothic construction but wanted to remove the flying buttresses that made the soaring heights with stones possible. What enabled him to turn inspiration from nature into material realities? He didn't rely upon two-dimensional sketches. Instead, Gaudi built three-dimensional, funicular models.[22] He built these models upside down, with weights and chords to test the distribution of stress in the walls, columns, and arches. By linking all the catenary curves together, Gaudi could see how changes in the size and span of his vision redistributes stress across the whole structure. A larger pull upon one section would have to be compensated for in another area. Working a hundred years before computer modeling, Gaudi figured out how to exceed the height of Gothic predecessors without buttresses. Gaudi incorporated mirrors to see what his upside-down test would yield when it was flipped into a concrete (or actually stony) reality. The result was more majestic, more spacious, more inspiring. Gaudi's upside-down perception provided a spiritual analogy. As Gaudi

used gravity and the laws of nature to shape his architectural concept, so God in heaven forms and reforms his Church.[23] Plans from above form and shape those below.

Honest creativity relies upon honest perception—careful observation of nature, the study of natural laws and behavior, which are then applied to our God-given flights of inspiration. Visions that arise from beyond us are refined in our workshops over time. Gaudi aspired to inspire. He studied nature to learn how to build a better spire that resembled the breath of life within us. He then applied his intelligence to the task at hand—constructing a sacred space that would serve Barcelona for centuries. One cannot avoid mathematics and science in constructing a technological marvel. The colors that pour through the windows each afternoon arise from a God-given spectrum. Yet each aspect of the building points us to a more ultimate reality behind the physics of light or the mechanics of engineering. Intelligence is a combination of perception and discernment. Gaudi studied nature long enough to perceive new solutions in architecture. He had to discern the laws and codes that governed plants and trees through testing. The natural DNA in their structures which allowed them to stand tall was translated into his building. The Sagrada Familia brims with life because it was designed with the best of God's creation in mind.

Analytical Engines

Our ability to make connections and perceive patterns precedes generative A.I. Ada Lovelace's nineteenth-century computing breakthroughs were rooted in honest perceptions—seeing commonalities between weaving and algebra. She'd been raised to beware of madness. Her mathematician mother feared that Ada would succumb to mental breakdown like

her father, the Romantic poet George Gordon, Lord Byron. Lady Byron sought to suppress her daughter's imagination, considering it "dangerous and potentially destructive and coming from the Byrons."[24] Yet Ada embraced the two sides of her parentage, the mathematical and the poetic. She described the imagination as "the combining faculty" which "seizes points in common, between subjects having no apparent connection." She wrote, "Imagination is the Discovering Faculty, pre-eminently. It is that which penetrates into the unseen worlds around us, the worlds of Science."[25]

At age seventeen, Ada's probing intellect ignited at her London social debut, where she met renowned mathematician Charles Babbage. He invited her to see the "Difference Machine" he was building in his home. It was the first mechanical calculator. Babbage encouraged Ada's mathematical pursuits during the seventeen years of letters they eventually exchanged, calling her the "Enchantress of Numbers."[26] Ada became the key interpreter for his more ambitious "Analytical Engine." In 1843, she translated a scholarly article about the Engine written in French but added her own lengthy observations in the footnotes. Ada made the connections between the Analytical Engine and Joseph Marie Jacquard's loom for making damask. His loom used prepunched patterns to create complex images on dresses and tablecloths, advancing the Industrial Revolution. Ada noted how "the Analytical Engine weaves algebraic patterns, just as the Jacquard-loom weaves flowers and leaves."[27] In note G of the appendix, she outlined a plan for punched cards to weave a long sequence of Bernoulli numbers in the Engine—what we regard today as the first computer program.

Ada introduced the notion that a number could represent more than a quantity, from text to pictures or sounds. Lovelace wrote how the machine "might act upon other things besides numbers. . . . Supposing, for instance, that the fundamental relations of pitched sounds

in the science of harmony and of musical composition were susceptible of such expression and adaptations, the engine might compose elaborate and scientific pieces of music of any degree of complexity or extent."[28] This sounds akin to how A.I. can generate music that resembles preexisting prompts in mere seconds. While Ada did not foresee the generative potential of A.I., she described her innovation as "the science of operations, as derived from mathematics more especially, is a science of itself, and has its own abstract truth and value."[29] In separating "operations" from "mathematics," Ada was founding what we now call "computing." Her leap from fashion to mathematics moved us from calculation to computation. When today's runway models wear high tech dresses with LED's sewn into the fabric, we have brought Ada's connection between fashion and computing full circle.[30]

We are analytical engines—observing astronomy and biology, perceiving differences in shape, color, and behavior, especially in our fellow humans. We open ourselves up to what's before us. Many things are predictable, but people are still full of surprises. Artists and scientists study nature and patterns, but then create on a hunch. They may not be sure what they'll get. There is always an X Factor—things we cannot predict or control—despite our efforts to play God. We must leave room for mystery, surprises, and mistakes.

Those who seek to create can never become calloused toward our world. The surprises within improv are not mistakes, but glorious mysteries. We must see the wonder in nature that Gaudi expressed in architecture. Can we also develop Ada Lovelace's ability to perceive the patterns and order that make computing possible? Whether perceiving life in comedic, poetic, or mathematical fashion, we must respond to people and places that are different than us with eyes of love and compassion. When Jesus was asked why he spoke in parables, he offered a cryptic answer.[31] He referred to people "though seeing, they do not

see; though hearing, they do not hear or understand." Creative breakthroughs combine perception and understanding. We are blessed if we develop eyes to see and ears to hear.

HONEST CHALLENGE

1. How do we develop our skills of observation like Gaudi or Lovelace? Pick an everyday object to focus upon. It could be a lovely flower, a towering tree, or a machine in your apartment. Find a comfortable height and distance to study it from. Quiet your soul enough to really sit with the item. Notice its texture, color, shape, and design. Consider how it works. What does it bring to the world? How does it fit into its surroundings?

2. Take it in long enough to see if you can reproduce it once you've walked away. Can you recall all the detail? Remember what you thought about. Maybe even reproduce it in a sketchbook from memory alone. Even more intriguing, how can you adapt a form and structure found in nature to an artistic medium or practical device? Can you dance what you've seen?

III

PRODUCTS

© Luke Clark

7

HONEST NEEDS

"When bankers get together for dinner,
they discuss art. When artists get together for dinner,
they discuss money."

—OSCAR WILDE

WHO INVENTED THE DELECTABLE DRINK KNOWN AS
the Margarita? Carlos "Danny" Herrera, owner of the Rancho La Gloria
restaurant outside Tijuana, claims he mixed up a margarita for actress
Marjorie King in 1938.[1] Pancho Morales, a bartender at Tommy's Place
in Juarez, Mexico, points to the Fourth of July 1942, when a customer
requested a "magnolia." Rather than asking what the drink included,
Morales improvised, adding tequila and Cointreau to lime juice, salt, and
sugar. When the customer said, "This is tasty, but it isn't a magnolia,"
Morales called his concoction a margarita, the Spanish word for "daisy."[2]
Dallas socialite Margarita Sames whipped up her namesake drink for
friends at her Acapulco vacation home in 1948. Among her guests was
Tommy Hilton, who introduced it to his family's chain of hotels. No one
established a patent, but the refreshing drink was immortalized by singer

Jimmy Buffet in his 1977 hit, "Margaritaville." A decade later, Buffet's business acumen turned his song into a retail store in Key West, Florida. "Margaritaville" expanded to over thirty restaurants across the United States, with franchises across the Caribbean and even in Australia. Margaritaville hotels and casinos continue to be a cheery gathering place for his dedicated fans, the Parrotheads. *Forbes* estimated Buffet's net worth at $1 billion before he passed. Buffet said, "I'm not about to apologize for being a good businessman. Too many people in music have ruined their lives because they weren't. I'm not a great singer and I'm only a so-so guitar player. . . . There's never been any grand plan to this thing. I'm making it up as I go along."[3] Despite all the imaginative Mexican bartenders who perfected the recipe, only Jimmy Buffet turned a sunny three-minute song about someone else's libation into a massive corporation offering an island escape in a drink.

One may not need to originate an idea to see its greater potential. There's creativity in recognizing opportunities. Plenty of books have been written about how to launch a business, develop a franchise, cash in on intellectual property. Others may offer instructions on how to monetize ideas. Jane Friedman focuses upon *The Business of Being a Writer* and *Publishing 101.* Yet she was shocked to discover a book titled *A Step-by-Step Guide to Crafting Compelling eBooks, Building a Thriving Author Platform, and Maximizing Profitability* offered on Amazon under her name. Someone had utilized Artificial Intelligence to copy her writing style, imitate her expertise, and brazenly offer it for sale right beside her real books! These kinds of challenges to authenticity and authorship will only increase as A.I. scrapes the Internet for inspiration. Friedman warns us, "Unless Amazon puts some sort of policy in place to prevent anyone from just uploading whatever book they want and applying whatever name they want, this will continue, it's not going to end with me."[4]

In the age of generative A.I., creators must seek out legal and business expertise to protect their imaginative work. After developing our personal creativity and honing our process, we may finally have a viable product. That may not mean we are the best person to package and market it. Wisdom begins by expressing an honest need for help because in areas where we are weak, others may be strong. Honest creativity depends upon savvy agents, accountants, and attorneys to survive and thrive.

Bright Ideas

We've all had those moments when a bright idea flashes across our mind. We may see a problem clearly and envision the solution immediately. Yet if we don't attend to that promising notion, the idea may pass. We may entertain the concept for a while, mulling the alternatives. Yet all too often our limited expertise or capital will keep us from acting on those creative impulses.

While directing a documentary in Yogyakarta, Indonesia, I came across the most refreshing soda I'd ever tasted. It had hints of lemon, lime, mint, and ginger. Our crew asked the server what was in it. Her not-so-secret ingredient was lemongrass. It brought a complexity to the carbonated citrus water that tantalized our tongues. Maybe it was the humidity or location that set this taste apart. As my sound recorder and I marveled at how quickly it rejuvenated us amid the heat, we talked about bringing it back to the States. We wanted to share the taste with others. People would LOVE THIS. We started riffing on names for the locals' concoction, settling on "Yogya Green." It had echoes of yoga, but with a different twist. It was a place, not a practice. Green could be the color of the bottle (echoes of the "limon" taste of Sprite) while also suggesting health and wellness. Who wouldn't want a refreshing taste of Southeast

Asian islands? Yet our brilliant idea (or rather Indonesia's) for a sparkling lemongrass soda never materialized. The original feeling lingered, but the form seemed so removed from our experience. As filmmakers, we didn't know anything about chemistry, bottling, or building a brand. We had a sensation that we couldn't turn into a reproduceable reality.

My neighbors were worried about how many Diet Cokes they were drinking. It may have had less sugar than regular sodas, but it wasn't exactly healthy. They turned their concern into Zevia, a healthier, zero calorie alternative. The name is a nod to stevia, a South American plant whose leaves provide a natural sweetener and when refined, a sugar substitute. As lawyers, they didn't have any experience making soft drinks, but they knew how to form a company, attract investment, and seek out experts. They formed partnerships that tried their patience but moved them closer to production. They started small but expanded their distribution. Zevia is now the best-selling soft drink at Whole Foods and is listed on the New York Stock Exchange. The path from bright idea to polished product may be crooked but rewarding. While I was merely thinking about a soft drink, my neighbors were busy brewing up fourteen different flavors.

We will never know who first controlled fire or who crafted the first bow, but we're deeply indebted to them. In *Who Ate the First Oyster?*, Cody Cassidy salutes the prehistoric geniuses who turned accidents into opportunities that enabled humanity to thrive.[5] Without an ability to catch and cook larger animals, we may not have had the muscle or means to cross lands and survive winters. These ancient, ancestral breakthroughs may not have been intentional. The chipping of rocks to make tools would have occasionally resulted in sparks. Which stonecutter observed that certain rocks generated more sparks than others? The prehistoric woman who struck pyrite against her rocks made fire a predictable and repeatable technology that could travel across seasons. The bow that launched

an arrow may have started as a toy. Imagine the delight that arose from the discovery that a bow could propel sticks up and out. Through an iterative process, the bows were expanded, the sinew stretched, and the arrowheads sharpened. Tie them all together on a large enough scale and a toy became a life-taking weapon. The movie *2001: A Space Odyssey* jumps from a prehuman reveling in the use of a bone to kill an enemy to a space station orbiting the earth. The history of human creativity (and weaponry) collapsed into a millisecond.

Creativity may be viewed as ingenuity, originality, or the shock of the new. It is associated with patents, inventions, novels. The resulting product may build upon prior innovations but rearrange them in a way that strikes us a fresh, helpful, convenient. It may involve plans for a building, a business proposal, and a scientific experiment. There are plenty of stories about ingenious innovators like Thomas Edison, George Washington Carver, and Marie Curie. We're grateful for their breakthroughs in electricity, farming, and medicine. Yet where would we be without the paper bag, the coffee filter, the dishwasher, or the windshield wiper? Each was invented by a different woman who spotted a problem and turned it into a product.[6] Their patents were challenged, their role largely forgotten. Thank God for Margaret Knight's paper bag, Melitta Bentz's coffee filters, Josephine Cochran's dishwasher, and Mary Anderson's windshield wipers. They all made our lives better in ways we largely fail to appreciate.

Why does Nestle have a Toll House label on their chocolate chips? Because dietician Ruth Graves Wakefield took an ice pick to a block of chocolate, folding the shards into her cookie dough. She introduced the chocolate chip cookie at her restaurant, The Toll House Inn. Nestle incorporated her recipe for the criminally small sum of one dollar and a lifetime supply of chocolate to Ruth. Creators may not get the renumeration we deserve (but millions sure enjoy the fruit of their labor).

There is a big gap in the usefulness of a toy like the Hula Hoop, the Super Soaker, or the Koosh Ball and a lifesaving vaccine that guards against COVID-19 infections, yet each play their role, whether delighting or delivering us. As a Stanford-trained engineer, Scott Stillinger thought he could do better than bean bags and bouncy balls that frustrated his kids.[7] He tied rubber bands together to teach his children how to play catch. The bands made a satisfying sound as they landed in their hands. In 1987, Stillinger refined his bouncy prototype, gave it an onomatopoetic name, and the Koosh Ball eventually landed in toy stores everywhere. When I met him on a North Shore beach in Hawaii, he and his grown-up kids were enjoying the fruits of his invention.

I also marveled at an episode of *60 Minutes* where Dr. James E. Crowe described how his team at Vanderbilt University's Vaccine Center identified and developed antibodies to protect the most vulnerable against SARS-CoV-2 (aka COVID-19). During twenty-five years of research, Crowe and his colleagues had pioneered techniques for isolating monoclonal antibodies that could neutralize viruses like Zika, HIV, influenza, and Ebola.[8] Just three months after the first COVID-19 case was diagnosed in America, Crowe and his team had isolated COVID-19 antibodies that were licensed to AstraZeneca. Evusheld became the first treatment to protect high-risk, immunocompromised individuals before exposure to COVID-19. I knew my old college classmate was smart. Jim was always curious, listening to new music, seeking out original experiences. Yet I didn't expect Jim to save thousands of lives via his groundbreaking therapeutic research. Stillinger's patent for the Koosh Ball probably earned him more than the breakthroughs Crowe led under the aegis of Vanderbilt. While we need joy-making toys, our lives depend upon preventative therapies. Creators' satisfaction may arise from intangibles—knowing how many lives were transformed through our insights.

You may never get the credit you deserve. Or you may cash in by adjusting others' innovations (think of Friendster versus Facebook). You may not cure cancer, but there is plenty to be proud of in bringing people delight via toys. What separates the bright idea from the burgeoning business? How to move from conception to reception, idea to implantation? Poet Wendell Berry distinguishes between "the Muse of Inspiration, who gives us inarticulate visions and desires, and the Muse of Realization, who returns again and again to say, 'It is yet more difficult than you thought.' . . . It may be that when we no longer know what to do, we have come to our real work and when we no longer know which way to go, we have begun our real journey."[9]

How do we move from potential to products? What ideas should we attend to and reflect upon to forge a different way forward? How do we sort out a passing feeling or phase from a considerable calling? Honest creativity recognizes and relies upon others to expand our influence.

Different Gifts

At age twenty-one, with a bachelor's degree in English literature in hand, I headed to Japan. I was shocked to discover that my liberal arts degree had some cultural cache abroad. How wild that all kinds of Japanese people, from businessmen to schoolgirls, would be interested in learning English. The most indulgent and seemingly useless of academic pursuits had marketplace value (abroad). It turned out that those looking to get ahead in their companies or college tests were more interested in English conversation than say, "A Treatise on Samuel Taylor Coleridge's Rime of the Ancient Mariner." I set off for adventure, unsure how I'd be greeted or received.

I joined a group of a dozen novice English teachers. We had a week of training in cross-cultural sensitivity and rudimentary Japanese lessons that would enable us to order a meal. We were also introduced to the basics of teaching, especially the art of English conversation. How do we engage those who are scared to speak in confidence-building activities? We heard testimonies about the joy found in those aha moments when the words students studied on the page take flight in a naturalistic way. When the Japanese no longer stumble while conjugating verbs in their head, they are ready to enjoy the wonders of English conversation.

After hearing from veteran teachers about what inspired them, the spotlight shifted to the business manager who organized our gathering. What inspired him? Nothing gave Ray more pleasure than to walk into a room and see all the chairs organized in straight lines. Full pitchers of waters and rows of freshly washed glasses also resulted in satisfaction. A well-dressed podium, equipped with a preadjusted microphone, fired him up. Ray brought order to chaos daily. And isn't that the original creative calling?

In the biblical book of Genesis, the earth is formless and empty and the Wind of God hovers over the deep waters. The world needs to be organized, to have daytime distinguished from night; land separated from seas. The stars become a means of keeping track of time and place. Something to measure ourselves against. The wide variety of animals need to be identified and named. Taxonomies are introduced almost immediately. Language gives us an ability to sort things out, to compare and contrast. Creativity and categorization are complimentary callings. After a propulsive creative act, one ancient and natural response is to figure out how to file it.

What kind of chaos do you need to get organized? Your time? Your space? All the variety of ideas dancing through your head? There are people who love to list things on a spreadsheet so they can be added and

subtracted, scheduled, and shipped out. They enable us to step back, to see where we are, to take stock of what's been initiated so we can more readily identify what's missing. Honest creativity admits that we need help getting our generativity in order. It is one thing to scribble out half-formed ideas. It is quite another to bring some craft and restraint to that initial brain dump. Creators need editors to sharpen their focus. They also need invoices to get paid. Artificial Intelligence can be a remarkably helpful and clarifying assistant. It spits out ideas and makes lists with remarkable acuity.

As a decidedly left-brained thinker, it had never occurred to me that the people getting all the desks in a row *liked* what they did. I thought conference organizers endured the drudgery of to-do lists because somebody had to. My sheltered, twenty-one-year-old self hadn't understood the variety of gifts and callings that we bring to a training session. What if some people *preferred* to be behind the scenes, getting all the elements in place, so the rest of us could step onstage without distraction or worry? Those natural born performers who never met a crowd they couldn't charm had a completely different set of skills than the conference organizer, the sound tech, and the business manager. I may lack administrative gifts but thank God for those who can organize chaotic creatives like me. We are made stronger by the gifts of a team. Admitting that we can't do it all, embracing our limits, makes room for others to flow in their calling. When we're honest about what we need, we expand our ability to succeed.

Business Interests

To turn our ideas into realities, we need a team. You may be gifted in writing, but not in business. You may know how to read profit and loss statements, but not how to reach a market. A logistics and operations

expert may be worth their weight in gold when it is time to scale. All these professions and roles depends upon creativity—with ideas, with images, with numbers, with pipelines and timelines. Once we acknowledge our strengths as well as our weaknesses, we make room for others to step up and join in the process. Two are likely stronger than one. Three or four may form a band that has all the right elements to succeed. Yet how many bands needed that fifth member, a manager, to handle all the details from contracts to bookings to budgets. Even the most talented individual performers will invariably thank their team on those ubiquitous award shows.

Who do you need to succeed? A cheerleader? A collaborator? An agent? A lawyer? A patron? A publisher? A publicist? There are times and seasons when we all need others to cover our shortcomings, to foresee our blind spots. It can be tough to admit we don't know it all. We have trust issues—insecurity regarding who we can call upon in times of need. So many creatives have been exploited over the centuries. Rock and roll founders like Little Richard, Chuck Berry, and Bo Diddley may have signed away the publishing rights to their music due to bad advice. Trusting the wrong people cost them millions of dollars over a lifetime of recording and performing. Canadian poet Leonard Cohen had to come out of retirement to cover the debts incurred by a thieving manager. His fans relished his comeback tour and final burst of recordings. We benefitted from his financial need to create. Yet shouldn't someone have taken better care of his songwriting royalties?

So many managers will attempt to lock rising talent into long-term contracts. Colonel Tom Parker famously exploited Elvis Presley's charisma for years. While Parker secured an impressive income for the King of Rock and Roll via merchandising, he also pocketed 25 percent of the profits. What might have been Elvis's most productive years of recording were largely squandered on forgettable Hollywood movies with bland

soundtracks. A young Dolly Parton had initial success as a songwriter. Her performing career only took off when country singer Porter Wagoner incorporated her into his weekly TV show. They were a dynamic duo for seven years before she penned a musical goodbye. "I Will Always Love You" was a declaration of independence from her boss. "Thank you for the opportunity. Glad you saw something in me, but I must move on." Elvis and The Colonel loved the song and wanted to record it. But they also required songwriters to surrender their publishing rights. Dolly declined the invitation because, "My songs were what I was leaving for my family and I wouldn't give them up."[10] She retained her intellectual property and Elvis moved on. Dolly recalls, "People said I was stupid. I cried all night. I would have killed to hear him sing it. But eventually, when Whitney (Houston) recorded it, I was glad I held out." Whitney's recording of "I Will Always Love You" topped the charts for fourteen weeks, becoming the best-selling single of all time by a female artist. Dolly Parton understands the value of protecting artists' rights (and has the publishing royalties to prove it!).

Whenever I've finished a movie project, someone usually wants to sue somebody. There have been painful instances of people stepping on my writing credits, trying to claim they contributed more than they did. Not only does it dilute your literal credit, but it also affects all subsequent residuals. Do you want to split your earnings on a project with someone who wasn't there when you created it? People who literally cannot type have claimed cowriting credit. And if you want to sue those who "jump" your credits, the lawsuit will often cost you more than the potential earnings. So now you get practical rather than principled. I should challenge those who are claiming they did more than they can prove. Yet getting to court, having a fair hearing, can prove too costly. Credit stealers are brazen. They dare creatives to sue, knowing that legal expenses may prevent them from pursuing justice.

If all this legal talk turns you off of the entertainment business, I don't blame you. It is disheartening to discover how many make a living off others' ideas. Executives' pay at movie studios, TV networks, and streamers continues to expand while they put a squeeze on screenwriters. Spotify offers musicians digital dimes rather than the dollars that used to flow from record sales. Technology that makes stories and songs more accessible also make creatives' work seems more disposable. Amid the glut of one hundred thousand new songs released *every day*, it can be tough to stand out (let alone make a living). How do you buy enough time to polish your gifts and sharpen your voice? Creator, you need a patron. Or rather, patrons. That is an older, fancier word for fans.

Fueling the Fire

There has never been a better time to build an audience or following. Social media allows us to distribute our latest songs, stories, and ideas almost instantaneously. We can also test our ideas in the public square before we start recording. We can build a fanbase through short videos uploaded to YouTube. We can follow and respond to the chatter our stories generate. We can respond to questions and requests for our art on TikTok. We can be genuinely surprised by what catches on with listeners. We can adjust our ideas based upon what people clearly want to hear from us. We can tailor the next project or pitch with our most devoted fans in mind.

If we get the funding via Kickstarter, then we can begin our projects with confidence. We already have enough to make it. Angel Studios famously allows underserved audiences to underwrite the kinds of projects they want to see. Fans' investment in series like *The Chosen* made it profitable before it commenced shooting. Consequently, a filmmaker can

start connecting with his core audience as production commences. Daily updates from on set or in the studio can build interest and anticipation for months, even years before the project is released. The production process becomes an extended marketing opportunity. It can take years to nurture a fanbase. Or we can be pleasantly surprised by how our creative idea attracts funding and support. It is tough to sustain a big project on our own.

Chris Woltman, manager of the band Twenty One Pilots, recalls the seven years of development that preceded their breakthrough *BlurryFace* album. The duo's early self-released albums were accompanied by an intimate online relationship with their fanbase fueled by intense live shows. They resisted the temptation to push their songs onto pop radio, aiming for a slow-burning "discovery" phase instead. Woltman explains, "Discovery could be in an image or Instagram that makes a potential fan ask 'what's that all about?', a video on YouTube or a friend sharing a band that they just discovered—things that were not what the industry has traditionally viewed as being the key to success."[11] The goal wasn't a quick radio hit but a sustained career. "You may have a breakthrough song, but a breakthrough artist is a much more complex idea. Long-term artistic careers have never been defined by the immediacy of radio singles."[12] It takes far more discipline and patience from an entire team.

Honesty creativity is a burning fire that must attended to. Too much wind can cause it to burn out of control. It may flame out fast. Yet it needs a steady supply of fuel to keep it from being extinguished. It is something that needs to be stoked. Poked. Lest it burn unevenly. Creative fires may start with a small spark. Minimal kindling is required. But to keep those fires going, we may need a friend to gather supplies while we maintain the flame. Trying to crank out "content" for our fans is a soul-draining process.

If we step away to gather more fuel, it can be helpful to have a creative companion focus on the fire. Make sure it stays confined and doesn't consume us. They can see what we may have missed. What kind of potential uses and applications have been overlooked. What about marshmallows and chocolate? Don't ignore the wonder of S'mores!

Who else should join us around a creative campfire? An accountant or line producer can foresee how much fuel will be required. They can offer projections that keep us tracking in a sustainable way. A music producer knows what kinds of instrumentation and performers to bring to the recording session. An editor can figure out what to remove. We may add garbage to the fire, considering all material good, not realizing some may produce noxious fumes. A scientist or engineer may figure out how to build a better fire. They can conjure something far more efficient and healthier for us all. The best fires radiate enough heat for many to gather round and enjoy the warmth and glow. Too much heat drives people away, causing them to cover their faces, shield themselves from the deadly flames. Who can help us keep us from burning out?

Creatives and entrepreneurs must be honest about our need for patrons, supporters, and funds. So many cultural wonders were community projects. It took hundreds of years for Parisians to build Notre Dame Cathedral. Centuries of crowdfunding resulted in the soaring spires along the Seine. After the nearly catastrophic 2019 fire, French politicians and artisans rallied to restore Notre Dame to her prior glory in time for the 2024 Olympic Games in Paris. This holy place is also a rousing symbol of civic pride.

Tourists flocking to Florence, Italy, to marvel at Renaissance art may not realize how one family underwrote much of that cultural economy. Profits from the Medici Family's bank, established by Giovanni de' Medici in 1397, financed the completion of Florence's stirring cathedral and the artistry of Michelangelo, Leonardo da Vinci, and Raphael. Giovanni's

son Cosimo de' Medici provided the funding for the Monastery of San Marco, including the frescoes painted by Fra Angelico. Cosimo commissioned Donatello to create bronze statues of *David* as well as *Judith Slaying Holofernes* for his Palazzo Medici. He also paid Brunelleschi to rebuild their parish church of San Lorenzo. His grandson, Lorenzo, dubbed the Magnificent for his patronage and poetry, supported Da Vinci, Michelangelo, and underwrote Botticelli's sublime *Birth of Venus*. Between 1434 and 1471, Lorenzo estimated that his family invested 663,000 florins (their regional currency) on public projects—the equivalent of $460 million in our current economy. He wrote, "I do not regret this, for though many would consider it better to have a part of that sum in their purse, I consider it to have been a great honor to our state, and I think the money was well-expended and I am well-pleased."[13] The House of Medici secured their political power by continuing to fund artistic projects, whether serving as popes or as queens.

The last heir to the Medici fortune, Anna Maria Luisa, signed a family pact (*Patto di Famiglia*) with Tuscany in 1737, ensuring that her family's art collection would remain in Florence. She stipulated that "these things being for the ornament of the state, for the benefit of the people and for an inducement to the curiosity of foreigners, nothing shall be alienated or taken away from the capital or from the territories of the Grand Duchy."[14] Their family offices (in Italian: *Uffizi*) were transformed into a permanent art gallery. Sixteen million tourists per year affirm her commitment to Florence. Despite many questions surrounding their political maneuvering, the Medici family became models of arts patronage for centuries to come.

We may not have known about the French Impressionist painters if gallerist Paul Durand-Ruel hadn't supported them. While the French academy rejected the Impressionists blurry artistic vision, Durand-Ruel bought more than 1,000 Monets, 1,500 Renoirs, and 800 Pissarros—over

5,000 impressionist pictures in total. Yet it took years for public taste to catch up with his collecting. Claude Monet stressed that "we would have died of hunger without Durand-Ruel, all we impressionists. We owe him everything. He persisted, stubborn, risking bankruptcy 20 times to back us."[15] Jennifer Thompson, curator for the Philadelphia Museum of Art's 2015 exhibition *Discovering the Impressionists: Paul Durand-Ruel and the New Painting*, noted, "He became a very good friend of the impressionist and would offer them stipends. When they needed to pay rent or had bills, he would offer them loans."[16] He staged eight group exhibitions of the Impressionist paintings between 1874 and 1886 with limited sales until he sailed to America with three hundred paintings. Durand-Ruel noted, "The Americans do not laugh, they buy."[17] Hundreds of Impressionist paintings in American museums today can be traced to his tour. Pierre-Auguste Renoir summed up his influence, "Durand-Ruel was a missionary. It was our good fortune that his religion was painting."[18]

Creative movements have been fueled by patrons who provided space to convene. A'Lelia Walker inherited her mother's, Madame C. J. Walker, multi-million-dollar hair care business in the 1920s. A'Lelia hosted lavish parties and salons in her Harlem townhouse, christening it "The Dark Tower." Leading figures in the Harlem Renaissance like poet Langston Hughes and novelist Zora Neale Hurston gathered for art exhibitions and readings. In his 1927 poem "From the Dark Tower," Countee Cullen names the racism that has kept too many African Americans from reaping the fruits of their labor. He encourages his fellow artists to continue to "tend our agonizing seeds."[19] Walker acknowledged her role in the movement, "Having no talent or gift, but a love and keen appreciation for art, The Dark Tower was my contribution."[20] Love and appreciation of art is a gift that creatives still desperately need.

I serve as president of The Wedgwood Circle, a nonprofit organization supporting good, true, and beautiful entertainment for the common

good.[21] We're named for Josiah Wedgwood, the chinaware entrepreneur who turned his artistry into advocacy during the 1700s. He sold images that challenged the slavery trade and poured his profits into underwriting the abolitionist movement of the Clapham Circle in England. Contemporary members of the Wedgwood Circle have supported upcoming musicians like Ryan O'Neal of Sleeping at Last long before he reminded us that "You Are Enough." Years before multi-instrumentalist Jon Batiste cleaned up at the Grammys for "We Are," we supported his development of a special melodica he ended up playing on *The Late Show with Stephen Colbert*. We were honored to invest in songwriter Ruby Amanfu's career before she was Grammy nominated twice for Song of the Year for helping H.E.R. through a "Hard Place" and making "A Beautiful Noise" with Brandi Carlile and Alicia Keys. We've supported young writers who went on to produce television shows like "Designated Survivor" and "The Good Doctor." Our circle has been instrumental in funding films like Martin Scorsese's *Silence* and a theatrical adaptation of *Babette's Feast*. We've found there are no shortage of artists with grand visions. Where creatives often struggle is in putting together a viable business plan. They need help connecting their projects to the marketplace. We're grateful for organizations like Praxis which focus upon redemptive entrepreneurship.[22] They mentor start-ups during a year-long training program that refines business plans. They connect founders to funders at the conclusion of the process, making sure their ventures are viable before they go to market.

Generative A.I. can allow an idea to take immediate shape. We can quickly see or hear what we're thinking. But we often need time in the creative wilderness, refining our voice, sharpening our business acumen, and securing a patent, before we're ready for the marketplace. Burgeoning bands need time to build a fanbase and refine their sound. Parents who encourage experimentation, teachers who provide the well-timed

word, and patrons who buy us time are all key parts of the creative process. Inventors are not always the best innovators. Great ideas have worth, but they need capital. There are talented people who are experts in areas beyond our comprehension—production, exhibition, distribution, branding, and copyrights. We must be honest about our shortcomings. Patrons can sustain us through formative years. We need lawyers, accountants, and execs who can guide us from concept to launch. Creatives need trustworthy collaborators to expand their visions and reach. To build a sustainable career, we need a team of business savvy supporters to keep us from being devoured.

Wolves, Serpents, Doves

Before sending his followers into the marketplace, Jesus encouraged them to combine two seemingly contradictory traits: "Be as shrewd as snakes and as innocent as doves."[23] This is an important balancing act in creative industries. Consider the warning that precedes it: "I am sending you out as sheep among wolves." This is a painful reality when we consider patents and intellectual property. There are plenty who will seek to exploit our talent. These wolves may gladly chew us up and spit us out, like just another tasty snack. Stories of assault and abuse are legion, especially for young women placed onstage. The pressure to sexualize ourselves may feel overwhelming. Yet at the end of the project, we will be the one embarrassed or ashamed while others merely collect the profits. Learning to stand firm on our foundations is essential. Kudos to the parents of Beyoncé and Taylor Swift who stewarded their daughters' careers rather than exploiting them.

In the Bible, the serpent is associated with craftiness, constructing persuasive arguments, and convincing people to compromise their

principles. Why would Jesus celebrate snakes? Perhaps it is permission to study the marketplace, to develop a sense of what's selling. What are people looking for? What is trending and hot? It is important to understand the industry you're entering. It is fine to be savvy about sales. We need to know what the competition looks like. Who and what are we up against? A serpent also knows how to see through others' craftiness. Once you understand how entertainment executives think, it is far easier to ferret out their motives. We can decide how to satisfy their longings while retaining the integrity of our mission and project.

What we're rarely taught in business classes is innocence. That doesn't mean naivete. I think it has to do with expectations. We can read the fine print of contracts carefully and still hope and trust that we won't need to sue our business partners. We can enter into agreements in good faith, with eyes wide open. We don't want to fear those we seek to collaborate with. We don't want to distrust band members who we hope to craft gorgeous melodies alongside. We need open hands to receive what may come our way.

Yet plenty of wide-eyed doves enter a creative industry and get gobbled up whole. They reek of desperation. They are impressed by proximity to power. They are easy marks, ready to be taken for a ride. They enter partnerships without doing due diligence. They sign exploitative contracts that dog them for years. This is innocence as foolishness.

When we couple innocence with wisdom, we learn how to protect ourselves. We may need a trusted mentor to talk through the contracts we've been offered. Over the past twenty years, I've gathered with a circle of four trusted friends in Hollywood to exchange stories, to offer warnings, to unpack meetings, and prepare for the next pitch. We also smoke cigars. We have a variety of gifts and callings in our circle. One directs projects all over the world. Another produces hundred-million-dollar-movies for demanding studio executives. A third focuses solely

upon marketing and public relations. I've carved out a roll as analyst, placing opportunities in context. What's the history we've inherited and the cultural moment at hand? Around a firepit, we warn each other about the wolves we encountered. We recount when we've been shrewd in our negotiations and when we've been duped due to innocence. Honest stories of failure allow us to retain our sanity and renew our hope. May we learn from our humbling mistakes. We will continue to tell the truth to each other, to market ourselves honestly, with humility about what we don't know. But in that process, over two decades, we've developed savvy that make us formidable. We've been fools and therefore have hard won, collective wisdom. We can peddle our wares with confidence in what we're offering and what's fair. We can negotiate from a place of strength rather than naivete. We know what we're worth because we know where our ultimate value comes from.

HONEST CHALLENGE

1. What areas of career management—accounting, invoicing, branding, calendaring—are you strongest in? Where do you need the most help? Who can you ask for referrals on getting the support structure you need to succeed?

2. Do you have an idea that needs resources to go from concept to launch? Who are some key patrons or investors who might support your endeavor? What kind of pitch deck or business plan can you prepare (perhaps with their help!) outlining your plans?

8

HONEST CRITICISM

"It's very pleasant to be praised, but it doesn't actually help you."

—FRANCIS BACON, PAINTER[1]

CRITICISM STINGS. IT CAN BURN A HOLE IN OUR HEART or take the wind out of our sails. How many children who create with a genuine innocence are eventually shut down creatively by a teacher's ill-timed word? When we've poured our heart and soul into a project, even the slightest hint of judgment can cause us to get defensive. We may have difficulty separating ourselves from our work. Consider the meltdown that overcomes a writer who overhears her husband's honest disdain for her latest novel in the 2023 movie *You Hurt My Feelings*.[2] Julia Louis Drey-fus plays the midcareer author who gasps for breath and bends over with nausea at the thought that her closest companion masked his disdain for her work. Opening to criticism is an invitation to have our most vulnerable places exposed and potentially violated. So much of our self-worth gets wrapped up in our work. We try to heal ancient wounds via creative output. Toni Morrison cuts through such sentiment, "Some authors

really want their books to be loved and want themselves to be loved, but I don't want that. I don't want my hand held. I don't want to be stroked. I don't want to be patronized."[3] She learned the constructive power of honest criticism. How do we develop an ability to receive notes, reviews, and criticism?

What is the strongest material in the natural world? Titanium? Granite? Diamonds? These are all inanimate objects. What about something in the animal world, designed to deflect intruders? We may think about armadillos or rhinos. Their skin has an ability to deflect whatever threats come their way. Comedians must develop an armadillo hide to withstand the hecklers who accompany public performance. When epithets are hurled from the stands or published online, the well-protected artist brushes off such criticism with aplomb. We can remain untouched by critical pans.

What about spiders? Their rail-thin silk has a remarkable ability to catch others in its trap. It is open enough to allow wind to pass through, but tight enough to catch prey in its web. Water may pour upon a spider web, but the material is usually adaptable enough to bear the weight of water. As the sun comes out, the water evaporates and the web returns to its sticky form. Isn't that closer to the skills that writers and performers need to develop? The creative tales we weave need to be strong enough to withstand criticism. They must endure the changing fashions in style and subject matter. We may be stretched in our understanding, but can our skills snap back to shape after being tested?

It turns out the strongest material in the natural world are shells. Or more specifically the teeth of an Australian limpet.[4] They must be porous enough to allow nutrients to enter, but also firmly attached to their setting. What kind of walls are needed to keep invaders from entering the inner sanctum? How much structure is required to resist the pressures that can assault a shell all day long? An armadillo can deflect criticism.

A spider can spin an attractive web that can be dismissed with a simple swipe, but a shell retains its power regardless of size. Whether small or large, they have filters which allow them to receive all kinds of nutrients. They can let fresh ingredients in but just as easily let them wash away. It is open to all kinds of exchanges that sustain a shell's life. The teeth provide a framework that is not easily dislodged. An artist or entrepreneur will lock on an idea, really sinking their teeth into a concept. But to move from an idea to a reality requires a humbler approach to sourcing.

Can we, like *New York Times* film critic A. O. Scott, dare to believe in *Better Living Through Criticism*?[5] He traces the roots of criticism back to the Creator. In Genesis, each stage of the creative process is concluded with an assessment, "And God saw that is was good." After bringing order to chaos, God stepped back, surveyed the results, and offered a judgment. Notions of good and bad, beautiful, and helpful have always been with us. We are intended to make aesthetic judgments, to distinguish between creatures and to assess what we've created. We may be inclined to consider our work "good," yet most creatives I know are usually their harshest critics. We may appreciate others' artistry but notice each imperfection in our canvas or writing. We're aware of how our story cuts corners or our business plan falls short. Consequently, it is tough to submit our projects for outside review. We can't handle the criticism that accompanies public performances. Yet how can we improve our efforts if we're unwilling to hear what makes it good or bad? As A. O. Scott contends, "Criticism, far from sapping the vitality of art, is instead what supplies its lifeblood."[6] Who are the trusted advisors who can tell us where and how to edit our work?

The sheer volume of self-appointed movie critics on the Internet can be daunting to any filmmaker. The social media hordes can wipe out a long career after one artistic or cultural misstep. Even critics are not immune to criticism. The unreflective chorus of jeers leveled by fan boys

at A. O. Scott prompted him to retire from film criticism after publishing 2,293 reviews. He'd grown tired of being swarmed on Twitter by "angry devotees of Marvel and D.C." In his resignation column, Scott bemoaned how "fan culture is rooted in conformity, obedience, group identity and mob behavior, and its rise mirrors and models the spread of intolerant, authoritarian, aggressive tendencies in our politics and our communal life."[7] We live in such a hypercritical, supersensitive age that even professional critics can't endure the blunt force of the masses. Creatives must endure self-criticism, resist mob behavior, and still welcome the genuine insights of trusted collaborators.

Writing is rewriting. That's the painful truth of the creative process. We want to believe our first drafts are brilliant. Lord knows, I've suffered through plenty of painful first cuts of students' films. But that first assemblage is merely the block from which the polished gem will eventually emerge. We need criticism to give us perspective, to separate the gold from the dross. Yes, we must overcome the inner critic that often keeps us from embarking on a creative journey. We must tame that voice in our head that prevents us from taking risks and putting ourselves out there. Yet studying others' accomplishments, appreciating why something works, can equip us to recognize our own weaknesses. Developing a realistic self-appraisal of our gifts and limits can aid our creative process. Getting something on paper or in concrete form is a huge step. Figuring out how to refine those half-formed ideas makes all the difference. This is how we move from amateur to professional.

Where do we find helpful feedback? It may arise from a creative collaborator. It may come from our family or friends. Lee and Janet Scott Batchler are a married screenwriting team I've known for more than twenty-five years. The writers of *Batman Forever* work on separate computers and rewrite each other's pages. Only when they've both critiqued and polished the others' work, do they feel it is ready to present it to the

movie studios. Those closest to us may know when to administer a finely tuned critique. But they also know how tender or insecure our hearts may be. They may be inclined to hold their tongues, offering encouragement rather than honest criticism. This is why we pay professors or coaches to put us through the paces. We turn to a more objective source to sharpen our skills. They draw upon a broader knowledge of the long sweep of art history, pulling from hundreds of examples as points of comparison and contrast. We're glad they know more. We expect them to offer advice, to point out our weaknesses, to shore up our areas that need improvement.

And yet, teachers get tired. They can be overwhelmed by the sheer volume of papers or projects to grade. The temptation to drop students' A.I. assisted papers into an Artificially Informed feedback engine is palpable (and defeating). Teachers may decide it is easier to give casual praise than genuine criticism. A comment like "good job" or "nice work" may offer faint encouragement, but it doesn't cause us to reflect on our process, to consider what's needed to move from good to great. There's plenty of good work to go around, but greatness is always in short supply.

We often know when we've phoned something in. It is possible to slap together an essay, to string a few scenes together without too much work. Generative A.I. can assemble enough fast facts to pass a class assignment. How about in the physical world of art? Oil paintings require time to dry. Watercolor is tremendously unforgiving. But acrylic allows us to cover our mistakes almost as we make them. Yet covering a canvas is never the same as inhabiting the space, really dwelling with the imagery long enough to see what it wants to become. A.I. may enable us to speed up the creative process through iteration. Yet learning to assess our own work, to build upon what we've assembled so far, to respond to criticism is hopefully a form of fun. An art professor can stroll through their students' studio every couple of days and see who is practicing their craft

rather than fulfilling an assignment. Editing is a muscle that develops with time.

Do we want to be criticized? The biblical Proverbs teach us that "Whoever loves discipline love knowledge, but whoever hates correction is stupid."[8] Ouch. That is blunt. We don't want to be attacked or derided. We want to be handled with care. Proverbs also suggests that "thoughtless words can wound as deeply as a sword, but wisely spoken words can heal."[9] The truly well-timed word can be life-giving. It can unlock our deepest intentions. It can push us back into the arena with fresh eyes, eager to dig deeper, to push harder. A few key questions can put us in touch with the gap between our aspirations and our execution. Concepts we thought were clear are revealed as muddy. Themes that we considered subtle are exposed as unrealized and undelivered. Good criticism reminds us how to make the main thing, the main thing. It can make our work more direct, unfiltered, and impactful. The artistic pretense starts to fade. The purity of our intent begins to shine through. It shifts from what I was trying to say toward "what I said." Suddenly, we're discussing the actual project rather than the aspirations behind the project.

Rarely have I found that our intent needs to be blurred. Sure, there can be propagandistic messages. A thesis can be stated too plainly. A project may lack metaphor. But most of the time, it is the mixed metaphors that need an adjustment. The competing claims must be sorted out. Three themes may need to be boiled down to one. A focus on the basic of plot, what a character wants, will bring that theme into sharp relief. The work will become unified, a merger of text and subtext that causes audiences to reflect upon their own place within the work. We finally have someone to bounce our own experience off, rather than expending our energy figuring out what the creator intended to communicate.

Bad mentors impose their agenda upon us. Their social, religious, or political lens colors every comment. The critique becomes a reflection

of their values rather than the students' intent. A professor who cannot set aside their agenda to enter the milieu of their class has imposed an unhelpful barrier. Yes, we all have passions and convictions and ideals. But if the student/artist doesn't share those passions, we do not pull them into our circle of influence by noting that gap. We can bring our love for a subject or a performer or a period into a discussion without demanding allegiance. My sources aren't likely to be your inspiration as well. But my respect for the craft, my years of reflection, may reveal how a well-trained eye or ear can deepen a creators' reservoir. Sharing our loves may prove infectious. Demanding others share that love often ends in resentment.

The Value of Editing

Artificial Intelligence can generate polished paragraphs in seconds. Abode's A.I.-enhanced Firefly can swap in new backgrounds or colors to any image with a single command. The ubiquity of digital cameras enables Reality TV producers to record hours of conversations that lack focus or drama. Computers can sort through so many permutations, offering us the best approximations and recommendations. But how do we hone what matters, turning good ideas into polished presentations? In an age of abundant words and images, editing is an art of increasing importance. These professional critics provide the honest feedback that creators often don't want to hear. Cut. Shorten. Delete. Not just to shorten a story or tighten a television show. But to get to the heart of the matter quicker. Editors don't dance around a concept. They literally cut to the chase, to the dramatic fulcrum, the moment when the stakes rise and choices matter. Editors are blunt. They've read everything, seen everything, and are not easily impressed. Well before generative A.I., they

were sorting through enough material to know what to expect. A sharp editor's notes can spark a whole new range of options in a creator's mind. A great editor challenges creatives to generate a different ending, a twist to the genre, a novel approach to solving a problem. Yet they rarely get the credit or recognition they deserve.

The long-time editor of *The New Yorker*, Robert Gottlieb said, "The editor's relationship to a book should be an invisible one."[10] As the lead editor for Alfred A. Knopf publishing house, Gottlieb was the observant eye who sharpened the early work of novelists like Michael Crichton, Cynthia Ozick, and Toni Morrison. He downplayed his role in their process, declaring, "Editing is simply the application of the common sense of any good reader. That's why, to be an editor, you have to be a reader. It's the number one qualification."[11] For a film editor, training begins by being an avid and active film viewer. For a record producer, a keen ear starts with listening to lots of music, all kinds of genres, to notice patterns and differences. A music supervisor blends the two professions—equal parts film editing and record producing—both rooted in familiarity with all kinds of styles. Cynthia Ozick recalls how Gottlieb's editorial voice influenced her writing over time. "Now, very often when I am writing, I have something like a bird sitting on my right shoulder, a watchful bird looking over my shoulder at what I'm doing. I want that bird's approval—I have to get it. It is a very critical bird, who is in a way a burden, but also grants me *permission*. This bird is the mind of Bob Gottlieb."[12]

Michael Crichton was working as medical doctor when he sought to publish his first novel, *The Andromeda Strain*. Gottlieb's editorial notes pushed Crichton to get to the crux of the drama much faster, to layer the character beats within the action. He also challenged Crichton to shift the ultimate tension, from whether a character turns on a nuclear device, to how to stop a machine that's turned itself on. Crichton reflects, "That

was the first time I understood that when there is something wrong in writing, the chances are that there is either too much of it, too little of it, or that it is some way *backwards*." We need editors to alter our perspective, to expand our point of view. Crichton insists, "I think every writer should have tattooed backwards on his forehead, like ambulance on ambulances, the words *everybody needs an editor*."[13]

Thanks to A.I., it is easy to generate an abundance of words or images. It can also edit images in seconds. But what if the angle of approach is wrong? A key, deeply human component to our creative work is P.O.V. Whose story are we telling? And what is the creator's unique voice or point of view?

We rarely see all the iterations a project goes through before it is complete. Harper Lee's beloved literary debut, *To Kill a Mockingbird*, has been adapted to film, plays, and graphic novels.[14] Yet the biggest adaptation occurred in the gap between Lee's early drafts and the book that has been assigned by thousands of school districts as a paragon of racial heroism. The prescient, six-year-old narrator "Scout" portrays her father, lawyer Atticus Finch, as the most virtuous advocate imaginable. His defense of a black man, Thomas Robinson, accused of raping a young white woman, inspired so many legal careers. *Mockingbird* chronicles the injustices that flow through Maycomb, Alabama, from lynch mobs to biased juries. Scout's loss of innocence takes readers through a series of revelations, challenging us all to check our prejudices and join Atticus's long march for equality.

Fifty-five years after *Mockingbird* was published, the public saw Harper Lee's original first draft, *Go Set a Watchman* (2015).[15] While Scout remains the narrator, she is returning to Maycomb at age twenty-six, during an annual visit from New York. Her father, Atticus Finch, is a retired lawyer and former state legislator. Scout's rosy view of her father is ruined by what she discovers. The Atticus of *Watchman* has pamphlets like "The

Black Plague," introduces racists at Citizens' Council meetings, and is trying to moderate the rate of integration brought on by the Supreme Court ruling in *Brown v. Board of Education*. Rather than admiring her father, a much older Scout is disappointed and distraught by his resistance to equality. He is portrayed not as a hero but as a mere man, full of cultural blind spots when it comes to race.

So where did the progressive approach to race and justice of Atticus Finch in *Mockingbird* come from? A literary editor saw the potential within *Go Set a Watchman* for what it might become. Tay Hohoff of the J. B. Lippicott Company found the flashbacks in the novel most compelling and encouraged Lee to develop the voice of a young Scout. But how did the dark tone of *Watchman*, about a daughter's disillusionment with her father, shift to redemption and aspiration? How did Atticus and Maycomb resisting the civil rights movement morph into how one heroic white lawyer can initiate change? This far more admirable Atticus may have been modeled on the research of Tay Hohoff that occurred alongside her editing of *Watchman*. While Harper Lee retooled her manuscript, Hohoff was working on a biography of social activist John Lovejoy Elliott. Hohoff drew upon her progressive Quaker roots in both her churchgoing and as well as her education. The advocate for the poor and downtrodden that Hohoff documented in her 1959 biography, *A Ministry to Man: The Life of John Lovejoy Elliott*, is more closely aligned with the virtuous Atticus of *Mockingbird* than the resistant segregationist of *Watchman*. The notes of an editor pushed Harper Lee's bitter first draft toward its inspiring, final form.

Perhaps Harper Lee's upbringing hadn't enabled her to put enough distance between her roots and her intent. In *Go Set a Watchmen*, she is still writing toward something. It aspires to greatness but struggles with blind spots. Writers hoping to create "the great American novel" should be encouraged that it doesn't come easily. That rough draft may need

more than a polish. The eye of an editor can make a huge difference. As a creator or entrepreneur, we must be ready to receive honest criticism.

A New Angle

Good criticism reveals a new angle, an approach to character or framing that enriches our intent. Director Destin Daniel Cretton won Best Short Film at the 2010 Sundance Film Festival for *Short Term 12* because he packed so much empathy into twenty-two screen minutes. He drew upon his own experience working in a group home for foster youth. The resulting project feels remarkably real and lived in because it was. *Short Term 12* demonstrates how similar the struggles of the professional caregivers and the "broken" foster youth can be. The challenges of navigating any given day may prompt any of us to swing at a punching bag, engage in self-harm, or seek relief in alcohol or drugs. Destin's initial, award-winning short is told through the eyes of a young man dealing with his girlfriend's impending pregnancy while caring for teens who've been abused and abandoned by their parents. How to reconcile potential fatherhood with all the fractured families that made his job so pressure-packed? It causes our lead character, named Denim, to nearly crack. Once we all acknowledge our fragile mental health and well-being, though, the distance between case worker and problem child begins to blur. Our common humanity becomes a bridge we can all cross. Destin's award for Best Short Film resulted in an invitation to the Sundance screenwriting lab.

How to expand a beautiful short into a full-blown feature? After being workshopped and held up to criticism, *Short Term 12*'s protagonist shifted from a guy dealing with his girlfriend's positive pregnancy test to the woman herself. Why not make put the focus upon the one bearing the greatest physical and emotional weight of the situation? The

resulting feature film, *Short Term 12* (2013), still takes place within the foster care system.[16] Some of the same young actors reprise their roles, like LaKeith Stanfield's sensitive rapper. Yet the dramatic spotlight falls upon the character of Grace, played by Brie Larson, as the adult counselor dealing with her own personal baggage amid a sea of adolescent angst. Restraining a violent foster kid could endanger her child. Her secret becomes a source of considerable anxiety for the audience identifying with her struggle. Flipping the script, altering the protagonist from a concerned boyfriend to a pregnant case worker, turns a very good short film into a great feature debut. *Short Term 12* cracks open audiences' heart with hard-earned empathy and compassion. We laugh, we cry, we cheer for the discarded teens and the professionals who care for them. The best artists learn how to change their perspective *within* the creative process. They find the freshest angle of approach for their story, sculpture, or song.

Once the raw material has been gathered, the editorial task commences. Sculpture was traditionally a subtractive process. Chipping away at the material until the figure emerges. Michelangelo's ability to find David within a marble block is astounding. Most editing these days involves chipping and sifting through too much. We are all digital millionaires, carrying so many files in our computers. Too many words, too many images, too many options are packed into our phones. Curation is key. We've come to depend upon A.I. to sort through the abundance. Out of the 100,000 new songs uploaded to Spotify every day, which one should I listen to? A.I. becomes the editor of our playlists, sorting through our viewing or listening history, to refine their commendations. So why do we need editors? They provide a point of view outside our experience that can make our good idea great. Editors must be rigorous in their opinions, exacting in their methods, demanding in their critiques. Editors supply the polish that turns a rough cut of a movie into a polished diamond.

Directors like Francis Ford Coppola, Steven Spielberg, and Martin Scorsese are often hailed as geniuses for their visionary and visceral films. Audiences still marvel at the roar of the helicopters waging war upon Vietnamese beaches in Coppola's *Apocalypse Now* (1979). The violent fight sequences in Scorsese's *Raging Bull* (1980) still pack a wallop. Steven Spielberg is celebrated for the chases which still thrill in *Raiders of the Lost Ark* (1981). Yet each of these cinematic classics were elevated by the precise work of a largely unseen editor. Their work begins by combing through all the raw material, take after take after take. On *Apocalypse Now*, editor Walter Murch started with 230 hours of footage, over a million feet of film. Guided by the screenplay, the editor will assemble a rough cut. It is usually painfully long, maybe three hours rather than a taut ninety minutes. This initial editing is largely a subtractive process, honing down the scenes, finding the core emotions in the story. Murch's goal is to "always try to do the most with the least."[17] The finest editors are also generating new overlaps within and between scenes, constructing subtle meanings. They find a rhythm within the work that turns it from a dirge into a symphony.

In *Apocalypse Now*, Walter Murch (not Coppola) cut images of American military might to the operatic sounds of Wagner's *Ride of the Valkyries*. We ride in the helicopters above gorgeous breaking waves on a beach. As bombs drop on the villagers, the soldiers break out surfboards. The contrast is thrilling and horrible at the same time. Murch's groundbreaking work earned him the first screen credit as "Sound Designer." Thelma Schoonmaker is the editor who put the body blows together in *Raging Bull*'s boxing scenes. Sometimes the shots are short and punchy, approximating the furious pace of a championship fight. Other images are slowed down long enough to deliver the visceral impact of boxer Jake La Motta's fists. In between, flashbulbs pop. Blood flies. Schoonmaker

creates a cinematic ballet out of hyperviolent imagery, a poetic rhythm that earned her an Academy Award for best editing.

Raiders of the Lost Ark is also about the contrasts of slow moments, the anxiety before Indiana Jones grabs the golden idol, and the hail of poison darts and giant boulders that follow. Editor Michael Kahn sorted through the many angles provided by Steven Spielberg's directing to craft the most dynamic escape possible. Close-ups of Indiana clinging to a vine are intercut with shots of the door dropping and the cave crumbling. Michael Kahn picks up the pace as the boulder bears down upon the stuntman playing Indiana Jones. This classic ten-minute opening sequence is a study in contrasts, starts and stops, pauses and panic. Film editors manipulate time and space to quicken our hearts and make us pay attention. They understand how the juxtapositions between what we're seeing and hearing cause us to sit up in our seats. Sound editors add the piercing sounds of arrows flying and bodies crashing that we expect from our blockbuster movies. Masters like Walter Murch literally wrote the book on editing pictures and sound, *In the Blink of an Eye*.[18] Thelma Schoonmaker and Michael Kahn share the honor of most Oscar nominations (eight) as well as awards (three). They are the unseen powerhouses behind our most celebrated filmmakers, balancing emotion, story, and rhythm.

Golden Ears

Record producers' function in a similar way to editors. They provide the golden ears that musicians need to sharpen their sound. The myriad of tools available to recording artists can be overwhelming. Every note can be tweaked. Any instrument added to the mix. How to resist the temptation to pack a track with too much? We don't see the bearded visage of

producer Rick Rubin onstage performing. I occasionally see him surfing before he heads into his Shangri-La studios in Malibu, California. The bombastic sounds of his early productions for rappers like LL Cool J and The Beastie Boys and metal bands like Slayer are seemingly in stark contrast to his polished work with Ed Sheeran and Adele. What does Rick Rubin's producing (or editing) provide? He gives musicians the confidence to rely upon their core abilities, to record their best selves. In the case of country singer Johnny Cash, that turned out to be just the man and his guitar. The stripped-down sound of Johnny Cash's American Recordings resurrected his career.[19] Rubin got Cash back to what he did best, telling a story with the dramatic timbre of his voice, with only the barest of accompaniment needed.

What kind of production help did the Dixie Chicks need on their Taking the Long Way album?[20] Bristling criticism of then-President George W. Bush and the invasion of Iraq by the Chicks lead singer Natalie Maines had resulted in all kinds of blowback from country radio programmers and Nashville fans. Very specific death threats arrived before a concert in Dallas. Two years later, their musical future was at a crossroads when they came to Los Angeles to record with Rick Rubin listening in. They didn't necessarily need a different sound. The Dixie Chicks thrived due to encouragement to speak their minds. Rather than stepping back, all three members, including sisters Martie Maguire and Emily Strayer, spoke up even more clearly with their first single, "Not Ready to Make Nice." The ideals of "forgiving and forgetting" are contrasted with the painful reality of an angry mother teaching her daughter to hate a perfect stranger. Natalie Maines's voice rises when she calls out a "fan" who says, "I better shut up and sing or my life will be over." The Dixie Chicks signal their resolve in an uncompromising artistic credo that follows throughout the album. Natalie acknowledges how she could have made it easier on herself, but she also never seems to do it like anybody

else. "The Long Way Around" is a hard choice the Dixie Chicks were willing to make. Grammy Awards for Album of Year, Song of the Year, and Record of the Year followed.

Artists are not obliged to listen to the producers. Adele penned the most emotional songs from her massive album *21* after an ugly break up with her boyfriend.[21] The propulsive pain in "Rolling in the Deep" was written the day after a fuming argument. She collaborated with London-based producer Paul Epworth to quickly record a demo that could serve as a touchstone for her later sessions scheduled with Rick Rubin. He had been so impressed by her live performances that he assembled a crackerjack band to support her LA recordings. Rubin wanted to capture the passion that pours out from Adele onstage in the studio. Plenty of room was left for spontaneity with musicians who could follow her lead, responding to shifts in her interpretation and voice. Rick's openness couldn't recreate the raw emotion that Adele brought to those original London sessions, though. She chose to build on her vocals from the first version of "Rolling in the Deep." Her breakup song became a global phenomenon, topping the charts and winning the Grammy for Record of the Year and Song of the Year. Sometimes an artist must learn how to trust their instincts, to consider the suggestions of a producer, agent, or editor, before ultimately deciding what best represents them.

Encouragement, Confrontation, Reminders

How do we learn to balance our instincts with others' critiques? We must be open to honest criticism even if we may not want to hear it. As Proverbs insists, "The way of fools seem right to them, but the wise listen to advice."[22] Those closest to us may have our best interests at heart—if we will get our own assumptions and presumptions out of the way.

Consider the complicated relationship of King David and his chief critic and friend, the biblical prophet Nathan. Early in David's reign, he tells Nathan about his ambitious plans to build a temple for the Lord. David is troubled by the gap between his majestic house of cedar and the Tabernacle of God, which is a mere tent. Doesn't God deserve a statelier and more permanent house of worship? Nathan affirms his vision, encouraging David to "Go, do all that is in your heart, for the Lord is with you."[23] These are the empowering words aspiring leaders, builders, and artists need. Yet that evening, Nathan has a clarifying dream in which God thanks David for the offer but insists that He will build him a house instead. That house will be more metaphorical, a throne and a kingdom that will be established forever. When Nathan shares the change of plans with the king, David responds with humble appreciation. He says, "You are great, O Lord God. For there is none like You."[24] Within his prayerful response, David repeatedly refers to himself as a servant, a willing vessel to oversee the great things ahead for God's people. Yet the second encounter between David and Nathan doesn't generate as much gratitude.

King David has abused his power, summoning the beautiful, married Bathsheba to his palace. He tried to cover up his adultery and her pregnancy by bringing her husband, Uriah, back from battle. Yet the honorable Uriah refuses to enjoy time at home while his troops are still at war. David sends Uriah to the front lines toward certain death to cover up his own sin. The purity and love of a younger David has been replaced by a power-abusing conniver. God prompts Nathan to confront David with a story about a rich man who steals the ewe lamb of a poor man. David is outraged by such theft, declaring that the pitiless rich man should pay four times the price of the lamb and be sentenced to death. Nathan makes the parallels to how David coerced a wife and murdered a poor husband abundantly clear, "You are the man!"[25] David doesn't dispute

the judgment, admitting, "I have sinned against the Lord."[26] Calamity follows, including the death of the expected child. Ultimately, David lost four children in the years ahead, exactly the judgment he had sworn upon the rich man (i.e., himself). This is a decidedly hard truth. We need people in our lives who can confront us when we've strayed from the path, reminding us of who we aspired to be.

Nathan continues to play a key role in David's life, through their later years. While David is aged and infirm, his fourth son, Adonijah, attempts to consolidate power and proclaim himself king. Nathan intervenes, reminding Bathsheba and David of the promises made to their son, Solomon.[27] He chronicles all the maneuvering done by Adonijah and inspires David to fulfill his oath. David rises to the occasion, swearing to Bathsheba, "As surely as the Lord lives, who has delivered me out of every trouble, I will surely carry out this very day what I swore to you by the Lord, the God of Israel: Solomon your son shall be king after me, and he will sit on my throne in my place."[28] The promises of God that the house of David will be secured are fulfilled through unlikely means—the offspring of his gravest error. What a dramatic reversal.

We may start on our creative journey with grand plans. We may need a faithful friend to cheer us on with encouragement. Or we may need to humble ourselves and follow a different path than we intended. Mistakes will invariably be made along the way. Hopefully, we remain connected to our roots so a trusted advisor can confront us with painful truths when we wander astray. At the end of our life, we may also need those traveling companions to remind us of our vows. Our legacy will be carried on by those we've invested in, who bear our imprint. A wise person learns to receive criticism. They are willing to alter their plans. They admit when they've made mistakes. They recall the original goal. May we be graced with expert editors and seasoned truth-tellers in our lives.

HONEST CHALLENGE

1. Artificial Intelligence can serve an editor or coach once we train it how to think. But will it only reflect our biases or offer a harder edged judgment? Submit your work to a generative A.I. and see if A.I. improves it.

2. Who else can you count on to critique your work and correct your blind spots? Do you have a collaborator who rounds out your weaknesses? Find an honest friend with whom you can share your hopes and dreams that responds with a well-timed word. Get their feedback on the same project. Compare and contrast the two different critiques. What have you learned through the process?

9

HONEST MARKETING

"Tell the truth, but make the truth fascinating."

—DAVID OGILVY[1]

COOKING AT THE UPSCALE MOON'S LAKE HOUSE IN THE 1850s, George Speck had undoubtedly dealt with picky customers before. George was known for being a gifted but surly chef. In restaurants, fielding complaints is part of the job. How to satisfy customers when there are so many distinct palettes? When it comes to food, everyone has their own sense of taste and a predilection to critique. Born of an African American father and Native American mother, George undoubtedly dealt with plenty of additional slights and barbs, including when the wealthy industrialist Cornelius Vanderbilt mistakenly called him "crumb." George embraced the mistake, changing his name because "a crum is larger than a speck."[2]

In 1853, Vanderbilt sent George's French-fried potatoes back to the kitchen for being too thick and soft.[3] George responded to the critique by slicing the potatoes as thinly as possible, then fried them in grease until brown. He may also have oversalted those deep-fried potatoes on purpose

to firmly communicate his disgust with the complaints. Yet George's "failure" with the original potatoes resulted in an unexpected hit. Vanderbilt loved this tasty concoction. Soon, even more guests were asking for Crum's "Saratoga Chips." By 1860, his chips were so successful that he opened his own upscale restaurant in Saratoga Lake. "Crum's House" featured a basket of his potato chips on every table.[4] Demand grew until Crum offered his original "Saratoga Chips" in take-out boxes. Saratoga Chips are marketed today as "America's First Kettle Chip." The variety of flavors, from "buffalo ranch" and "honey bbq" to "thai sweet chili" reflect the range of tastes across cultures, something for every palate.

The only problem with this American success story? It isn't true. George was a chef, and he did own a restaurant in Saratoga that served chips. Yet his 1914 obituary didn't mention his role in inventing them. His sister Catherine claimed they stumbled across the tasty treat when she dropped a potato in a deep frier. Yet recipes for potato chips had already been published in cookbooks decades before. When did Commodore Cornelius Vanderbilt become associated with this story of the "Original Saratoga Chips"?

A 1973 advertising campaign for St. Regis Paper, the company that packaged potato chips, burnished the legend of George Crum. They connected the dots between George's chips, his wealthy clientele in Saratoga Springs, and the billion-dollar potato chip business that followed. During their 1976 convention in Saratoga Springs, the Potato Chip/Snack Food Association erected a memorial plaque celebrating George. One year later, the wife of the great-great-great grandson of Cornelius Vanderbilt hosted a fundraiser for the Saratoga Performing Arts Center featuring a *Potato Chip Cookbook* "in honor of the 124th Birthday of its Founder, Commodore Cornelius Vanderbilt."[5] When the Saratoga County historian challenged such claims, it created a local controversy that prompted a deeper dive from scholars at nearby Skidmore College. Their well-documented

"Case of Potato Chip Legends" demonstrates how marketing played a key role in creating credible folklore that still fuels the industry today. The Original Saratoga Chips trace their origins back to George Crum, although I'm confident none of his offspring receive any royalties.

John Ford, film director of the most seminal Westerns, famously quipped, "When the legend becomes fact, print the legend." It summarizes the mythmaking associated with how the American West was won. Writers built up considerable mythos around Western pioneers like Sheriff Wyatt Earp or outlaws like Jesse James. Dime store novels became the source for America's unique cinematic genre, the Western. John Ford's pioneering movies elevated actors like John Wayne to iconic status. The Hollywood celebrity machinery polished the public images of stars with glossy magazine photos of poolside mansions. Those idealized images became so ubiquitous that fans began to emulate the stars' glossy lifestyles. Today's social media platforms have turned self-promotion into a highly profitable art form. Those with the largest numbers of followers have been rechristened as "influencers," hired by brands to promote their products. As with the creation of potato chips, we're so busy self-mythologizing that we rarely question the truth behind the dictum.

John Ford never said, "When the legend becomes fact, print the legend." It was the closing line of the classic Western *The Man Who Shot Liberty Valence* (1962), which Ford directed toward the end of his career. It was a dark coda on his career that elevated the American cowboy to heroic status. The line is uttered by a journalist who has been interviewing a politician played by Jimmy Stewart, who is on the verge of becoming vice president of the United States. The line was written by the screenwriters James Warner Bellah and Willis Goldbeck, yet the popular association of directors as the "authors" of the film ended up giving John Ford more credit than he deserved (or claimed).[6] The movie is also about the same process, whereby an oft retold story from a politician's youth becomes

fuel for his latest campaign. It is not advice. It is a hard, cynical truth about the American West: how facts got fudged and legends supplanted the truth. Like the recent *Killers of the Flower Moon*, *The Man Who Shot Liberty Valence* is a cautionary tale, designed to wake audiences up, to distinguish between the images we've been sold and the realities behind it.

Dishonest Marketing

Dishonest marketing is a daily temptation in our image driven culture. We can perform for our mobile cameras within a limited time and space. We can hide messier truths about our settings and circumstances just off-screen. Generative A.I. can paste smiles onto our family's faces that felt too glum in reality. The pressure to project a false image for fame and fortune can be draining and even deadly. Documenting our lives for social media followers may be lucrative for a few, but it is exhausting for almost all who must figure out how to perform for the camera daily. It is tough to experience contentment when we're mining our personal life for content. How can we unplug when our daily fashion, exercise, or eating habits are a marketing opportunity? We've reduced our lives to a public performance for audiences that are only asked to click on a post. What happens when we can't escape the expectations of our fans and fall short of our carefully coiffed, personal brands? I've watched friends fall apart both in public and private when they cannot live up to the personas they've developed through plenty of hard work and perseverance.

A successful Disney film exec stepped away from his career to manage a seemingly even more lucrative business with his social influencer spouse. Dave and Rachel Hollis relocated their family of four young kids from Los Angeles to Texas.[7] Rachel's self-effacing, best-selling books like *Girl, Wash Your Face* gave them a platform to monetize their family life.

They started each day with their "Rise Together" podcast talking about goals, workouts, and marriage advice. Their hyped-up marriage seminars stressed the work needed to make family, careers, and relationships successful. The snapshots posted on social media talked about the progress they'd made and how profitable the Hollis Company had become. The gap between their public personas and their real-world struggles only surfaced when they announced their divorce.[8] Their dedicated followers were shocked by the disconnect between how they marketed their family life and what was transpiring over the past three years. Dave began dating another equally famous fitness influencer, documenting their daily weightlifting routines. All the focus on health and wellness made the announcement of his death due to a heart condition even more confusing. The autopsy report listed his cause of death as "the toxic effects of cocaine, ethanol, and fentanyl." It turns out the author of *Get Out of Your Own Way* had "a history of hypertension, depression, illicit drug use and alcohol abuse."[9] Perhaps more public honesty about his struggles would have prevented Dave's tragic death at age forty-seven.

Authenticity in our art and marketing enables us to sustain a creative life. Ace songwriter Jason Isbell overcame the alcoholism that nearly shipwrecked his career and marriage. He chronicles his harrowing fight for sobriety and the love that sustained him in his signature song, "Cover Me Up." He learned the hard way how one might "use me for good." Isbell suggests, "Controlling your image is the opposite of creating art."[10] Acknowledging our insecurities can be attractive not as a marketing ploy but as an attainable approach to problem-solving. We can be savvy about our self-promotional efforts and still retain some personal privacy.

Beyoncé turned racism, misogyny, and marriage problems into her classic video album *Lemonade*.[11] She didn't bother with prerelease publicity or carefully orchestrated marketing plans. A challenge to her fans to get in "Formation" was enough to generate worldwide buzz. On the

opening track, she addresses the dishonesty and cavilier attitude toward infidelity that sparked countless rumors about her marriage to rapper Jay-Z. On "Don't Hurt Yourself," she acknowledges her beautiful man's lying, but insists, "I am not broken, I'm not crying." She turns lemons into lemonade. She leaned into her Alabama and Louisiana roots to imagine a different outcome for New Orleans during Hurricane Katrina. Beyoncé demonstrated how to slay all who stood in her way. Honest marketing acknowledges our struggles, our shortcomings, our challenges, and our gifts. Under promising and over delivering will stand out in a noisy, boastful world. Do we have the confidence to make the quiet attractive?

Online platforms like Etsy, Shopify, Big Cartel (and yes, even Amazon Handmade) have enabled us to sell our wares directly to customers. From pottery and photography to jewelry and T-shirts, handcrafted products have made a biiiiig comeback. For electronic storytellers, YouTube and TikTok make it easy to post homemade videos and develop a following. Bandcamp allows musicians to set the price for their latest releases. The democratization of the Internet has enabled talent to be discovered from further afield. More aspiring singers from Canada will still be discovered on YouTube (Bieber, The Weeknd). Homemade mixtapes will captivate executives' ears (Drake, Nikki Minaj). An animated Christmas card will make a studio boss laugh (*South Park*). Of course, so many artists are crowded into these easy-to-use platforms that it is tough to get noticed. Publishing and posting are easy. Achieving a scale that sustains a creative career is another question. Not all of us have the self-promotional engine burning within to push our latest endeavors. Can odd, old-fashioned values like honesty cut through the clutter?

The proximity between creatives and our customers has never been cozier. We can speak and ship directly to fans and followers. We can respond to complaints, answer questions about our influences, broadcast our songs live from our living rooms. Backstage meet and greets are now

a standard part of premium concert packages. This is all amazing. And problematic. Because those customers also gain unprecedented access to our homes and our families. They feel like they know us. And casual relatability on social media becomes an additional requirement beyond the challenge of making great art and inventions. It is tougher to get away, to escape expectations, to find room to think, grow, and breathe. Carefully crafted careers can be cancelled due to one errant post. As the space between public and private collapses, it is easy to mistake "our brand" for ourselves. We can lose sight of who we are and whose we are.

Withholding

In the classic movie *Grand Hotel* (1932), Swedish actress Greta Garbo repeatedly declares, "I want to be alone." The Garbo mystique is rooted in that desire to make space between her admirers and herself. She retains more power by not inviting fans in. Brad Pitt has remained a Hollywood sex symbol by adopting a cool distance from the press hoopla. He plays the game, shows up for red carpet premieres, but never gets too excited. He declines to express the totality of his feelings both onscreen and off. The air of mystery that results becomes a source of power and fascination. As he lays back, on a bed or in a car, the audience leans in, looking for clues about what's going on behind the mask. Withholding is an intriguing antistrategy. By retaining a degree of privacy, we become more fascinating.

Consider the iconic imagery associated with Bob Dylan. He only began hiding behind sunglasses after he became an adored and therefore overwhelmed "voice of generation.' As his protest songs unmasked the powers and principalities that preserve injustice, Dylan grew unwilling to be "Only a Pawn in Their Game." In the seminal documentary *Don't*

Look Back, film cameras document how after a concert, rabid fans press against the windows of his getaway car.[12] When it is time to speak to the press, the questions about the meaning of Dylan's songs become repetitive and intrusive. His black sunglasses made room between Dylan and his fans as well as the press. By going into hiding, even while in public, the Dylan mystique only grew.

What are the roots of such cool detachment? Scholars have traced the mode to African Americans who were only able to endure the pressures of slavery by "keeping their cool."[13] The ability to hide rage or confusion behind an impenetrable mask was a necessary coping strategy. Those who became too hot were liable to be singled out for extreme punishments. Those who made distance between the persona they presented to the plantation owner and their genuine self were more likely to survive.

Years before Bob Dylan's shades become de rigueur, trumpeter Miles Davis also hid behind his sunglasses on and offstage. The birth of cool jazz with Miles in the 1950s contrasted with the "hot jazz" of trumpeter Louis Armstrong and his band, "The Hot Five" from the 1920s. Louis's musical notes came fast and furious, pouring forth in bursts of energy. Louis withheld almost nothing from his fans, famously sweating onstage in a highly accommodating performance. His eyes popped, his smile was infectious, inviting fans to notice how much energy and empathy Louis expended on their behalf. Miles Davis adopted the opposite strategy, turning his back to the audience and leaving plenty of room between notes on his trumpet. The less he played, the more haunting and beautiful the results. Same instrument, same musical idiom, yet vastly different relationships to their audience. Louis gave, Miles withheld.

After making two highly acclaimed feature films, *Badlands* (1973) and *Days of Heaven* (1978), director Terrence Malick grew frustrated with the Hollywood studio system. He withdrew to France, satisfied to write screenplays from afar. In his twenty years away, rumors and speculation

about Malick's next project grew. By the time he returned to filmmaking with the World War II drama *The Thin Red Line* (1998), every major actor was eager to work with him. Sean Penn committed early, saying, "Give me a dollar and tell me where to show up."[14] Eventually, Nick Nolte, Adrien Brody, Woody Harrelson, John Travolta, and George Clooney all headed toward the Pacific to join Team Malick. Yet the resulting film only offered the briefest cameos to Hollywood's biggest stars. Malick's transcendental style reduced even the most distinctive voices to a small part in a much larger examination of the human condition. *The Thin Red Line* was nominated for seven Academy Awards, with Malick beaten out as Best Director by Steven Spielberg for *Saving Private Ryan*. Yet by living abroad, refusing to do interviews, and not making movies, Terrence Malick burnished his legend.

We are needy and vulnerable. We are riddled with fear and pride. We are desperate to be loved. But when we outsource that, we put ourselves in a weird, powerless position. Needy. Externally defined. It is tough to be desperate for affirmation and retain personal dignity. What does it look like to play for an audience of one? How to communicate how much you don't need fans' adulation? We are not defined by our followers. We are more than our platform. "Cool" arises from an inner power and confidence. I know who I am, I know whose I am. I know why I play. And I will be okay irrespective of how this audition goes.

Our work must be more than content to be consumed—because otherwise it may consume us. There is such a gap between content and contentment. We must figure out what the Lord's prayer for "our daily bread" means and includes. As consumers, we will always be hungry, rarely satisfied, in need of a daily download and dopamine rush. But if we teach a person to create, they can sustain themselves, in relationship with their primary audience—God.

What is the social contract between creator and those who will consume their creation?

To treat people with dignity. To love our characters and our audiences. To dare to care. Not how we're received, but how they're portrayed and perceived. Did we create a worthy mirror? Wasn't that God's original activity—making humanity in his image? We now can return the favor.

Paintings for the Future

The larger canvasses are ten feet tall. The bright oranges, yellows, and blues invite us in. Spirals and circles and lines dance across the space. Amid a pale purple backdrop, we see suggestions of flowers, onions, and mushrooms—nature aglow. There are letters and numbers that suggest a secret code waiting to be unlocked. This is the vibrant visual world of Swedish artist Hilma af Klint (1862–1944). Her paintings have the precision of Mondrian, the geometry of Kandinsky, and the free-flowing delight of Matisse. Yet her abstract "Paintings for the Temple" were made before any of these modernist masters. Daniel Birnbaum, director of Sweden's Moderna Museet wonders, "During her lifetime, Af Klint had no lobby, zero, nothing. Her art was like a thought experiment: if a tree falls in the forest and no one sees it, did it fall?"[15] Why was a pioneering abstract painter like af Klint unknown to the art world for almost a century? Journalists and historians have slowly unraveled the mystery.

The Guardian reported that when Hilma af Klint passed away at age eighty-one, "She stipulated in her will that her work—1,200 paintings, 100 texts and 26,000 pages of notes—should not be shown until 20 years after her death. It was not until the 1986 Los Angeles show 'The Spiritual in Art' that her work was seen in public. . . . It is through Stockholm's

sensational 2013 exhibition, Pioneer of Abstraction, that she blazed into view internationally—it was the most popular exhibition that the Moderna Museet has ever held."[16] Her "overnight success" with work painted at the turn of the last century drawing record crowds in the twenty-first century, only added to the fascination with Hilma.

Biographers have traced her interest in the natural world to childhood summers on the island of Adelso. She studied at the Royal Academy of Fine Arts in Stockholm, exhibiting strong skills in landscape painting, portraiture, and botanical drawings. The death of her younger sister, Hermina, moved an eighteen-year-old Hilma further into another lifelong interest—spiritualism. Hilma sought to reconnect with her departed sister through paranormal means. Hilma found solace and solidarity in meeting with The Five, a group of fellow artists and women devoted to the Theosophical teachings of Helena Blavatsky and the esoteric wisdom of Rosicrucianism. Starting in 1896, The Five gathered regularly for prayer, Bible study, and a séance. An interest in science and séances may seem foreign to our contemporary sensibilities. Yet Hilma was heavily influenced by Rudolph Steiner who described his Anthroposophy as a scientific exploration of the spiritual world.

In their pursuit of ancient, divine wisdom, Hilma and The Five were contacted by spirits, "the High Masters," who inspired their artmaking. During a séance in 1906, a spirit called Amaliel commissioned Hilma to create The Paintings for the Temple. They would illustrate the unity and connectedness of the world, what nature and our humanity have in common. Over the next decade, she made 193 Paintings for the Temple. Hilma af Klint served as an artistic conduit, writing, "The pictures were painted directly through me, without any preliminary drawings, and with great force. I had no idea what the paintings were supposed to depict; nevertheless, I worked swiftly and surely, without changing a single brush stroke."[17]

Talk about a creative zone! What are we to make of this overtly spiritual art rooted in the occult?

As a trained journalist, af Klint biographer Julia Voss approached Hilma's accounts with a certain skepticism. In reading her notebooks, Voss began to see it more like a dialogue with forces that are like invisible friends. Voss says, "They support her, they make offers. They ask whether she wants to do something, and then she says yes; sometimes she doesn't."[18] The more Voss read her notebooks, "The more I was ready to accept that this is her reality and that I should not judge it."[19]

So why did af Klint seemingly bury these paintings, stipulating them to be put away until twenty years after her death? Voss finds that her reticence to share may have been rooted in rejection. With an academic background in painting, af Klint knew what was acceptable and embraced within the art world. Her more traditional illustrations paid the bills. Yet she put small-scale reproductions of her abstract canvasses into a traveling suitcase to show to gallery owners. Responses in Switzerland, Amsterdam, and London were muted. When she showed *The Paintings for the Temple* including *The Ten Largest* canvasses to her spiritual mentor, Rudolph Steiner, he failed to make a connection and encouraged her to put them away for fifty years.[20] What a brutal assessment. Thankfully, his discouraging words did not keep her from creating. After taking a four-year break to care for her ailing mother, af Klint returned to her *Paintings for the Temple* project. She documented her work with an eye toward the future when audiences might be more receptive to her vision. She foresaw a spiral-shaped gallery displaying her work.

When curators at the spiral shaped Guggenheim unveiled Hilma af Klint's vibrant work to the public in 2019, they described them as "Paintings for the Future." Perhaps af Klint was too far ahead of her time. The overt misogyny of Sweden's art world circa 1900 may have rejected her progressive visions outright. Yet in keeping her brilliant canvasses in a

family attic for fifty years, af Klint also gave society time to catch up. Lead curator Elizabeth Bashkoff wrote, "I think her impulse not to show the work to the public, and to hold it pretty privately throughout most of her life, was really motivated by wanting an understanding audience."[21] The Guggenheim exhibition (in their spiral-shaped building) offered af Klint the massive embrace she missed during her lifetime. In keeping her work under wraps, Hilma ultimately made us even more interested in solving the mystery of her paintings.

Your work may not be appreciated in your lifetime. It is easy to get discouraged and feel misunderstood. Clearly, you are not alone in that feeling of rejection. Yet perhaps your creative contribution awaits an audience from the future.

Subverting Expectations

In the Gospel of Mark, Jesus expresses a curious ambivalence toward fame. After performing miracles that could lead to immediate attention, Jesus will often tell the recipient of his remarkable healing not to talk about it. To a leper he healed, Jesus said, "See that you tell no one anything."[22] Instead, "The man went away and began to publicize the whole matter." When Jesus heals a deaf and mute man, he commands the witnesses not to tell anyone. "But the more he did so, the more they kept talking about it."[23] Isn't that always our temptation—to spread whatever secret our friends entrusted to us? Especially if it involved something strange or miraculous!

After Jesus has cast out demons, healed the sick, and restored sight to the blind, he asks his followers, "Who do people say I am?"[24] All kinds of claims and theories are being tossed around. So, Jesus asks more pointedly, "Who do you say I am?" When Peter answers, "You are the Messiah,"

Jesus warned them not to tell anyone about him. Why did Jesus want to keep his identity and power a secret? Scholars have debated this question over the past century.[25] Jesus clearly prefers to lay low, deflecting attention. Was it a clever marketing ploy, like the famous actors who learn how to play games with the press? By asking people not to talk about him, did stories of his miraculous power become even more viral?

Clearly, the crowds that arose from such displays of power became problematic. After too much talk about his miraculous acts, "Jesus could no longer enter a town openly but stayed outside in lonely places. Yet the people still came to him from everywhere."[26] As we've seen with today's celebrities, overzealous fans can block motorcades, press in too closely, becoming a threat to those they want a glimpse of (or even to themselves). Our biggest pop stars are practically confined to their houses, unable to move about freely, fearful of the hubbub their presence ignites. The security cameras outside the compounds of Lady Gaga and Robert Downey Jr. keep them both safe and confined. For those seeking popularity, beware of what you seek.

Perhaps Jesus tried to keep his identity hidden to distinguish himself in the marketplace. There are allusions to other prophets or healers who made public displays of their power. It was a time when competing claims of authority and spectacle vied for an anxious peoples' attention. If there were many seeking a savior and plenty claiming to be the one the crowds were longing for, then underplaying your power was unusual. Plenty talked a big game. Jesus follows miraculous moments by withdrawing, fleeing the spotlight, waiting for a more opportune time. It is tempting to play into people's expectations of us. It is tougher to go against the grain, biding our time, sorting out the sincere from the sycophant.

Jesus takes the time to redefine his followers' thinking. They expect a great teacher. They want to see miracles. Demonstrations of power have always been a way to galvanize audiences. Jesus ultimately defies and

redefines their understanding of authority. He speaks in parables riddled with paradoxes. The meek will inherit the earth. The weak will be made strong. To gain our lives, we must lose them. These aphorisms stuck in people's heads because they inverted popular notions of how the world works. Before dropping another zinger, Jesus would preface it with, "You have heard it said, but I say . . ." This is subversive marketing, flipping the conventional thinking. He separated himself from the populist pack with smart bombs that made sense in hindsight. Jesus played the long game, willing to sacrifice his life for our sake. That kind of honesty is shocking, bracing, and sustaining. It causes us to sit up, to take stock, to consider another way of being.

Asking

Most creatives I know loathe marketing and self-promotion. It does not come naturally. They have developed their gifts via observation, by standing apart from the crowd long enough to perceive what's really happening. So when the observer now becomes the observed or even stalked, the creative process is interrupted. We may long to return to anonymity, to the distance that allowed us to perceive clearly.

Plenty of creatives self-sabotage by pouring so much time and energy into creating a product that they have no reserves left for marketing. We are exhausted at the moment when we need to find a new source of energy. It is hard to finish a book, wrap a film, or patent a product. All too often only when we've polished our project do we start to think about marketing. Rather than focusing upon an audience after we've finished our creative work, we may need to listen to the marketplace before we commence our creative project. Making something and then hoping it finds an audience is shortsighted and foolish. When we shirk our

responsibility as storytellers, advocating for our work, by saying, "I did my part," now the results are up to somebody else (often including God in that bargain).

There is an oft quoted verse in the Bible that reads, "You do not have because you do not ask God."[27] Taken out of context, it can lead to prayers in which we name it and claim it. We tell God what we want as a demand rather than a question. We seek to manifest our vision, rather than submitting ourselves to the Lord's will. A closer look at the context reveals that the passage is about why we fight, quarrel, and covet. Don't these problematic behaviors arise from desires that battle within us? We covet and kill when we can't always get what we want. Yes, we may not have because we do not ask God. But when we ask, we may not receive because we ask with the wrong motives, so we can spend what we get for our pleasure. What a resounding critique of so many self-seeking patterns.

Some may hesitate to ask a person of means for a favor because we lack self-confidence. We may have been burned or disappointed in the past. We can't bear to be rejected again. Our hopes have been exhausted, our dreams too deferred. At these low points, brutal honesty may be the only option we have left. Such dark nights of the soul will often result in our most resonant work.

I've watched networkers in the entertainment industry "work a room," using people to get to someone who can open a door or ignite their career. I've also been that hustler, on the move, eager to get the one person who can seemingly make our dreams come true. There's nothing wrong with ambition, but there's plenty problematic about using people. After a while, such unfettered desperation starts to stink. You can tell (and smell) when you're a means to someone else's end. It is ugly, calculated, and cold.

Honesty about our motives is a prerequisite for God's favor. Humility is the virtue which allows us to be lifted up. It doesn't mean we can't plan and pray. We can express out our longing for inspiration, for an audience, for funding. But to the degree those prayers are all about us, our platform, our profit, we will likely be frustrated. Honest marketing is rooted in honest motives. When we seek the welfare of our clients, we prosper. When I'm honest about what I can and can't do, I remain within my wheelhouse. I promise what is deliverable. A creative career becomes sustainable instead of a scramble via honest marketing.

HONEST CHALLENGE

1. Put your core idea or product into a generative A.I. engine. What kind of suggestions does it offer? Try out those titles or tag lines on social media. See what people gravitate toward. Is it humbling when others may not share your sensibility?
2. Consider the idea or product you are attempting to sell. What's the most direct and honest thing you could say about it? Can you boil that down even further to a single word or image? Compress your thoughts into an honest blast of creative expression.

CONCLUSION:
HONEST RESILIENCE

"There's some good in this world, Mr. Frodo. And it's worth fighting for."

—SAMWISE GAMGEE[1]

IT IS A TUESDAY MORNING. JOHN LENNON IS RUNNING late. On a London soundstage, Paul McCartney noodles on his Höfner bass guitar while waiting for John to show up. Technicians are in place, ready to record. A film crew has been hired to document their creative process even when not much is happening. Paul strums and hums while George Harrison and Ringo Starr look on, smoking cigarettes. The Beatles have been in a self-proclaimed "creative doldrums" for over a year. They've lost their beloved manager, Brian Epstein, to an early death and felt the pressure to compose new songs and perform for rabid fans around the globe. They've consolidated their intellectual property under the new banner of Apple Corps. All the legal wrangling can't ensure a musical spark. Without an older leader to guide them, they're stuck in a painful rut. Then, in a flash, while the cameras roll, a fresh musical idea blows into the room.

Paul develops the riff, adding some nonsense words in lieu of lyrics. George Harrison yawns, but Paul persists, attending to the tune flowing through his hands. Slowly, the chunky chords start to come into focus.

George adds some rhythm guitar. Ringo provides some handclaps. All three slowly become present to the opportunity before them. Two words stand out. A chorus starts to emerge. Ringo gets behind his drum kit and the three of them begin to play together. The pressure of living up to their legendary status is held at bay. When we're in the creative zone, time is suspended. Countless options emerge. Ideas flow. Work becomes play. A carefree, childlike sense of glee kicks in. In a few inspired moments, before the camera's eye, the classic rock song "Get Back" is born.

This sequence was left out of the original documentary about the troubled recording sessions that produced the Beatles' final album, *Let It Be*. Fifty years later, director Peter Jackson and his editors unspooled the original footage and discovered a rich vein of creativity. The resulting three-part, eight-hour special on Disney+ tells a different story that causes fans to reevaluate why the Beatles broke up.[2] (Spoiler alert: it wasn't Yoko's influence upon John after all.) *Get Back* goes beyond the internal drama to document how creative lightning strikes. Yet it also illustrates how many iterations, how much perspiration occurs between that first flush of generativity and the release of their seventeenth number one song. Let's consider the stages of the song's creative path from conception to public reception.

Creativity begins with a notion, a riff, a vision. It is a gift that arrives in a form we may not fully understand. To move from possibilities to probabilities, we must be present. We can resist or ignore the prompt. Yet is so much easier to ride the wind or wave we've been given. Sometimes the ideas bubble up from within, rooted in complex and inchoate feelings. The spark may be prompted by a headline, a galvanizing experience, something that's bugging us. When the wind blows, we turn our face toward the breeze. We breathe and receive whatever is coming our way. We turn off our inner critic, silence the self-doubt long enough to get something down on paper, on record, in camera.

We can easily lose focus, get disheartened, or give up too soon. What if Paul McCartney put off that riff or forgot about it? A possibility loaded with potential could be derailed by procrastination. He also could have second-guessed himself, tossed it aside as unworthy of attention. "It's nothing really. Just a notion. Let's move on." All too often we self-sabotage, letting doubts overrun our insights. Would he have recalled it a day, a week, or a month later?

Paul could also have cut the other Beatles out via perfectionism. He could have retreated to his own corner of the studio or kept it a secret until he felt it was ready to be heard. Instead, he opened to the inspiration pouring through his fingers. He put himself out there, took a chance that the fledgling song could have been dismissed. Nonsense lyrics are preferable to no words at all. Mumble, stumble, but press on in search of clarity. Ringo and George also went with the flow, despite the early morning hour. They may have only been half awake, but they leaned into Paul's unformed idea. They all resisted self-criticism—opting for openness and collaboration instead.

A couple of days later, Paul returned with more detailed lyrics. He reimagined "Get Back" as a protest song. White nationalists in Parliament were seeking to restricts the rights of colonized people within the British Commonwealth. The call to "Get Back to where you once belonged" was being aimed by British politicians at Pakistanis. As Paul unveils his revised lyrics, producer Glyn Johns enters the studio with a copy of *The Daily Mirror* that proclaimed the proposed policy: "No extra immigrants." In this early iteration, "Get Back" is a racist rant that Paul also puts in the mouths of Americans telling Puerto Ricans to leave the USA. Creativity occurs within a specific cultural context. It is often a prophetic response to vexing problems. Artists and entrepreneurs look at painful realities from a unique perspective. They protest, they fire back, they imagine a different future. Creating is a generative, hopeful activity.

Craig Detweiler

The Beatles' creativity was also aided by a certain amount of pressure. They had a deadline to deliver a new album. So, they set parameters. They booked the rehearsal space at Twickenham Studios, marked off days on a calendar, invited in a film crew, set a morning call time. They brought what they had into the process. George unveiled songs he'd been writing in private like "Something." Paul and John showed up with tunes as well, like "Let It Be" and "Don't Bring Me Down." On January 7, 1969, Paul only had one chunky chord on his bass. Paul's germ of an idea was filled in by his partners. "Get Back" arose from a combination of playfulness and persistence. Paul vamps some words until he finds the groove. Ringo claps his hands before he gets behind the drum kit. George and eventually John bring some searing, offbeat licks on their guitars. Playing together is supposed to be fun. Their jokes and the wordplay flowed freely despite the pressure. Showing up every day, open to collaborate requires intent: playful persistence.

Paul's new song arose from years of practice. To American audiences, the Beatles seemed to come out of nowhere in 1964, fully formed. Yet the Beatles developed their musical chops through hours of playing in nightclubs in Hamburg, Germany. Their skills were honed via hundreds of gigs, getting attuned in front of distracted audiences. They played, they practiced, they persisted through honest preparation for years before a rollicking gift like "Get Back" arrived.

"Get Back" isn't wildly original, but it is a catchy tune within an established genre. It recalls lyrics George Harrison already wrote and a chord the Beatles heard once and had already worked on. In his song "Sour Milk Sea," George had challenged listeners to "Get back to where you should be." In the *Get Back* documentary, John Lennon credits the chord to the Memphis soul combo Booker T. and the MGs. So many ships sailed across the Atlantic from the docks of Liverpool that the sounds of the American Delta rhythm and blues traveled back with the sailors. Shops

in Liverpool had imported records by Ray Charles and the Shirelles to inform the impressionable ears of Lennon, McCartney, Harrison, and Starkey. They studied and learned from these predecessors. They covered "Long Tall Sally" and "Rock and Roll Music" in open acknowledgement of their influences like Little Richard and Chuck Berry. All that practice, drawing upon their influences, is built into the chords of "Get Back." Creators internalize what they've studied until it spills out without editing or thought. They've become utterly proficient. As they rehearse "Get Back" for a third time, Paul announces, "It's good enough for the rock and roll thing. Just doing simple things until it's your go." Hours of practice and rehearsal are in preparation for those magic moments when it all flows together.

How to launch this new song out into the world? The director of the *Let It Be* documentary, Michael Lindsay-Hogg, offers some truly awful suggestions throughout the recording process. He's fishing for a grandiose conclusion to his film about their new album. Lindsay-Hogg pitches the Beatles his idea for a concert in Tunisia, at an ancient Roman amphitheater featuring two thousand torch-bearing Arabs. Wouldn't two weeks be sufficient to stage such a massive event with their money? When his North African vision fails to captivate the band, the director suggests a show at a hospital or an orphanage instead. Again, no traction. Only late in the process, with time running out, does Lindsay-Hogg's suggestion of a rooftop concert at the Apple Corps office take hold. The seeming simplicity and spontaneity captures the Beatles' imagination. Roof supports will be needed. An extra camera is set up on a nearby building. Their recording engineer Glynn Johns prepares to capture the rooftop sounds in the basement studio below.

When the January day arrives, the sheer joy of performing with the wind in their hair prevails. Despite the chilly temperature, the Beatles "Get Back" to their roots as a live act, playing for a modest audience of

friends and family. A befuddled crowd of Londoners on a lunch break look up, wondering where the rock and roll ruckus is coming from. The Beatles escaped the pressure of performing before adoring fans by rising above their circumstances. No performing permits had been secured. This was an unannounced forty-five-minute "happening." They flout the police, recovering that youthful, rebellious edge that rock was born out of. As they finish a third and final rendition of "Get Back," John offers a cheeky comment, "I'd like to say thank you on behalf of the group and ourselves, and I hope we've passed the audition." What a lovely and spontaneous throwback to their modest roots. The biggest band in the world conclude their final public concert with a humble and humorous coda.

Throughout these recording sessions, the Beatles display resilience. They show up whether they feel like it or not. They strive to compose new songs even as outside circumstances are conspiring against them. They work together even when they don't care for each other's company. They lean into the pressure to perform. Having already been acclaimed as musical geniuses, the expectations pressing upon their young shoulders could have intimidated them. So many artists and entrepreneurs struggle to follow up on an unexpected success. There are plenty of one-hit wonders in music. A cinematic phenomenon like *The Blair Witch Project* may not be reproduceable despite Hollywood's repeated attempts to cash in. The massive sales of a book like *The Shack* cannot be replicated with a sequel. A sophomore slump is often expected. How do we follow unexpected success?

The Burden of Success

Creatives are riddled with doubts, maybe even more so after they've been acclaimed. Plenty are still pushing for their big break. But those who've

felt the first rush of success, from an appearance on live television to an Academy Award race, can testify to how dizzying the whirlwind can be. Agents and managers want hitmakers to duplicate their formula. A musician or writer may get pigeonholed within a particular genre. Artists may not know why a particular piece broke through to mainstream success. It is tough to reproduce another bestseller when you aren't sure where the first idea came from. Most creatives get into production as a form of experimentation. We aren't sure where we're headed. The creative process is both unnerving and energizing. We like the variety that accompanies different mediums and projects. We don't want to duplicate ourselves. But business principles are rooted in highly repeatable products. Freedom to create doesn't translate into an opportunity to recreate. Financial success is a beautiful benefit from creative output. Yet financial pressure to perform can be quite debilitating.

As we reach our conclusion, I hope you've been encouraged in your creative pursuits. Honest creativity arises when we combine unlikely sources. It pulls from multiple inputs to forge a different approach. It takes time to reflect on our failures. It retools, retrains, restarts. Learning often arises from discomfort rather than reassurance. If we're asking the wrong questions, we'll continue to get the wrong responses. So how do we put ourselves in teachable moments? Where are the risky embarrassments that yield lifelong lessons of humility, perseverance, and adaptability? Honest creativity is rarely safe. It is a high wire act with a limited net.

We focused upon how our weaknesses can be transformed into strengths when approached with humility. Study and practice prepare us for creative breakthroughs. An ability to breathe and receive inspiration will spark our process. Art and craft blend when we apply our intellect and imagination to that inspiration. Editors and collaborators help us refine our vision and polish our project. The resulting product will still need plenty of patronage and support. Protecting our intellectual

property is basic to business. Learning how to communicate with our friends and followers is also an art. The main virtue separating the aspirational artist from the seasoned professional is often resilience. How will we respond to the inevitable hurdles and even failures?

Those who endure figure out how to perform for an audience of one. It may start with ourselves, in a quiet bedroom. A growing fanbase can motivate us to crank new projects out faster. Yet the long-term careers circle back to an inner drive that transcends popularity. St. Paul offered this advice to the ancient faith community in Colossae, Greece: "Whatever you do, work at it with all your heart, as working for the Lord, not for human masters."[3] It is easy to focus on fans or followers or likes. But soon we can end up serving the platforms and their prompts. Their promise to elevate us can become a form of drudgery when we're responding to pings on their timeline rather than ours. The urgent overtakes the important.

We Will Survive

It is an anxious time for artists. The rise of generative A.I. makes us question our usefulness. A.I. can crank out suggestions for ad campaigns without copywriters. Actors have found their voices and likeness repurposed in films and games without their permission. Will there still be a need for graphic designers or photographers when A.I. can generate complex images on command? Machines seems to be mastering skills at a much faster pace than we are. Yet I would never gamble against H.I.—Human Intelligence, Ingenuity, and Innovation. We will continue to train A.I. engines to serve our purposes, turning these tools into accelerators rather than competitors. We will continue to express the fear of failure, the pain of heartbreak, the pleasure of

companionship. Our honesty will be a distinguishing feature in an age of pale imitations that reshuffle prior forms. While A.I. gets better at predicting, we must deepen our level of discerning. Understanding history, drawing upon precursors in context will set us apart. We'll be called upon to choose among a range of options. Wisdom and resolve are key traits to develop.

The triumphant disco anthem "I Will Survive" began under depressing circumstances. Songwriter Dino Fekaris has recently been fired by Motown Records after almost seven years creating for the company. He recalls, "I was an unemployed songwriter contemplating my fate. I turned the TV on, and there it was: a song I had written for a movie theme titled 'Generation' was playing right then (the song was performed by Rare Earth)." Amid dark days, Fekaris notes, "I took that as an omen that things were going to work out for me. I remember jumping up and down on the bed saying, 'I'm going to make it. I'm going to be a songwriter. I will survive!'"[4] Fekaris transformed the lyrics into a defiant tale of moving on from a toxic relationship. Despite the triumphant tone, it took two years before Fekaris and his cowriter, Freddie Perren, found the right singer for their resilient anthem.

"The Queen of Disco," Gloria Gaynor, was still mourning her mother's death from two years earlier. She'd also slipped onstage, ending up paralyzed from the waist down. After spinal surgery and a three-month hospital stay, Gaynor restarted her music career wearing an unwieldy back brace. Her record label introduced Gloria to Perren and Fekaris with the intention to record a new version of a South African hit "Substitute." Fekaris and Perren insisted the "B-side" of the record include one of their original songs. They told Gaynor, "We think you're the one that we've been waiting for to record this song that we wrote a couple of years ago."[5] Gaynor reflected upon her own pain and setbacks, "When I read the lyrics, I realized the reason they'd been waiting for me to record that song

was that God had given that song to them for them to set aside, waiting for Him to get everything in order for me to meet up with them. And that song was 'I Will Survive.'" She belted out the life-giving lyrics while wearing that back brace. For Gaynor, it was a statement about recovering from spinal surgery and overcoming grief.

Audiences on and off the dance floor responded to it as a declaration of independence and overcoming abuse. "I Will Survive" won the first (and only) Grammy Award for Best Disco Recording. Forty years later, Gaynor proved how prescient the song remained. She won her second Grammy for Best Roots Gospel Album with *Testimony*. Why has "I Will Survive" endured? Gaynor credits, "I love the empowering effect, I love the encouraging effect. It's a timeless lyric that addresses a timeless concern."[6] How we survive setbacks, disappointments, and loss. For Fakaris, the challenge was job loss. For Gaynor, it was ongoing grief and recovery. For listeners, it may be toxic relationships, bad bosses, prejudice, inequality, anything that causes us to despair. "I Will Survive" is a hopeful anthem for artists who deal with writer's block, sophomore slumps, financial insecurity, and the spectre of A.I.

Throughout this book, I've encouraged us to lean into those recurring human challenges. How to turn apparent failures into opportunities. How to receive criticism in a way that propels us to greater resolve. The difference between success and failure in our creative endeavors often comes down to resilience. Can we bounce back from unsettling setbacks? Will rejection letters or bad reviews deter our creative pursuits?

Perhaps you stumbled onstage like an athlete missing a shot with the game on the line. Maybe you've scraped together enough money to assemble a prototype, to make a short film, to release a single on Spotify. Yet what happens when the public fails to notice? When we don't get the recognition we anticipated or the response we longed for? Honest creativity is bound to fail. It will deal with disappointment. Our dreams

may be more than deferred. The true test of honest creativity arises when we've been tried and tumbled. What can we learn from our blunders and bummers? How do we develop creative muscles that allow us to rise and risk again?

"Imposter syndrome" may summarize our experience. No one wants to have their failures aired in public. We go to such lengths to guard against it. The right clothes, a fresh haircut, an air of confidence seem mandatory to sell ourselves or our ideas. But behind our designer handbags, sunglasses, and shoes resides a frightened child hoping they won't be called on. And yet, honest creativity inevitably pushes us toward public appearances. We'll have to let our idea, our dance, our design speak for us. As a teacher, I can aspire to create a safe space for students to present. We can encourage and model constructive criticism. We can ask for positive feedback, "pluses" we liked first. But amid the likes and affirmation, there lurks that lingering fear that the real, hard truths are about to drop.

To gird ourselves for setbacks, I've turned to the biblical beatitudes. Jesus reversed all the established wisdom of his day, regarding who matters, what's important, why we should be encouraged despite present circumstances. It is a long view toward crafting a life that endures. I adapted this blueprint for creatives. Consider these artistic beatitudes:

> Blessed are the failures, for they have a great starting point—nowhere to go but up.
> Blessed are the fearful procrastinators, for they are not alone and will eventually begin.
> Blessed are the humbled, for their modest ambition will be satisfied.
> Blessed are the righteously angry, for their complaints will be heard and acted upon someday.

Blessed are the poor with limited time and resources, for they will value what they create.

Blessed are those who practice, a lot, for a beloved hobby can become a profitable career.

Blessed are those who need others, for they will (eventually) find the collaborators they seek.

Blessed are those who are ready to receive, for happy accidents will arrive.

Blessed are those with eyes to perceive, for much will be revealed.

Blessed are the criticized, for they will get better. Much better. By listening carefully.

Blessed are the honest, for their character sets them apart.

Blessed are the disappointed and defeated, for they will grow resilient.

These are our advantages, our underappreciated weapons, in the struggle against machines. Our humanity is our superpower because it reflects the very nature of God. In grief and mourning, we are like God. In persecution, we are like Christ. When we are swept up in creating, we are in the very breath and Spirit of God. Let's consider one final example of how that Creative Wind blows.

Saori: Eyes That Shine

During the COVID-19 pandemic, my wife sought a creative outlet that could be practiced daily within our home. Caroline couldn't travel to classes. And she didn't want to take the time to master a new medium. We already had ample frustration in our lives. As a college professor, she'd already invested too much time on Zoom. What art form could be

adopted quickly but leave room for plenty of experimentation and error? Caroline was delighted to discover SAORI weaving, founded by Misao Jo in 1969.

Born in Osaka, Japan, Misao Jo studied the art of *ikebana* for more than seven years, becoming a licensed teacher. Floral design is quite formalized in Japan, with rules of how to present natural beauty. Patterns and variations fall within a traditional, bounded set of options. Studying ikebana meant copying the forms that the instructor presented. Yet in pruning branches to make flowers conform to standards, Misao felt like a failure. She writes, "I bet that the origin of ikebana lay in appreciating the beauty of flowers in their natural form. But as time passed, it changed to arranging fixed patterns, and the original purpose was forgotten."[7] Her teaching shifted toward an alternative ikebana that encouraged students to demonstrate their creativity freely, without restrictions, using the beauty of nature. After rearing a family and teaching ikebana, at age fifty-seven Misao took up a new hobby. Her youngest son, Kenzo, made her a handloom.

Misao decided to weave an obi—a belt for a Japanese kimono. She noticed a warp thread was missing, but thought it was making an interesting effect. A pleasing pattern formed by accident. Yet when she showed her obi to a man who ran a weaving factory in her neighborhood, Misao was told it was "flawed" and worthless as a commercial product. Her work was criticized for being less than perfect. She thought, "I have a brain and emotion. I'm a human being. I will weave an obi that is full of humanity."[8] After all, aren't exceptions beautiful too? She made a defiant vow, "I swore that I would produce work that no machine could match."[9]

After weaving an obi with intentional flaws, Misao Jo took her work to the owner of a fashionable kimono shop. To her considerable surprise and delight, he bought all the obi she brought him. They sold out

quickly and he requested more. When Misao tried to repeat her mistakes and fill his orders for specific patterns, she found that her joy in weaving was gone.[10] Spontaneity was the secret of her success. As she wove additional items and shared them with friends, they asked if she could teach them how to weave. She became convinced that everyone had an innate *kansei* within, an intuitive sense of beauty. Weaving could bring out their latent creative abilities if given an opportunity. After teaching the basic techniques of using the loom, she encouraged students to remove their preconceptions of weaving by breaking from conventional, patterned thinking. Once they mastered the basic technique, she offered only minimal suggestions. "Do not teach, try to help develop individual creativity."[11] The idea is for Saori weavers to follow their own path: "We do not make an imitation, but rather a new creation."[12]

Saori is a combination of her name, *Sao*, and *ori*, the Japanese word for weaving: basically, "Misao's weaving." As her hobby and style expanded beyond herself, Misao connected Saori to the Japanese word *sai* (差異), which means "difference." This word doesn't refer to the difference *between* objects in comparison, but rather the difference *among* objects, each with their own dignity.[13] This philosophy connects back to her study of ikebana. Misao Jo noted, "All flowers are beautiful, even though each individual flower is different in form and color. Because of this difference, 'all are good.' Because everything has the same life, life cannot be measured by a yardstick. It is this individuality that makes everything meaningful and the uniqueness of each thread that creates the tapestry of life."[14] Under Misao Jo's leadership, Saori came to mean "weaving individual dignity."

She approached weaving as a meditative activity, accessible to all regardless of age or ability. Misao wove almost every day from age fifty-seven until she was ninety-eight years old.[15] It makes room for people who may be isolated or marginalized due to mental or physical health

issues. It is a holistic form of therapy, rehabilitation, trauma recovery, stress reduction, and community building. It is uncomplicated by design. Yet that doesn't mean that Saori is a mindless practice. Jo wrote, "Saori weaving places importance on thinking rather than just on technique. Technique is the ability to copy a sample faithfully just as requested, and unlike thinking it allows no room for creation. Creation requires thinking."[16] The conscious decision to embrace mistakes and adjust to flaws that emerge during the process makes Saori comparable to artistic improv. It does not follow a plan but makes room for shifts in our feelings, materials, and results. Misao suggests that for Saori weavers, "the finished cloth should represent their individuality, attitude toward life, personal history, capabilities."[17] It is an unfiltered expression of the weaver, "an attempt to identify our true selves."[18]

This is art as philosophy; weaving as an active means to cultivate mindfulness. It is a reclamation of our roots, when clothes were made at home, not bought. Designs arose from each person's *kansei*. Misao noted, "Genuine fashion expresses our true selves, just as our faces do."[19] Over time, the core philosophy of SAORI was refined to four principles:[20]

1. Consider the differences between a machine and a human being.
2. Be bold and adventurous.
3. Look out through eyes that shine.
4. Inspire one another and everyone in the community.

These principles should extend from weaving into every aspect of life. As you engage in weaving by hand, you reflect upon the difference between people and machines. We may work slowly by choice. We stop and start. We need breaks. We make mistakes. Yet those flaws have a particular beauty. No two weavings are alike. We can take chances, experimenting

with textures, colors, and patterns. Even when we fail, we may be satisfied by "the beauty with lack of intentions."[21]

What does it mean to look through eyes that shine? Misao writes of how aesthetic eyes pay attention to beautiful things—"through grass on the street, a poster half peeling off the wall, paintings and sculptures, we can get tips for our design."[22] Saori weavers notice details. It is an artistic practice that is free of judgments and preconceptions. It encourages kindness toward ourselves. As Saori weavers extend grace to themselves, they also offer compassion toward others. Differences in age or ability do not matter when there is no pattern or ideal. When Saori weavers spot flaws and imperfections, they admire them as unique and individual signs of God's loving stamp. What a gracious approach to art making and life.

Zuma Beach, by Zoe Detweiler, 2022, photo by the author

During the pandemic, SAORI weaving became an opportunity for my wife to experiment. There was no goal. No deadlines. Just a daily time to create. Caroline approached it as something meditative for herself. She invited our children into it, "inspiring one another and everyone in the community." They loved the chance to play with all kinds of colors and variations. Old T-shirts could be recycled into artistic expressions. My family could create without a plan, embracing imperfections, like the suggestion of ocean waves found in the white stitches of my daughter's depiction of California's Zuma Beach. Together, they are now Zuma Textiles on Instagram. It is not a business. It is far too inefficient and costly. It is more like a movement of deeply satisfied artisans. My daughter is proud of the curtains she made. My wife loves wearing a dress sewn together from long strands of her weaving. My son wears a sport coat that is one of a kind—just like the weaver and the wearer.

Machines can reproduce things perfectly. They're much more efficient than humans. They cost less and deliver more. Is efficiency the goal within our long lives? What about satisfaction, appreciation, gratitude? These are inefficient virtues. Intangible rewards. The things we are remembered for. The cookies we baked for holidays. The sweaters we knit for our nephews and nieces. The rocking chair we crafted for our kids. The card we made for Mother's Day. The handwritten letters from our father that we kept. The poem we wrote for our spouse. It is the small acts, laden with massive heart, which set us apart from the machine. It is the time we wasted making a lasagna, knowing it would be so tasty that there wouldn't even be leftovers. Sure, we hoped our family would notice. A little encouragement goes a long way. But we may have made the lasagna because we wanted to eat it too. We wanted to experiment with a new recipe, to see how it might turn out.

We see these gifts on refrigerators. Or in a lunch box. On a belt buckle. Or key chain. On a finger. They're physical things that took time. That could easily fail. They were risks. One-offs. They're presented as offerings and mementos for special occasions. Which makes them inherently special. They can also be everyday practices. Acts of love delivered so repeatedly that it is only in hindsight one can recognize how extraordinary this corpus of accumulated work or offerings appears. A great cloud of witnesses comes forward to talk about the casserole they delivered. The letters they sent. The sweaters they knit. It is the everydayness of the craft that makes it so special.

As a final creative challenge, reflect upon a homemade project that you treasure. Why does it mean so much to you? Consider what you can make and give to someone you love. It may be a sweater, a cake, or a letter. It doesn't need to be perfect. How can you express your love and care for the person through the art form? If you're called to dance, act, or sing, what kind of gift can you freely extend to everyone in the community? Set aside questions of budget. Work with what's already at hand. From whatever you've freely received, freely give.

We are sustained by God's grace rather than compulsion, "For we are God's handiwork, created in Christ Jesus to do good works, which God prepared in advance for us to do."[23] The Greek word for handiwork is *poiema*, the same root word for poem. We are God's poetry, handcrafted as a divine work of art. Like a SAORI weaving, we are precious, beautiful, and unique. We may struggle to see the pattern and form which shapes us. We often focus upon the flaws. Yet the result is tailor-made for good work and with enough craft and care, maybe even great things. As God refines our character, we also commit to polishing our craftmanship. Something beautiful emerges through the process that testifies to the beauty of our Creator. As we write, we are also written upon. As we sculp, we are also sculpted. As we paint, we are also painted. As Michelangelo

looked at a block of marble, loaded with potential, he allegedly mused, "I saw the angel in the marble, and I carved until I set him free." May you recognize your full angelic potential. May you polish your skills, chip away at your character, until that majestic project burgeoning within you is set free.

ACKNOWLEDGMENTS

WRITERS NEED ADVOCATES TO CHAMPION THEIR WORK.
That's why I'm thankful for my agent, Alex Field, who saw the potential within my inchoate proposal and patiently guided me toward a new literary home. After emphasizing how much artisans need editors to refine their work, I'm grateful for the boundless encouragement offered by Phil Marino and the team at Morehouse Publishing.

As an educator, I always seek opportunities to encourage the next generation of creators. Thank you to Professor Jared Trask who invited his stellar design students at Grand Canyon University into the publishing process. Their probing questions and visionary designs turned my ideas into vivid images, opening each chapter by Jack Merashoff, Tlaloc I. Iniguez-Cortez, Bethany Brainard, Bella Bowman, Leah Cesario, Elisabeth Dombrow, Christopher Chase, Kateri Carrasco, Luke Clark, Georgia Jones, Elizabeth Joy, and Sarena Bouwkamp.

Special thanks to my most patient collaborator, Caroline Cicero, and to the two creatives we've been honored to raise, Zoe and Theo. You inspire me every single day.

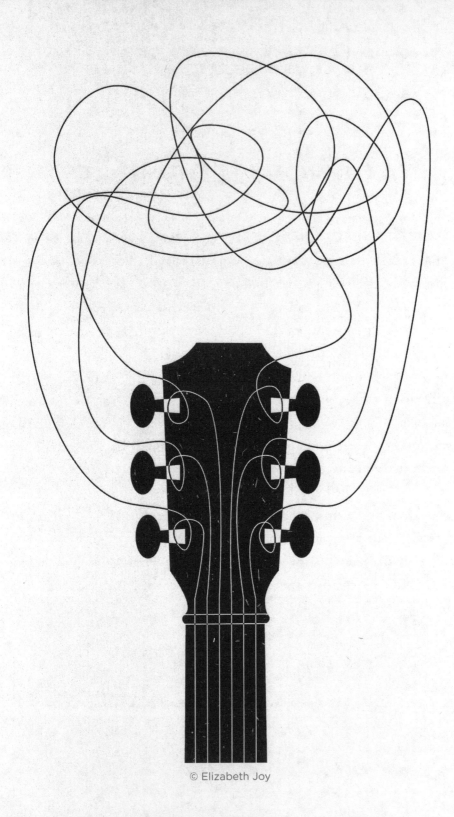

© Elizabeth Joy

NOTES

Introduction: Honest Creativity

1. Oprah Winfrey, "The Wholehearted Life: Oprah Talks to Brené Brown," Oprah.com, https://www.oprah.com/spirit/brene-brown-interviewed-by-oprah-daring-greatly/4, accessed September 24, 2023.
2. Arabelle Sicardi, "Billie Elish Just Wants to Feel Good," *Allure*, September 28, 2023, https://www.allure.com/story/billie-eilish-interview.
3. The Westminster Confession of Faith from 1646 identifies the chief end of humanity as "To glorify God, and enjoy him forever."
4. Ahmed Elgammel, "How Artificial Intelligence Completed Beethoven's Unfinished Tenth Symphony, *Smithsonian Magazine*, September 24, 2021, https://www.smithsonianmag.com/innovation/how-artificial-intelligence-completed-beethovens-unfinished-10th-symphony-180978753/.
5. Ian Leslie, "'Now and Then, I Miss You': The Love Story at the Heart of the Last Beatles Song," *New York Times*, November 5, 2023, https://www.nytimes.com/2023/11/05/opinion/beatles-lennon-mccartney-last-song.html.
6. Larry Charles wrote "The Bris" episode for *Seinfeld*, which NBC aired on October 14, 1993.
7. Elizabeth Gilbert, "Your Elusive Creative Genius," TED, February 2009, https://www.ted.com/talks/elizabeth_gilbert_your_elusive_creative_genius.
8. Ken Robinson, "Do Schools Kill Creativity?" TED, February 2006, https://www.ted.com/talks/sir_ken_robinson_do_schools_kill_creativity.
9. *Jason Isbell: Running with Our Eyes Closed*, directed by Sam Jones (New York: HBO, 2023), 1 hour, 38 minutes, https://www.hbo.com/movies/music-box-jason-isbell-running-with-our-eyes-closed.
10. For YouTube: https://youtube.com/playlist?list=PLMAx6-zH7paJL0-KlIEXsoHqpUmAiZkD4 and Spotify: https://open.spotify.com/playlist/6NseXcZLmTwgsTETsHpmmp?si=58aca44798cf4f38.

11. Nick Cave, "Any Advice to a Young Songwriter Just Starting Out?," *The Red Hand Files* 248 (August 2023): https://www.theredhandfiles.com/chatgpt-making-things-faster-and-easier/.

12. Ibid.

13. Screamin' Jay Hawkins, vocalist, "I Put a Spell on You" 10-inch record, 78 rpm, New York: Okeh Records, 1956.

14. Nina Simone, vocalist, "I Put a Spell on You" first track on *I Put a Spell on You*, LP album, New York: Philips Records, 1965.

15. Anastasia Tsioulcas, "From Funerals to Festivals, The Curious Journey of the 'Adagio for Strings,'" NPR, February 13, 1999, https://www.npr.org/2019/02/13/694388226/samuel-barber-adagio-for-strings-tiesto-william-orbit-american-anthem.

16. Oliver Whang, "The Reason People Listen to Sad Songs," *New York Times*, May 19, 2023, https://www.nytimes.com/2023/05/19/science/behavior-music-sadness.html.

17. Chris Willman, "Music Streaming Hits Major Milestone as 100,000 Songs Are Uploaded to Spotify and Other DSPs," *Variety*, October 6, 2022, https://variety.com/2022/music/news/new-songs-100000-being-released-every-day-dsps-1235395788/.

18. Genesis 1:28.

19. *Barton Fink*, directed by Joel and Ethan Coen (Los Angeles: 20th Century Fox, 1991), streaming on Amazon, Roku, YouTube, etc, 116 minutes.

20. Ibid.

21. Mihaly Csikszentmihalyi, "The Creative Personality," *Psychology Today*, July 1, 1996, https://www.psychologytoday.com/us/articles/199607/the-creative-personality.

22. William Blake, "Auguries of Innocence," in *The Complete Poetry and Prose*, ed. David V. Erdman (New York: Anchor Books, 1988), 490.

23. Brené Brown, "Why Experiencing Joy and Pain in a Group Is So Powerful," *Greater Good Magazine*, January 9, 2019, https://greatergood.berkeley.edu/article/item/why_experiencing_joy_and_pain_in_a_group_is_so_powerful.

24. Matthew 5:45 (ESV).

25. "The World's 50 Best Foods," *CNN Travel*, April 13, 2021, https://www.cnn.com/travel/article/world-best-food-dishes/index.html.

26. Frederick Buechner, *Telling the Truth: The Gospel as Tragedy, Comedy, and Fairy Tale* (New York: Harper & Row, 1977).

27. Rollo May, "The Nature of Creativity," in *Creativity and Its Cultivation*, ed. Harold H. Anderson (New York: Harper and Brothers, 1959), 61.

28. Mark Turner, *The Origin of Ideas: Blending, Creativity, and the Human Spark* (Oxford: Oxford University Press, 2015), 2.

29. Oshin Vartanian, Adam S. Bristol, and James C. Kaufman, eds., *Neuroscience of Creativity* (Cambridge, MA: MIT Press, 2016), 6–8.

30. John Anderer, "ChatGPT Scores in the Top 1% for Original Creative Thinking," *StudyFinds.org*, July 7, 2023, https://studyfinds.org/chatgpt-original -creative-thinking/.

31. I appreciate the categories of person, process, and product provided by Elliot Samuel Paul and Scott Barry Kaufman, editors of *The Philosophy of Creativity: New Essays* (Oxford: Oxford University Press, 2014), 6.

32. Kyna Leski, *The Storm of Creativity* (Cambridge, MA: MIT Press, 2020).

Chapter 1: Honest Fears

1. Marianna Hunt, "Party Tricks and Naked Writing: The Eccentric Life of Victor Hugo," *The Guardian*, December 30, 2018, https://www.theguardian .com/books/booksblog/2018/dec/30/party-tricks-and-naked-writing-the -eccentric-life-of-victor-hugo.

2. *Summer of Soul*, directed by Questlove (Los Angeles: Searchlight Pictures, 2021), https://www.hulu.com/movie/summer-of-soul-6f2160ed-eaa2-462a-b 495-f61f4f31714d, 117 minutes.

3. Nir Eisikovitz and Alex Stubbs, "ChatGPT, DALL-E2, and the Collapse of the Creative Process," *The Conversation*, January 12, 2023, https://theconversation .com/chatgpt-dall-e-2-and-the-collapse-of-the-creative-process-196461.

4. Susan Donaldson James, "Not So Vain: Carly Simon's Panicky Past," *ABC News*, April 30, 2008, https://abcnews.go.com/Health/SummerConcert/story?id =4754440&page=1.

5. Dan Farrant, "The Stories of 15 Famous Musicians Who Suffered from Stage Fright," hellomusictheory.com, February 17, 2023, https://hellomusictheory .com/learn/famous-musicians-with-stage-fright/.

6. Genesis 3:9–10 (ESV).

7. Blake Brittain, "AI-generated art cannot receive copyrights, US court says," Reuters, August 21, 2023, https://www.reuters.com/legal/ai-generated-art -cannot-receive-copyrights-us-court-says-2023-08-21/.

8. For an inspiring pep talk on creativity, check out Elizabeth Gilbert's discussion with Marie Forleo, "Elizabeth Gilbert Talks 'Big Magic'—Fear, Failure, & the Mystery of Creativity," YouTube.com, September 22, 2015, https://www.youtube.com/watch?v=HyUYa-BnjU8.

9. Dawn Smith-Theodore, "Dancers and Eating Disorders—Warning Signs and Helpful Resources," 4Dancers.org, July 8, 2019, https://4dancers.org/2019/07/dancers-and-eating-disorders-warning-signs-and-helpful-resources/.

10. Rhian Jones, "'So Much Pressure to Look a Certain Way': Why Eating Disorders Are Rife in Pop Music," *The Guardian*, March 25, 2021, https://www.theguardian.com/music/2021/mar/25/eating-disorders-pop-music-industry-demi-lovato-documentary.

11. Chris Willman, "Taylor Swift Opens Up about Overcoming Struggle with Eating Disorder," *Variety*, January 23, 2020, https://variety.com/2020/music/news/taylor-swift-eating-disorder-netflix-documentary-miss-americana-1203478047/.

12. Jessica Wong, "The Punishing Pressures behind K-pop Perfection," *CBC News*, February 24, 2018, https://www.cbc.ca/news/entertainment/kpop-hard-life-1.4545627.

13. Willman, "Taylor Swift Opens Up."

14. Curt Thompson, "Not the Tale We Were Hoping For," Curt Thompson, MD, https://curtthompsonmd.com/not-the-tale-we-were-hoping-for/, September 24, 2023.

15. Romans 7:15–20.

16. Isaiah 41:10 (ESV).

17. Luke 1:30 (ESV).

18. Matthew 1:20.

19. Luke 2:10–11.

20. https://www.bettercitiesfilmfestival.com.

21. http://www.filmschoolafrica.org.

22. Glenn Heath, Jr., "Interview: Destin Daniel Cretton on *Short Term 12*," *Slant Magazine*, September 4, 2013, https://www.slantmagazine.com/film/interview-destin-cretton/.

23. Sarah Laoyan, "How to Solve Problems Using the Design Thinking Process," Asana.com, November 2, 2022, https://asana.com/resources/design-thinking-process#.

24. Cassie Werber, "'There Is a Crack in Everything, That's How the Light Gets In': The Story of Leonard Cohen's 'Anthem,'" *Quartz*, November 11, 2016, https://qz.com/835076/leonard-cohens-anthem-the-story-of-the-line-there-is-a-crack-in-everything-thats-how-the-light-gets-in/.

Chapter 2: Honest Aspirations

1. Emily Hainon, "Taylor Swift Is Sending a Powerful Message to Women on the Eras Tour," *CNN*, April 23, 2023, https://www.cnn.com/2023/04/23/world/taylor-swift-ambition-essay-wellness/index.html.
2. Natalie Dixon, "Taylor Swift Is a Role Model for Everyone as She Unapologetically Owns Her Success," PeopleWorld, April 24, 2023, https://www.peopleworld.co.uk/music/taylor-swift-powerful-message-success-eras-tour-4115990.
3. Dixon, "Taylor Swift Is a Role Model."
4. K. Anders Ericsson, Michael J. Prietula, and Edward T. Cokely, "The Making of an Expert," *Harvard Business Review*, July–August 2007, https://hbr.org/2007/07/the-making-of-an-expert.
5. *Amadeus*, written by Peter Shaffer and Zdenek Mahler (Los Angeles: Orion Pictures, 1984).
6. Shaffer and Mahler, *Amadeus*.
7. Shaffer and Mahler, *Amadeus*.
8. Ashley Lee, "With the Tony-Winning 'A Strange Loop,' Jennifer Hudson Becomes an EGOT Recipient," *Los Angeles Times*, June 12, 2022, https://www.latimes.com/entertainment-arts/story/2022-06-12/jennifer-hudson-egot-winner.
9. *Glee*, Season 1, Episode 13, "Sectionals," written and directed by Brad Falchuk, aired December 9, 2009, on Fox Television.
10. "Ferrari vs Lamborghini: The Astonishing True Story," *Discovery UK*, February 22, 2021, https://www.discoveryuk.com/motoring/ferrari-vs-lamborghini/.
11. Peter Ternstrom, "The Epic Story behind the Ferrari and Lamborghini Rivalry," GranTurismo.org, February 12, 2021, https://www.granturismoevents.com/story-the-epic-story-behind-the-ferrari-and-lamborghini-rivalry/.
12. "Ferrari vs Lamborghini."
13. Ternstrom, "Epic Story."
14. Emmy Pérez, "Not one more refugee death," *With the River on Our Face* (Tuscon, AZ: University of Arizona Press, 2016).

15. Katelyn Beaty, *Celebrities for Jesus: How Personas, Platforms, and Profits Are Hurting the Church* (Grand Rapids, MI: Brazos Press, 2022), 8.
16. Genesis 11:4.
17. 1 Corinthians 4:7 (New Century Version [NCV]).
18. Rose Lichter-Marck, "Vivian Maier and the Problem of Difficult Women," *The New Yorker*, May 9, 2014, https://www.newyorker.com/culture/culture-desk/vivian-maier-and-the-problem-of-difficult-women.
19. Lichter-Marck, "Vivian Maier."
20. Ann Marks, *Vivian Maier Developed: The Real Story of the Photographer Nanny* (New York: Atria Books, 2018).
21. Ibid.
22. Dani Lamorte, "Keeping the Negative: On Ann Marks' 'Vivian Maier Developed,'" *Cleveland Review of Books*, July 14, 2021, https://www.clereviewofbooks.com/writing/ann-marks-vivian-maier-developed-review.
23. Lichter-Marck, "Vivian Maier."
24. Ibid.

Chapter 3: Honest Limitations

1. Kendrick Lamar, vocalist, "HUMBLE" track 8 on the album, *Damn*, Los Angeles: Top Dawg, 2017.
2. Rachel Quin, "Soggy Bottoms and Baps: The Proven Glossary of The Great British Bake Off," Collins Language Lovers (blog), *Collins Dictionary*, November 14, 2022, https://blog.collinsdictionary.com/language-lovers/soggy-bottoms-baps-the-proven-glossary-of-the-great-british-bake-off/.
3. Soren Kierkegaard, *The Concept of Anxiety: A Simple Psychologically Orienting Deliberation on the Dogmatic Issue of Hereditary Sin*, translated by Reider Thomte with Albert B. Anderson, (Princeton, NJ, Princeton University Press, 1981).
4. Humphrey Carpenter, *J.R.R. Tolkien: A Biography* (New York: Houghton Mifflin, 2000), 151.
5. Samatha Shannon, "How Tolkien Created Middle-earth," *The Guardian*, May 31, 2018, https://www.theguardian.com/books/2018/may/31/drawn-into-tolkiens-world-exhibition.
6. Jack D. Forbes, "Indigenous Americans: Spirituality and Ecos," *Daedalus*, Fall 2001, https://www.amacad.org/publication/indigenous-americans-spirituality-and-ecos.

7. Genesis 1:1–4.

8. E. N. Tigerstedt, "The Poet as Creator: Origins of a Metaphor," *Comparative Literature Studies* 5, no. 4 (December 1968), 455–88.

9. Barry Liesch, "Creativity in the Bible, Part 1 of 2," *WorshipInfo.com*, https://worshipinfo.com/creativity-in-the-bible-part-1-of-2, accessed September 24, 2023.

10. Guy Raz, "How Franz Liszt Became the World's First Rock Star," NPR, October 22, 2011, https://www.npr.org/2011/10/22/141617637/how-franz-liszt-became-the-worlds-first-rock-star.

11. Cody Cassidy, *Who Ate the First Oyster?: The Extraordinary People Behind the Greatest Firsts in History* (New York: Penguin Books, 2020), 53–62.

12. Johan Huizinga, *Homo Ludens: A Study of the Play-Element in Culture* (Boston: Beacon Press, 1971). Originally published in 1938.

13. Cassidy, *Who Ate the First Oyster?*, 50.

14. Cassidy, *Who Ate the First Oyster?*, xxi.

15. Cassidy, *Who Ate the First Oyster?*, 41.

16. Cassidy, *Who Ate the First Oyster?*, 9.

17. "Can You Tell Your Story in Exactly Six Words," NPR, February 3, 2010, https://www.npr.org/2010/02/03/123289019/can-you-tell-your-life-story-in-exactly-six-words.

18. Rachel Fershleiser and Larry Smith, eds., *It All Changed in an Instant: More Six-Word Memoirs by Writers Famous and Obscure* (San Francisco: Harper Perennial, 2010).

19. Denise Schrier Cetta, producer, "The Revolution," *60 Minutes*, New York: CBS News, April 19, 2023, https://www.youtube.com/watch?v=TUCnsS72Q9s.

20. Gene Marks, "When Keith Jarrett Played on a Very Broken Piano . . . and Then Sold 3.5 Million Albums," *Entrepreneur*, March 1, 2018, https://www.entrepreneur.com/leadership/when-keith-jarrett-played-on-a-very-broken-pianoand-then/309653.

21. Robert Rodriguez, *Rebel Without a Crew: Or How a 23-year-old Filmmaker with $7000 Became a Hollywood Player* (New York: Plume, 1996).

22. The enduring inspiration sparked by Simon Rodia's Watts Towers are explored in the PBS series Craft in America, season 14, episode 1, "Inspiration" aired on November 1, 2022, https://www.pbs.org/video/inspiration-episode-sz9je3/.

23. Betye Saar, *Betye Saar: Migrations, Transformations* (New York: Michael Rosenfeld Gallery, 2006).

24. http://www.betyesaar.net.

25. Amy Scattergood, "In the Dirt with Ron Finley, the Gangsta Gardener," *Los Angeles Times*, May 19, 2017, https://www.latimes.com/food/dailydish/la-fo -ron-finley-project-20170503-story.html.

26. Check out Thomas Reidelsheimer's moving documentary, *Andy Goldsworthy: Rivers and Tides* (New York: Roxie Releasing, 2001), streaming on Amazon Prime, 94 minutes.

27. Y-Jean Mun Delsalle, "This British Artist Makes Portraits of Pebbles," *Forbes*, November 13, 2022, https://www.forbes.com/sites/yjeanmundelsalle/2022/11 /13/this-british-artist-makes-portraits-out-of-pebbles/.

28. Vinod Maharta, "How GC Got Out of the GE Way to Create the Nano of ECGs," *The Economic Times*, May 11, 2011, https://economictimes.indiatimes .com/how-ge-got-out-of-the-ge-way-to-create-the-nano-of-ecgs/articleshow /7673404.cms?from=mdr.

29. Ecclesiastes 1:9.

30. Jon Batiste, "'Soul' Wins Best Original Score | 93rd Oscars," Oscars, June 2, 2021, YouTube video, 4:24, https://www.youtube.com/watch?v=0PN1NsO2 Zoo.

31. Note that non-Western music has different sounds and scales. For example, check out the enchanting Gamalan orchestras of Indonesia.

32. "Wastepicker Struggles and Water Contamination in Jardim Gramacho, Rio de Janeiro, Brazil," Environmental Justice Atlas, https://ejatlas.org/conflict /wastepicker-struggles-and-water-contamination-in-jardim-gramacho-rio-de -janeiro-brazil, accessed September 24, 2023.

33. "Vik Muniz," Sarasota Art Museum, https://www.sarasotaartmuseum.org/vik -muniz/, accessed September 24, 2023.

34. Pimploy Phongsirivech, "Vik Muniz's Illusory Reality," *Interview Magazine*, September 8, 2016, https://www.interviewmagazine.com/art/vik-muniz.

35. Vik Muniz, *Reflex: A Vik Muniz Primer*, ed. Lesley Martin (New York: Aperture, 2005).

36. Carol Kino, "Where Arts Meets Trash and Transforms Life," *New York Times*, October 21, 2010, https://www.nytimes.com/2010/10/24/arts/design /24muniz.html.

37. The parable of the sower is retold with slight variation in Matthew 13:1–9, Mark 4:1–9, Luke 8:4–8. Jesus unpacks its meaning for his disciples in the verses that follow.

38. Luke 8:15 (ESV).

Chapter 4: Honest Preparation

1. Simone Weil includes her "Letter to Joë Bousquet, 13 April 1942," in Simone Pétrement, *Simone Weil: A Life*, trans. Raymond Rosenthal (New York: Pantheon Books, 1976).

2. Louis Pasteur, quoted by R. M. Pearce, "Chance and the Prepared Mind," *Science* 35, no. 912 (June 21, 1912): 941.

3. Nathan Lee, "FILM IN REVIEW: Nights and Weekends," *New York Times*, October 10, 2008, https://archive.nytimes.com/query.nytimes.com/gst/fullpage-9900E5D61430F933A25753C1A96E9C8B63.html.

4. Ibid.

5. "Nights and Weekends," *BoxOfficeMojo.com*, https://www.boxofficemojo.com/title/tt1186248/, accessed September 24, 2023.

6. Emma Brockes, "Greta Gerwig: Daydream Believer," *The Guardian*, July 13, 2013, https://www.theguardian.com/film/2013/jul/13/greta-gerwig-frances-ha.

7. *Lady Bird*, written and direted by Greta Gerwig (New York: A24, 2017), streaming on Amazon, Apple, etc, 93 minutes.

8. Malcolm Gladwell, *Outliers: The Story of Success* (New York: Little, Brown, and Company, 2008).

9. Roxanne Shante interviewed by Jon Caramanica, "How Do You Tell the Story of 50 Years of Hip-Hop?" *New York Times*, "Arts and Leisure," August 6, 2023, 13.

10. Ibid.

11. Antonio Pequeno IV, "Grimes Helps Artists Distribute Songs Using Her AI Voice—If They Split Royalties. Here's How It Works," *Forbes*, June 12, 2023, https://www.forbes.com/sites/antoniopequenoiv/2023/06/12/grimes-helps-artists-distribute-songs-using-her-ai-voice--if-they-pay-royalties-heres-how-it-works/?sh=337a26f449ae.

12. Naomi Osaka, "It's O.K. Not to Be Okay," *Time*, July 8, 2021, https://time.com/6077128/naomi-osaka-essay-tokyo-olympics/.

13. Danielle Silva, "We're Human, Too: Simone Biles Highlights the Importance of Mental Health in Olympics Withdrawal," *NBC News*, July 27, 2001, https://www.nbcnews.com/news/olympics/we-re-human-too-simone-biles-highlights-importance-mental-health-n1275224.

14. Melody Chiu, Hannah Sacks, and Mary Elizabeth Andriotis, "Naomi Osaka Welcomes First Baby, a Girl, with Boyfriend Cordae," *People*, July 11, 2023,

https://people.com/naomi-osaka-boyfriend-cordae-welcome-first-baby
-daughter-exclusive-7504607.

15. Matthew 7:24–27.

16. Franz Kafka, *The Aphorisms of Franz Kafka*, ed. Reiner Stach, trans. Shelley Frish (Princeton, NJ: Princeton University Press, 2022), aphorism 109.

17. Julia Cameron, *The Artist's Way: 30th Anniversary Edition* (New York: Tarcher Pedigree, 2016).

18. "Denzel on His New 'Antwone Fisher,'" *ABC News*, December 18, 2002, https://abcnews.go.com/Primetime/story?id=132010&page=1.

19. Exodus 31:1–18.

20. Barry Liesch, "Creativity in the Bible, Part 1 of 2," *WorshipInfo.com*, https://worshipinfo.com/creativity-in-the-bible-part-1-of-2, accessed September 24, 2023.

21. Find more about Christopher Nolan's creative process in Jada Yuan, *Unleashing Oppenheimer: Inside Christopher Nolan's Explosive Atomic-Age Thriller* (San Rafael, CA: Insight Editions, 2023).

Chapter 5: Honest Reception

1. Meister Eckhart's poem "Expands His Being" is included in Daniel Ladinsky, *Love Poems from God* (New York: Penguin Publishing Group, 2002).

2. Marina Abramović, *512 Hours*, London: The Serpentine Gallery, June 11–August 25, 2014, https://www.serpentinegalleries.org/whats-on/marina-abramovic-512-hours/.

3. Marina Abramović, *The Artist Is Present*, New York: Museum of Modern Art, 2010, https://www.moma.org/learn/moma_learning/marina-abramovic-marina-abramovic-the-artist-is-present-2010/.

4. Marina Abramović, *Walk Through Walls: A Memoir* (New York, Three Rivers Press, 2016), 318.

5. Ibid.

6. Jonah Lehrer, *Imagine: How Creativity Works* (Boston: Houghton Mifflin Harcourt, 2012), 31.

7. Lehrer, *Imagine*, 35.

8. Carlos Aguilar, "How a First-Time Director's Own 'Past Lives' Inspired One of the Year's Best Films," *Los Angeles Times*, June 2, 2023, https://www

.latimes.com/entertainment-arts/movies/story/2023-06-02/past-lives-a24
-celine-song-greta-lee.

9. *A Purple State of Mind*, directed by Craig Detweiler and John Marks (Boise, ID: Priddy Brothers Production, 2008), DVD, 82 minutes.

10. Paul J. Pastor, "Andrew Peterson: Present in Creation," *Outreach Magazine* 21, no. 2 (March/April 2022): 81.

11. Trisha Gopal and Beryl Shereshewsky, "How a NASA Scientist Invented the Super Soaker," *cnn.com*, August 15, 2020, https://www.cnn.com/2020/08/15/us/super-soaker-lonnie-johnson-great-big-story-trnd/index.html.

12. Monica M. Smith, "Meet Lonnie Johnson, the Man Behind the Super Soaker," *Smithsonian*, January 16, 2017, https://invention.si.edu/meet-lonnie-johnson-man-behind-super-soaker.

13. "Lonnie Johnson," *Biography*, updated January 26, 2021, https://www.biography.com/inventors/lonnie-g-johnson#synopsis.

14. *Citizen Kane*, directed, produced, and cowritten by Orson Welles (Los Angeles: RKO Pictures, 1941), streaming on Amazon Prime, 1 hour, 59 minutes.

15. David Marchese, "Paul McCartney Is Still Trying to Figure Out Love," *New York Times Magazine*, December 5, 2020, 16, https://www.nytimes.com/interactive/2020/11/30/magazine/paul-mccartney-interview.html.

16. Paul McGuinness, "'Yesterday': The Story Behind the Beatles' Song," udiscovermusic.com, June 14, 2022, https://www.udiscovermusic.com/stories/yesterday-beatles-song-story/.

17. Paul McCartney reveals the stories behind his beloved songs in *The Lyrics: 1956 to the Present* (New York: W. W. Norton, 2021).

18. Jordan Runtagh, "Paul McCartney Reflects on How His Late Mother Became His Greatest Muse," *People*, November 2, 2021, https://people.com/music/paul-mccartney-reflects-on-how-his-late-mother-became-his-greatest-muse/.

19. Runtaugh, "Paul McCartney Reflects."

20. "Paul McCartney Carpool Karaoke," YouTube, 2018, https://www.youtube.com/watch?v=QjvzCTqkBDQ&t=1s.

21. Howard Hibbard, *Bernini* (New York: Penguin, 1965), 136–37.

22. Rachel Hall, "Drugs and Alcohol Do Not Make You More Creative, Research Finds," *The Guardian*, March 24, 2023, https://www.theguardian.com/science/2023/mar/24/drugs-and-alcohol-do-not-make-you-more-creative-research-finds.

23. Hall, "Drugs and Alcohol Do Not Make You More Creative."

24. Exodus 3:5.

Chapter 6: Honest Perception

1. Quoted in Sheena Iyengar, "AI Could Help Free Human Creativity," *Time*, June 23, 2023, https://time.com/6289278/ai-affect-human-creativity/.

2. Lehrer, *Imagine*, 60.

3. Lehrer, *Imagine*, 90–91.

4. John Coltrane, *My Favorite Things*, compact disc, New York: Atlantic Records, 1961.

5. Nick Cave and Sean O'Hagen, *Faith, Hope, and Carnage*, (New York: Farrar, Straus and Giroux, 2022), 6.

6. Nick Cave, *Faith, Hope, and Carnage*, 54.

7. Christian Zervos, "Conversation avec Picasso," *Cahiers d'Art* 10, no. 10 (1935) 173–78.

8. Elton John, *Me* (New York: Henry Holt and Company, 2019), 93.

9. *The T.A.M.I. Show*, directed by Steven D. Binder (Hollywood, CA: American International Pictures, 1964).

10. Tyler Golsen, "The Historic Night Jimi Hendrix Set Fire to His Guitar," *Far Out Magazine*, August 27, 2021, https://faroutmagazine.co.uk/the-night-jimi-hendrix-set-fire-to-his-guitar/.

11. *Motown 25: Yesterday, Today, Forever*, produced by Suzanne de Passe, aired on May 16, 1983, on NBC.

12. *U2 Live at Red Rocks: Under a Blood Red Sky*, directed by Gavin Taylor, recorded on June 5, 1983, at Red Rocks Amphitheatre in Colorado, VHS, Island Records, 1984.

13. Ben Kaye, "Video Reward: Eddie Vedder Climbs Stage Scaffolding at Drop in the Park, Consequence of Sound," Consequence, July 12, 2013, https://consequence.net/2013/07/video-rewind-eddie-vedder-climbs-stage-scaffolding-at-drop-in-the-park/.

14. Mahita Gajanan, "The Controversial Saturday Night Live Performance That Made Sinead O'Conner an Icon," *Time*, July 26, 2023, https://time.com/6298448/the-controversial-saturday-night-live-performance-that-made-sinead-oconnor-an-icon/.

15. Sinead O'Connor, *Rememberings* (Boston: Houghton Mifflin Harcourt, 2021), 177.

16. O'Connor, *Rememberings*, 181.

17. Kyna Leski, *The Storm of Creativity* (Cambridge, MA: MIT Press, 2015), 111.

18. "Nature and Its Influence on the Sagrada Familia: Three Examples," Blog Sagrada Família, March 11, 2020, https://blog.sagradafamilia.org/en /divulgation/nature-on-the-sagrada-familia/.

19. Kendall Strautman, "Gaudi, Biomimicry, and Bonsai: How Nature's Genius Inspired the Greatest Architect," Mirai, https://bonsaimirai.com/blog/gaud %C3%AD-biomimicry-and-bonsai, accessed September 24, 2023.

20. "Nature and Its Influence on the Sagrada Familia."

21. Jeremy Berlin, "133 Years Later, Gaudi's Cathedral Nears Completion," *National Geographic*, November 5, 2015, https://www.nationalgeographic. com/history/article/151105-gaudi-sagrada-familia-barcelona-final-stage -construction.

22. Leski, *Storm of Creativity*, 78.

23. Leski, *Storm of Creativity*, 80.

24. Betsy Morris, "Ada Lovelace: The First Tech Visionary," *The New Yorker*, October 15, 2013, https://www.newyorker.com/tech/annals-of-technology/ada -lovelace-the-first-tech-visionary.

25. Ada Lovelace. "Notes upon L. F. Menabrea's 'Sketch of the Analytical Engine Invented by Charles Babbage, Esq.,'" *Scientific Memoirs* (London, Taylor and Francis: 1843), 3:666–731.

26. Lauren McKenzie Reynolds, "Meet Ada Lovelace, the World's First Computer Programmer," *Massive Science*, August 10, 2018, https://massivesci.com/articles /ada-lovelace-first-programmer-science-heroes/.

27. D. Scarsprungli, "Ada Lovelace: Weaving Algebraic Patterns Like Looms Weave Flowers and Leaves," *The Good Times*, June 28, 2022, http://www.the -good-times.org/people-2/ada-lovelace-weaving-algebraic-patterns-like-looms -weave-flowers-and-leaves/.

28. Scarsprungli, "Ada Lovelace."

29. Morris, "Ada Lovelace."

30. Yasmin Kafai and Jane Margolis, "Celebrating Ada Lovelace," *The MIT Press*, October 11, 2016, https://mitpress.mit.edu/celebrating-ada-lovelace/.

31. Matthew 13:10–17.

Chapter 7: Honest Needs

1. Lisa Bramen, "The History of the Margarita," *Smithsonian Magazine*, May 5, 2009, https://www.smithsonianmag.com/arts-culture/the-history-of-the-margarita-57990212/.

2. Brad Cooper, "The Man Who Invented the Margarita," *Texas Monthly*, October 1974, https://www.texasmonthly.com/food/the-man-who-invented-the-margarita/.

3. Stephen Thomas Erlewine, "'Margaritaville' singer-songwriter," *Los Angeles Times*, September 3, 2023, A10.

4. Ella Creamer, "Amazon Removes Books 'Generated by AI' for Sale under Author's Name," *The Guardian*, August 9, 2023, https://www.theguardian.com/books/2023/aug/09/amazon-removes-books-generated-by-ai-for-sale-under-authors-name.

5. Cody Cassidy, *Who Ate the First Oyster?: The Extraordinary People Behind the Greatest Firsts in History* (New York: Penguin Books, 2020).

6. Katherine, "Sisters in Innovation: 20 Women Inventors You Should Know," *A Mighty Girl* (blog), August 20, 2023, https://www.amightygirl.com/blog?p=12223.

7. Diana Aguilera, "You Knew Stanford Alumni Invented Google; but the Koosh Ball?" *Stanford Magazine*, July 2018, https://stanfordmag.org/contents/you-knew-stanford-alumni-invented-google-but-the-koosh-ball.

8. Bill Snyder, "Vanderbilt's Crowe Receives the Building the Foundation Award from Research!America, *VUMC Reporter*, October 6, 2022, https://news.vumc.org/2022/10/06/vanderbilts-crowe-receives-the-building-the-foundation-award-from-researchamerica/.

9. Wendell Berry, "Poetry and Marriage," in *Standing by Words* (Berkeley, CA: Counterpoint, 1983), 92–105.

10. "I Will Always Love You," Songfacts, https://www.songfacts.com/facts/dolly-parton/i-will-always-love-you, accessed September 24, 2023.

11. Rhian Jones, "A Breakthrough Artist Is a Much More Complex Idea than a Breakthrough Song," *Music Business Worldwide*, December 30, 2016, https://www.musicbusinessworldwide.com/a-breakthrough-artist-is-a-much-more-complex-idea-than-a-breakthrough-song/.

12. Jones, "Breakthrough Artist."

13. Kame Hame, "The Medici and the Arts—Politics, Patronage, and Power," *Wonderwalls*, September 29, 2021, https://www.widewalls.ch/magazine/medici-arts.

14. Jacqueline Martinez, "The Medici Family: Ultimate Power and Legacy in the Renaissance, *The Collector*, July 28, 2020, https://www.thecollector.com/the-medici-family-legacy/.

15. Michael Prodger, "The Man Who Made Monet: How Impressionism Was Saved from Obscurity," *The Guardian*, February 21, 2015, https://www.theguardian.com/artanddesign/2015/feb/21/the-man-who-made-monet-how-impressionism-was-saved-from-obscurity.

16. Susan Stamberg, "Durand-Ruel: The Art Dealer Who Liked Impressionists Before They Were Cool," NPR, August 18, 2015, https://www.npr.org/2015/08/18/427190686/durand-ruel-the-art-dealer-who-liked-impressionists-before-they-were-cool.

17. Prodger, "Man Who Made Monet."

18. Prodger, "Man Who Made Monet."

19. Countee Cullen, "From the Dark Tower," in *My Soul's High Song, The Collected Writings of Countee Cullen* (New York: Anchor Books, 1991), 139, https://www.poetryfoundation.org/poems/42622/from-the-dark-tower.

20. Claytee D. White, "A'Lelia Walker (1885–1931)," BlackPast.org, February 28, 2007, https://www.blackpast.org/african-american-history/walker-alelia-1885-1931/.

21. https://www.wedgwoodcircle.com.

22. https://www.praxislabs.org.

23. Matthew 10:16.

Chapter 8: Honest Criticism

1. Francis Bacon in conversation with David Sylvester in Anthony Lane, "Snippy," *The New Yorker*, May 29, 2023.

2. *You Hurt My Feelings*, written and directed by Nicole Holofcener (New York: A24, 2023), in movie theatres, 93 minutes.

3. Toni Morrison, interviewed by Larissa McFarquhar about her relationship to her longtime book editor, "Robert Gottlieb, The Art of Editing No. 1," *The Paris Review*, Issue 132, Fall 1994.

4. Dominic Harris, "Sea Snail Shell the World's Strongest Material," *Australian Graphic*, February 19, 2015, https://www.australiangeographic.com.au/news/2015/02/sea-snail-shell-the-worlds-strongest-material/.

Notes

5. A. O. Scott, *Better Living Through Criticism: How to Think About Art, Pleasure, Beauty, and Truth* (New York: Penguin Books, 2017).

6. Daniel Mendelsohn, "A. O. Scott's 'Better Living Through Criticism,'" *New York Times*, February 19, 2016, nytimes.com/2016/02/21/books/review/a-o-scotts-better-living-through-criticism.html.

7. A. O. Scott, "And Now Let's Review," *New York Times*, March 17, 2023, https://www.nytimes.com/2023/03/17/movies/film-critic-ao-scott.html.

8. Proverbs 12:1.

9. Proverbs 12:18 (Good News Translation [GNT]).

10. Larissa McFarquhar interview, "Robert Gottlieb, The Art of Editing No. 1."

11. Ibid.

12. Ibid.

13. Michael Crichton, interviewed by Larissa McFarquhar about her book editor, "Robert Gottlieb, The Art of Editing No. 1."

14. Harper Lee, *To Kill a Mockingbird* (New York: J. B. Lippincott, 1960).

15. Harper Lee, *Go Set a Watchman* (New York: William Heinemann, 2015).

16. *Short Term 12*, written and directed by Destin Daniel Cretton (Los Angeles: Cinedigm, 2013), rentable on Amazon Prime, 96 minutes.

17. I highly recommend all the wisdom gathered in Walter Murch, *In the Blink of an Eye* (Los Angeles: Silman-James Press, 2001).

18. Murch, *In the Blink of An Eye*.

19. Johnny Cash, vocalist, *American Recordings*, produced by Rick Rubin, compact disc, Los Angeles: American, 1994.

20. The Dixie Chicks, vocalists, *Taking the Long Way*, produced by Rick Rubin, compact disc, Nashville, TN: Columbia Nashville, 2006.

21. Adele, 21, compact disc, New York: Columbia Records, 2011.

22. Proverbs 12:15.

23. 2 Samuel 7:3 (ESV).

24. 2 Samuel 7:22 (ESV).

25. 2 Samuel 12:7.

26. 2 Samuel 12:13.

27. 1 Kings 1:17.

28. 1 Kings 1:29–30.

Chapter 9: Honest Marketing

1. David Ogilvy, *Confessions of an Advertising Man* (New York, Atheneum, 1963).
2. Creighton Reed, "George Crum (1824–1914)," BlackPast.org, June 6, 2020, https://www.blackpast.org/african-american-history/george-crum-1824-1914/.
3. Laura Belman, "Potato Chip Inventions," Lemelson Center, September 21, 2014, https://invention.si.edu/potato-chip-inventions.
4. "The Story of George Crum and The Original Saratoga Kettle Chips," The Original Saratoga Chips, https://originalsaratogachips.com/our-story/, accessed September 25, 2023.
5. William S. Fox and Mae G. Banner, "Social and Economic Contexts of Folklore Variants: The Case of Potato Chip Legends," *Western Folklore* 42, no. 2 (April 1983): 114–26, https://www.jstor.org/stable/1499968.
6. M. Bijman, "The Mystery of the Misquoted Quote from 'The Man Who Shot Liberty Valance,'" *Seven Circumstances*, June 15, 2018, https://sevencircumstances.com/2018/06/15/the-mystery-of-the-misquoted-quote-from-the-man-who-shot-liberty-valance/.
7. Pamela McClintock, "Disney Distribution Chief Dave Hollis Leaving to Run Wife Rachel Hollis' Company," *The Hollywood Reporter*, March 5, 2018, https://www.hollywoodreporter.com/news/general-news/disney-distribution-chief-dave-hollis-leaving-run-wife-rachel-hollis-company-1092111/.
8. Rebecca Onion, "I Just Spent 10 Hours Listening to Marriage Advice from a Power Couple That Went Kaput. Whew.," *Slate*, May 5, 2021, https://slate.com/human-interest/2021/05/rachel-hollis-marriage-advice-divorce-podcast.html.
9. Morgan Hines and Elise Brisco, "Former Disney Exec and Author Dave Hollis' Cause of Death Revealed in Autopsy," *USA Today*, April 25, 2023, https://www.usatoday.com/story/entertainment/celebrities/2023/04/25/disney-dave-hollis-cause-of-death-cocaine-ethanol-fentanyl/11735973002/.
10. *Jason Isbell: Running with Our Eyes Closed.*
11. Beyoncé, *Lemonade*, streaming on Spotify, New York: Columbia Records, 2016.
12. *Don't Look Back*, directed by D.A. Pennebaker, streaming on The Criterion Collection, 96 minutes, (New York: Leacock-Pennebaker, Inc., 1967).
13. Dick Pountain and David Robins, *Cool Rules: Anatomy of an Attitude* (London, Reaktion Books, 2000).

14. Josh Young, "Days of Hell," *Entertainment Weekly*, January 15, 1999, https://web.archive.org/web/20110623081655/http://www.ew.com/ew/article/0,,274092,00.html.

15. Kate Kellaway, "Hilma af Klint: A Painter Possessed," *The Guardian*, February 21, 2016, https://www.theguardian.com/artanddesign/2016/feb/21/hilma-af-klint-occult-spiritualism-abstract-serpentine-gallery.

16. Kellaway, "Hilma af Klint: A Painter Possessed."

17. Stephanie Graf, "How Occultism and Spiritualism Inspired Hilma af Klint's Paintings," TheCollector.com, September 19, 2021, https://www.thecollector.com/how-occultism-spiritualism-inspired-hilma-af-klint-paintings/.

18. Kate Brown, "'This Is Her Reality': The First-Ever Biography on Hilma af Klint Unearths How the Swedish Artist Lived, Worked, and Communed with Spirits," *Artnet*, March 27, 2023, https://news.artnet.com/art-world/hilma-af-klint-biography-2266438.

19. Brown, "'This Is Her Reality.'"

20. Kellaway, "Hilma af Klint: A Painter Possessed."

21. Caitlin Dover, "Who Was Hilma af Klint?: At the Guggenheim, Paintings by an Artist Ahead of her Time," guggenheim.org, October 11, 2018, https://www.guggenheim.org/blogs/checklist/who-was-hilma-af-klint-at-the-guggenheim-paintings-by-an-artist-ahead-of-her-time.

22. Mark 1:43–45.

23. Mark 7:36.

24. Mark 8:27.

25. The debate was sparked by William Wrede, *The Messianic Secret*, trans. J. C. G. Grieg (Cambridge: James Clarke & Co., 1971).

26. Mark 1:45.

27. James 4:2.

Conclusion: Honest Resilience

1. *The Lord of the Rings: The Two Towers*, written by Peter Jackson, Fran Walsh, Philippa Boyens and Stephen Sinclair (Los Angeles: New Line Cinema, 2002), DVD, 179 minutes.

2. *The Beatles: Get Back*, directed by Peter Jackson (Burbank, CA: Disney+, 2022), streaming on Disney+, 468 minutes.

3. Colossians 3:23.

4. Tom Eames, "The Story of . . . 'I Will Survive' by Gloria Gaynor," Smooth Radio, March 7, 2022, https://www.smoothradio.com/features/the-story-of/i-will -survive-gloria-gaynor-lyrics-meaning-facts/.

5. Karen Grigsby Bates, "'I Will Survive' Saves Marginalized People a Spot on the Dance Floor," NPR, September 24, 2019, https://www.npr.org/2019 /09/24/763518201/gloria-gaynor-i-will-survive-american-anthem.

6. Eames, "The Story of . . .".

7. Misao Jo and Kenzo Jo, *SAORI: Self Discovery through Free Weaving* (Osaka, Japan, Saorinomori/Sakaiseikisangyo Co., 2012), 130.

8. "Misao Jo and the Beginning of Saori," Saorimore, https://www.saorimor.co.uk /about/misao-jo-and-the-beginnings-of-saori/, accessed September 24, 2023.

9. Misao Jo and Kenzo Jo, *SAORI*, 17.

10. "Beauty with Lack of Intentions," Wayward Weaves, https://www.wayward weaves.co.uk/saori.html, accessed September 24, 2023.

11. Misao Jo and Kenzo Jo, *SAORI*, 14.

12. Kenzo Jo and Kenzo Jo, *SAORI*, 6.

13. "About Saori," Saori Global, https://www.saoriglobal.com/about-saori, accessed September 24, 2023.

14. "Misao Jo and the Beginning of Saori."

15. "About Saori."

16. Misao Jo and Kenzo Jo, *SAORI*, 19.

17. Misao Jo and Kenzo Jo, *SAORI*, 29.

18. Misao Jo and Kenzo Jo, *SAORI*, 14.

19. Misao Jo and Kenzo Jo, *SAORI*, 135.

20. "Saori: Zen Weaving from Japan," Loop of the Loom, https://loopoftheloom .com/weaving, accessed September 24, 2023.

21. "Saori: Zen Weaving from Japan."

22. Misao Jo and Kenzo Jo, *SAORI*, 18.

23. Ephesians 2:10.